PHOTOGRAPHER'S
EXPOSURE
HANDBOOK

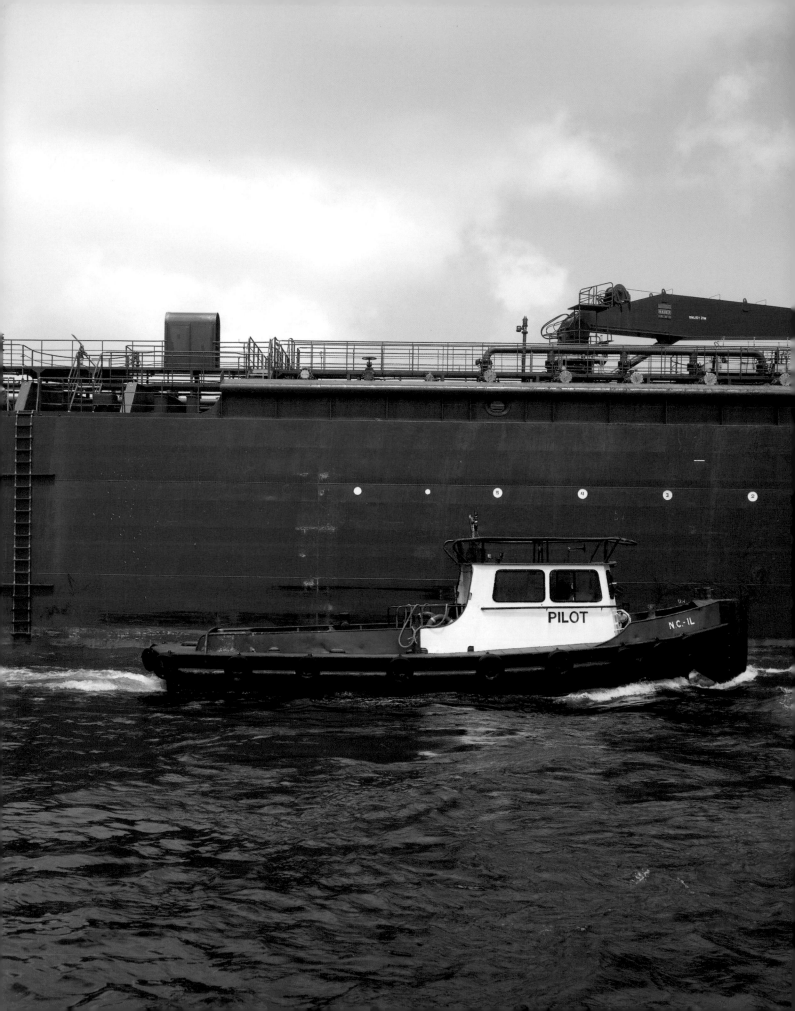

PHOTOGRAPHER'S
EXPOSURE
HANDBOOK

Professional Techniques for Using Your Equipment Effectively and Creatively

JACK NEUBART

AMPHOTO BOOKS

An imprint of
Watson-Guptill Publications/New York

a pdn PROS book
PHOTO DISTRICT NEWS

About *PDN*
Photo District News is the award-winning leading publication for professional photographers and creatives. As it has every month for over two decades, *PDN* delivers unbiased news and analysis, interviews, photographer portfolios, exhibition listings, marketing and business advice, product reviews, technology updates, and all the information photographers need to survive in a competitive business. It is the definitive resource for those who take pictures and those who use pictures.

Editorial Director: Victoria Craven
Art Director: Gabriele Wilson
Designer: Pooja Bakri
Production Director: Alyn Evans

First published in 2007 by Amphoto Books
an imprint of Watson-Guptill Publications
Crown Publishing Group,
a division of Random House Inc., New York
www.crownpublishing.com
www.watsonguptill.com
www.amphotobooks.com

Library of Congress Cataloging-in-Publication Data
Neubart, Jack.
 Photographer's exposure handbook : professional techniques for using your equipment effectively and creatively / Jack Neubart.
 p. cm.
 Includes index.
 ISBN-13: 978-0-8174-5908-6 (pbk.)
 ISBN-10: 0-8174-5908-1 (pbk.)
 1. Photography—Exposure—Handbooks, manuals, etc. I. Title.

 TR591.N458 2007
 771—dc22

 2007013631

Typeset in New Baskerville and Helvetica Neue

Printed in China

2 3 4 5 6 7 8 9 / 16 15 14 13 12 11 10 09

Acknowledgments

I have many people and companies to thank for their help in the execution of this book. Back home in the New York metropolitan area, I had the support and cooperation of numerous friends, some of whom also modeled for me. Special thanks go to Eric and Nava and their adorable little girls, Noa and Avery; Renee and son Nathaniel; Falene; Jennifer; and actor and chef Beverly Lauchner. In and around picturesque Asheville, North Carolina, I am indebted to photographer Benjamin Porter and friends DeWayne and Billie, for their invaluable assistance (and to Ed Meyers back home, for the introductions); the kind folks at Cumberland Falls B&B; and Jason of Blue Ridge Day Hiker, my guide who kept me a safe distance from an irate timber rattler. On the charming and scenic island of Curaçao, Netherlands Antilles, my sincerest gratitude goes to Maria and Paola, for providing countless moments of inspiration; Simon, for showing me some of the most picturesque spots on the island; Marilyn, for her tour of the hidden nooks and crannies in Willemstad; my friends at Iguana Café; Babette of Amazing Island Tours, for first introducing me to the wonders of Curaçao; and Helen, who arranged my tours out of the Howard Johnson Hotel during my initial visit. I am especially indebted to Simon and Maria, for hosting my stay during my second visit to Curaçao and making both trips so memorable.

I am thankful to numerous photographers for their words of wisdom and encouragement over the years, most notably David Allan Brandt (and wife Elaine), Chris Collins, Don Dixon, Rafael Fuchs, Lois Greenfield, and Jeff Smith (and wife Emily). Their contributions can be found in the first two books in the PDNpros series: *Studio Lighting Solutions* and *Location Lighting Solutions* (both published by Amphoto Books).

Companies that provided assistance with equipment, software, film, or technical support include Adobe, Alien Skin Software, Argraph, Bogen Imaging, Canon USA, Eastman Kodak, Fujifilm USA, HP Marketing, Imagenomics, Interfit Photographic, Logitech, Lowepro, MAC Group, Nikon USA, Noho Productions (New York), Olympus America, Pantone, Photek, PhotoVision, RTS, Wacom, and Wolverine Data. And I am ever grateful to Canon's resident tech guru, Chuck Westfall, for his ready willingness to share his vast technical knowledge and expertise.

Shutterbug's George Schaub and Bonnie Paulk provided words of encouragement and guidance. Also, a special shout-out to Peter Burian, for challenging my thinking at every turn, and to Jon Canfield, for his assistance. And I am deeply obliged to Elinor Stecker-Orel, mentor and friend, for reviewing select sections of this book.

This entire series would not be possible without the inspired motivation of Amphoto's Victoria Craven and the help of a great team working with her, notably Alisa Palazzo, as well as the support of *Photo District News*, in particular Holly Hughes and Lauren Wendle.

CONTENTS

Introduction

Much has changed and little has changed in the nearly twenty years since I wrote my first book, *The Photographer's Guide to Exposure*. Technology has taken great strides forward, but the best pictures still come from an understanding of the tools at our disposal and a mastery of our own creative vision as we bring each exposure to life.

Increasingly, the cameras in our hands are digital. We look at pictures differently, with an eye toward finding an ever-increasing array of uses. Even when we shoot film, we often end up with something scanned that we can manipulate on a computer screen and likely e-mail, post to a Web site, burn to disk, or publish in print. And so, with the plethora of potential uses stemming from that one image, it becomes even more important to get the exposure right. That has not changed. What *has* changed is the moment we choose to get it right—in camera or in post.

When we talk about photographic exposure, we talk about more than setting ISO, *f*-stop, and shutter speed. We're also talking about lighting and composition, as well as how best to capture a subject or scene. Lighting obviously affects exposure. Composition may affect the tonalities read by the meter, owing to the way we choose to frame the subject. And the subject or scene dictates mood, the need to stop action or blur it, and the depth of sharpness captured.

It's all interrelated, down to the way we choose to interpret what is in front of our camera. Exposure is not simply an objective measurement. We assess the qualities that need to be brought out and emphasized, or subdued. Sometimes the subject controls the picture, demanding that subtle tones be expressed; other times we dictate what's important by the visual statement we wish to make. Contrast is another element that we need to understand and control, as it also affects what is seen and unseen.

As cameras and their exposure control systems get more sophisticated, so do handheld exposure meters. We may think that we no longer need a handheld meter because the camera is so high-tech, what with all those computer-governed metering systems in vogue today and the availability of automatic bracketing. But do we really want to chance the success of a picture by relying on the vagaries of some computer algorithms that may or may not get it right? A microprocessor, along with its set of embedded instructions, is not foolproof. It interprets the information someone originally fed it—someone other than us.

Admittedly, I don't pull out a handheld meter to take a reading every time there's a potentially confusing display of tonalities in front of me. I first visually and mentally evaluate the scene to determine how the various tonalities will affect the camera meter and potentially ruin the exposure or lead to success. And often, that's an instantaneous process, arrived at from years of experience. The process isn't perfect. But I'm also aware of what steps to take to point myself in the right direction.

Other times, the handheld meter is simply the best tool for the job, such as with outdoor portraits or scenic views that require a more studied approach. The handheld meter helps not only in determining exposure but with judging lighting contrast, as well. And sometimes it's the only practical tool for the job, namely with studio strobe lighting. Granted, numerous professional photographers have got their studio lighting down to a science and may be able to eyeball the exposure—relying on years of experience—with a little help from Polaroids, if not digital previews.

Like our cameras, shoe-mount electronic flash has come a long way, as well, becoming as much a product of the computer age. Depending on how we use this tool, the flash may deliver superb results most of the time or prove to be a costly disappointment. Here, too, an understanding of photographic exposure comes into play. What governs the camera exposure also governs the flash exposure, and then some.

I shot many pictures expressly for this book so that I could bring you information based more on experience than hearsay. And I learned a lot in the process. Most important, I had to ask myself one very challenging question and then—the tough part—answer it to my satisfaction. The simple question was this: Who decides when the exposure is correct? The answer was not so simple. The exposure is "correct" when it brings out a desired quality in the subject, or when it conveys the necessary mood or feeling or message. A commercial client sees the exposure as correct when it portrays the product in all its glory. The fine art photographer may see the exposure as correct when it captures a temperament, evokes a sentiment, or forces us to stand and stare at the picture and perhaps question our sense of reality. Photojournalists see the exposure as correct when it tells the story they set out to tell. One person might prefer more subdued tones, while another would rather see the stark reality that surrounds us. The exposure gives us that control.

There's no such thing as a "perfect" exposure, and don't let anyone tell you otherwise. Each exposure is a "best fit" scenario—what best fits the subject, your impression of or artistic vision surrounding it, the end use, or your client's needs. There is considerable leeway here.

In the end, exposure comes down to a visual assessment. You assess the situation in front of the camera; you assess the result you're looking at on a piece of film, in a print, or on a screen. You don't necessarily have to know how to crunch all the numbers and get bogged down in a bunch of techno-babble or immerse yourself in the technology to the point of drowning in it, but you do have to be able to look at an image and say, This feels right, or, This meets my needs. Countless professional photographers take this approach and produce beautiful imagery as a result. You may not get it right the first time or the tenth, and over time, your opinion of an image may change. I've had that experience numerous times, reviewing images and realizing another

exposure may have been the better choice. But over time, you will get it simply by looking at the image and seeing what works. It may require an examination of someone else's images to garner that understanding and mastery, and that's what this book is designed to help you do.

The passage of time has not altered one fact: No matter how we arrive at it, exposure is largely subjective—and so is the approach any one person takes toward it. When you master exposure and the way you look at the images you've captured, you're one step closer to mastering your destiny as a photographer.

Technical Notes

PHOTO GEAR, SOFTWARE & PERIPHERALS

I predominantly used Canon cameras (notably the EOS 5D and EOS 20D) and EF lenses to shoot new pictures for this book. For hand-held meters, I mostly used Sekonic light meters. Interfit strobes provided studio lighting, whereas Canon Speedlites were my portable lighting solution. Film scanning was done on a Nikon film scanner after viewing slides on a Gepe light box, with a Canon flatbed handling other scanning chores.

For digital editing, I used Dell and iMac computers, each with widescreen 24-inch displays, with a Wacom Intuos 3 wide-format tablet on the Mac. Digital postproduction primarily involved Adobe Photoshop, with RAW files being converted most recently in Adobe Photoshop Lightroom. Monitor calibration made use of Pantone products, and prints were output on a Canon printer.

LENS FOCAL LENGTH

Focal lengths mentioned assume use of a 35mm camera or full-frame digital SLR. Users of APS-C and other digital formats should calculate focal length based on the applicable lens conversion factor.

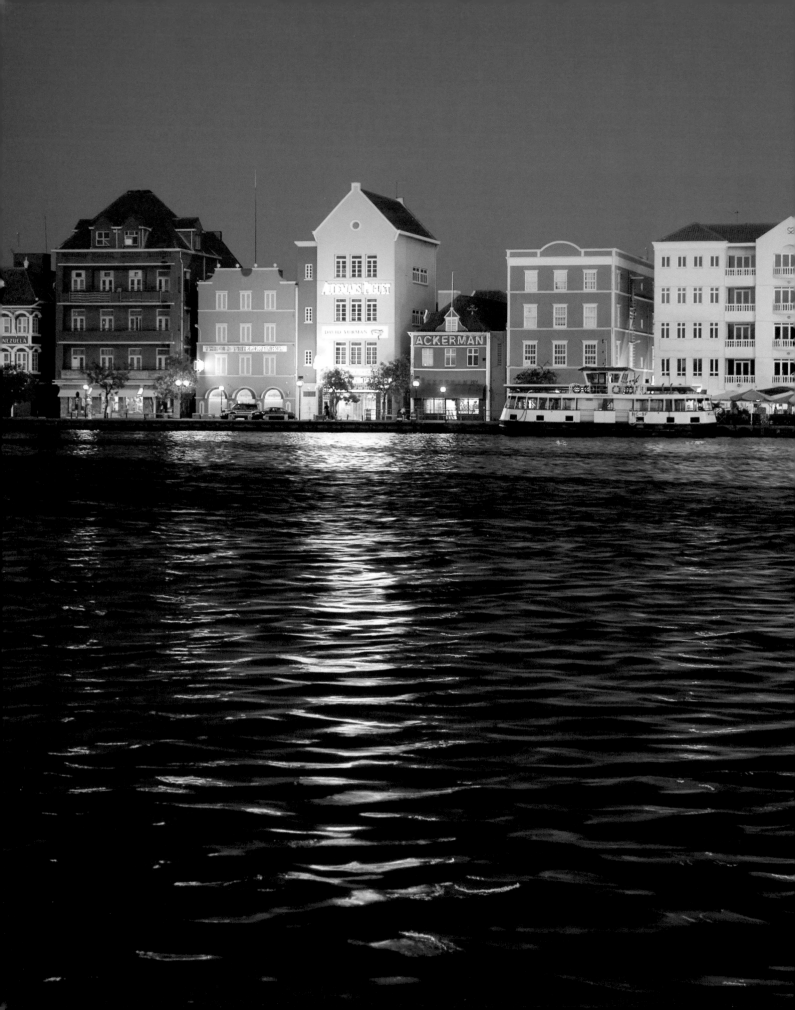

LIGHT & EXPOSURE

Before you can adequately and properly understand and master exposure, you have to understand light and the role it plays in imbuing the subject with a certain individuality. Light has a distinctive quality that shapes the subject, lends it texture, endows it with form, and gives it character. Light essentially defines the subject. The exposure would be nothing without light, so you also have to understand how light affects exposure.

Light: The Key to Exposure

When you look at a scene, you immediately take note of the presence or absence of shadows. These shadows, or the lack thereof, will tell you much about the photograph you're about to take. What may be less obvious is the color the light takes as it gives life to the photograph, and less obvious still, the exact exposure the scene requires for a faithful rendering.

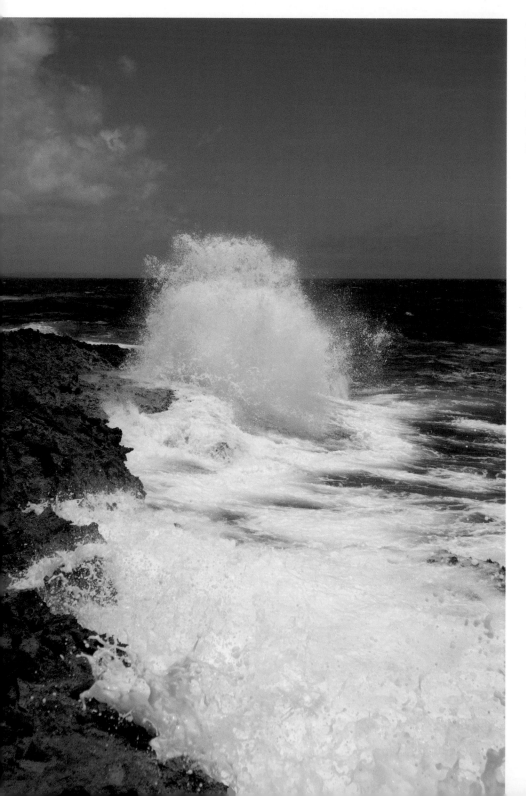

Capturing the vitality of violent surf breaking against the lava-rock shoreline of Curaçao meant watching and waiting for the right wave. The noonday sun helped to evenly illuminate the scene. At another time of day, the crashing waves would have had a completely different look.

The Yin and Yang of Light

When you look out at a bright, sunlit sky and then look around, you can see distinctive shadows being cast by neighboring trees, buildings, and people. You may first note the depth of the shadows by the seeming lack of detail in the areas they cover. Then you'll see how clearly defined the edges bordering these shadows are, further defining their depth. These distinctive shadows tell you you're dealing with *hard* light.

When the sky is overcast, the clouds break up and scatter the light, destroying the hard edges. The clouds have the effect of diffusing the light and making it *soft*. This soft light may also be shadowless, or practically so. When a cloud passes in front of the sun, it effectively casts a shadow that masks other shadows within its sphere of influence. Standing in the shadow of a building has largely the same effect, resulting in a soft, shadowless light. Step out from the shadows, and other shadows form. When the weather clears up or you step away from the building, the light changes from soft back to hard.

Aerial haze and fog likewise contribute to varying degrees of soft lighting. A light haze will have less of an effect on shadows—almost negligible, in fact—so that shadows may still have a somewhat hard edge to them. Strong aerial haze will blur details, along with any shadows that exist, although these shadows may still be evident upon close inspection. Now, if you think of fog as a gauzy material and watch the light filtering through this gauzy curtain that slowly rolls toward you, you'll note that the light has softened somewhat and that shadows within this "low-lying cloud" are indistinct at best.

Also important is the direction in which shadows fall. The point of origin of the light source determines the direction that shadows follow. A hard light is a readily definable source, with a definable direction. Soft lighting is much less defined, if it's defined at all. In fact, it may be omnidirectional, lacking an obvious source entirely and seeming to originate from anywhere and everywhere. In addition, shadows have length. When the sun is at its highest, at or about noon, the shadow is shortest and falls directly below the subject. The early-morning or late-evening sun produces long, sweeping shadows that add a dramatic touch to a scene.

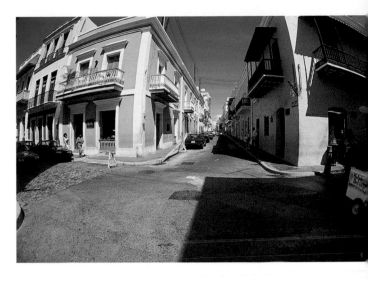

The intense hard light and deep shadows are characteristic of Caribbean islands. In this street scene in Old San Juan, Puerto Rico, note how the hard lighting creates a deep foreground shadow. In contrast, the shadow enveloping part of the facades of the buildings on the right is just a tad softer. Reflected light from the bright buildings on the opposite side of the street helped to fill in detail, thereby softening adjacent shadows.

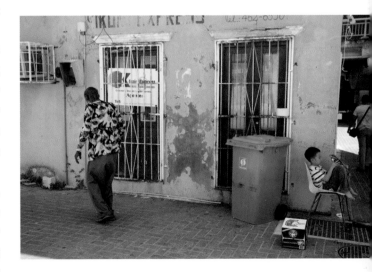

Open shade leads to soft lighting in this setting. It proves to be the great equalizer, working well to bring equal attention to the elderly man and the young boy in this alley in the Otrabanda quarter of Willemstad, Curaçao.

Although we've mapped these observations out in our mind in some kind of order, there really is none. This awareness of light can come all at once or one step at a time as you note its hardness or softness, its direction, and the length of the resultant shadows. What is important is that you do become aware of each of these factors. They will affect the pictures you take. What it all comes down to is that we judge light by the shadows that form, or the seeming lack of these shadows. You might say that shadow and light are yin and yang that influence how we approach each subject and expose for it.

The Intensity and Duration of Light: A Measure of Exposure

If you stare at a white sheet of paper under bright sunlight, you'll find the glaring reflection practically blinding. If you look at the same piece of paper under a conventional desk lamp, you'll find it tolerable. From this, you can conclude that the quantity of light falling on a subject and, subsequently, reflecting off it is a measure of its intensity.

Now, step into a dark room. Allow your eyes to acclimate to the darkness. Soon, you will be able to make out some shapes, provided that even a hint of light has entered the room and that there are some reflective surfaces. Time is a factor. Your visual system needed time to gather sufficient light to register on the retina and to stimulate the necessary rods and cones at the back of the eye. When you step out into bright sunlight, your eyes immediately respond to the brightness, and you squint.

So, we now have the two key ingredients involved in exposure, or the total volume of light that defines the relative levels (densities) of white, gray, and black tonalities (or their color equivalents): intensity of light and time (defining time as the duration or length of exposure to light).

Light and Contrast

As noted, light has intensity—it can be strong or weak or somewhere in between. That, together with the hard or soft quality of light and subject reflectance, in turn, defines *subject contrast.* Normally, you judge contrast by your ability to see into the shadows, although it applies equally to the brightest areas in the scene, where blindingly bright tonalities prevent you from distinguishing any detail.

On a bright day, a scene exhibits strong contrasts of light and shadow. It is said to be *contrasty* or, more correctly, to exhibit *high contrast.* Subject tones and colors tend to be deep and rich and full of body. They have an easily definable character and texture. On an overcast day, subject tones and colors become muted—a mere hint of their former selves—and much less definable. This is a *low-contrast* scene.

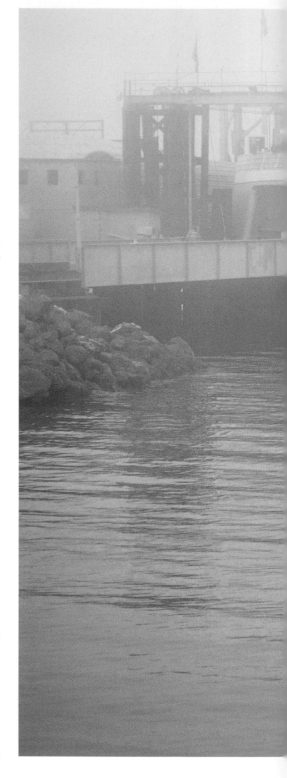

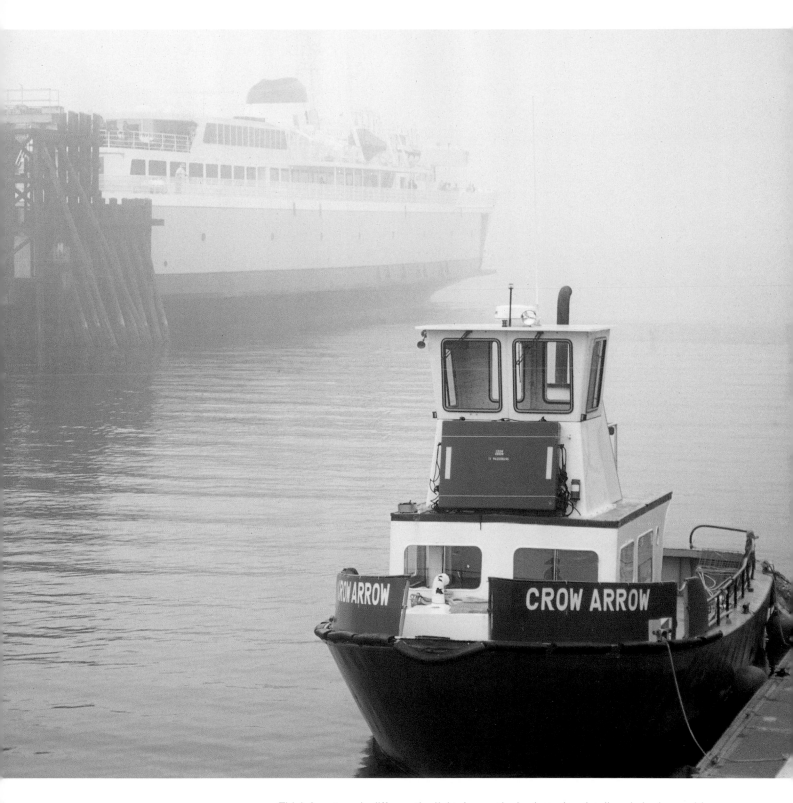

Thick fog strongly diffuses the light, increasingly obscuring detail and shadows with increasing distance. The fog in this scene has already largely obscured the ferry off the Port Angeles docks, on Washington State's Olympic Peninsula, leaving the moored tugboat to await its fate as the fog rolls in.

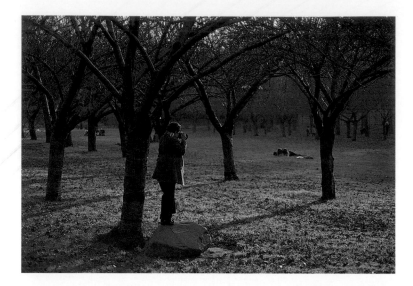

Shadows are often a strong element in a picture. The long, sweeping shadows add a certain depth to this scene and help direct our attention to the photographer, who appears preoccupied with capturing a young couple's intimate moments off in the distance. These distinct shadows also tell us a bright sun lies fairly low on the horizon. By the same token, the photographer and surrounding trees are in shadow, with only rim lighting helping to separate her from the background. Had the exposure focused more on the shadows, it would have weakened them and lessened the role they played.

Subject tones practically cover the gamut from white to black (white flowers to deep shadow) in this scene atop Hurricane Ridge on Washington State's Olympic Peninsula. Even with overcast skies and the resulting soft lighting, there isn't much leeway in exposure before the white flowers get washed out or the surrounding forest goes too dark to show any detail.

When contrast falls to a level at which shadows disappear or become practically indistinguishable, the scene and lighting are said to be *flat*. But don't take that to be synonymous with *lifeless*. Don't assume that flat lighting is anathema to a good picture. Flat lighting can do much to level the playing field so that what needs to be seen clearly in the image is seen. (Having said that, we still have a tendency to refer to flat lighting as lifeless, and I am equally guilty of that indiscretion.)

Flat lighting can also come about when a hard light source hits the subject head on, washing over the surface. This light practically annihilates the shadows, because it practically fills in every nook and cranny. Shadows may still be there, but they may be hiding beneath the folds of a garment or among distant trees and remain practically indistinguishable unless you look for them.

There is also the *tonal range* inherent in the subject to consider. Light and dark tones—from white to gray to black, for example—represent another form of contrast, referred to as *tonal contrast*. A penguin, for example, is a clear illustration of tonal contrast and limited tonal range (barring the rest of the scene), with its white and black feathers. These subject tones play a key role in how we perceive the subject and how we expose for it.

The tonal range doesn't necessarily have to be represented by black, gray, and white; it could just as easily be color equivalents. If you take a color image and render it as grayscale (or if you desaturate it), you'll see how the relative brightness or vividness of the various colors equates to shades of black and white. When making an exposure, you have to be able to make that conversion in your mind so that you have a better understanding of the subject and a clear sense as to how to interpret its needs and capture it fully.

When working with natural light, we don't always think in terms of *lighting contrast*. We experience contrasts in the amount of illumination falling on, or incident to, the light side and dark side of the subject. When you look at a tree trunk and note that one side is brightly lit and the other side is in shadow, you are witnessing lighting contrast. You can measure the relative amounts of light contributing to the light and dark tones, or sides of the tree. Returning to the example of the penguin, in that instance, when you are evaluating light levels coming off the white and black feathers, you are seeing *reflected light* and getting a sense of subject contrast. With the tree, when you are evaluating light levels on each side of the tree (not light bouncing off it), you are seeing *incident light* and getting a sense of lighting contrast. These are key concepts to keep in mind when measuring exposure.

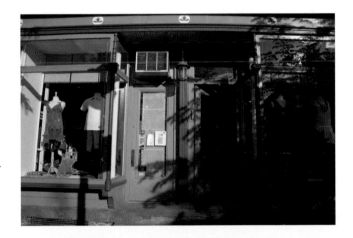

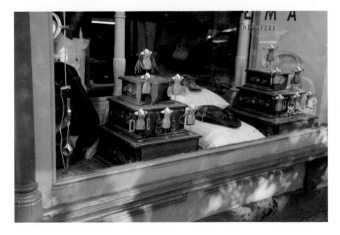

The relative amounts of light and shadow contributed to the way I approached this shot. This sunlit storefront scene required a small exposure boost to deal with the brightness. Isolating the store window on the right for a separate shot required me to open up the exposure by several stops.

The Character of Light

Light has many forms beyond natural lighting, each giving the subject a defining character. Even when artificial, light has many faces. And whether natural or artificial, light has color—many colors, in fact—which we often fail to see except when blatantly obvious. But the recording medium sees every shade and nuance.

Neon is always fun to photograph. The trick is holding as much of the color as possible, which means that using the best practical exposure is important. The lingering daylight helped fill in where streetlights and other light sources failed to reach, to capture this colorful scene on Curaçao.

Artificial Light

Until now we have limited our discussion to natural daylight. This is, of course, not your only recourse when it comes to lighting. The beauty of daylight is that it's there in abundance (with obvious exceptions), but in the absence of daylight, or to augment it, you can call upon a wealth of other light sources—whether you're indoors or out. In essence, there are two very broad forms of light: natural light and artificial light. And then there are two subclasses: continuous or constant, and discontinuous or pulsating. Since the human eye doesn't readily distinguish micropulses of light, we see something like fluorescent lighting as continuous, when, in fact, it's not. The same holds true for high-intensity discharge lamps,

namely sodium vapor, metal halide, and mercury vapor. The discontinuous nature of these lights only becomes obvious when the lights come on or start to extinguish. The quality of these lights shouldn't have any practical effect on everyday photography, except to dictate against using ultrashort exposure times that might catch the intermittent bursts. But this is rare.

Arguably, another source of artificial light is fire. A campfire, burning logs in a hearth, and candlelight provide a pleasantly warm glow for taking intimate photographs. The flickering flames play with the subject in a teasing manner. Longer exposures are often mandated by the low light levels generated by the flame.

This restaurant in Funchal, Madeira, is aglow in artificial lighting. Despite all the lights used by the restaurant, falloff leads to dramatic contrasts of light and dark. Still, I refused to use flash and spoil the ambiance, choosing instead to capture the colorful atmosphere as it was. Further, allowing the foreground to go dark serves as an invitation for you to step into the picture.

Electronic Flash: A Special Form of Light

In the past, when daylight failed us, we turned to the flashbulb as the artificial light du jour. Okay, we can go back even further to flash powder, but must we? Each of these light sources had its day. Flashbulbs provided fairly short, intense bursts of light—but not nearly short or intense enough to suit modern-day purposes. When electronic flash "burst" upon the scene, literally, it opened up a world of image-making previously unimagined. This light source is largely controllable, immediate, of short duration, and potentially powerful.

What sets electronic flash, commonly referred to as *flash* or *strobe*, apart from the flashbulb goes well beyond the obvious. Flash set the stage for a more sophisticated form of light to be used indoors and out. It soon evolved with microprocessor control, ushering in a whole new generation of picture-taking. But at the same time, it mandated a new awareness and a need to harness this energy so that we remained in control over every phase of our picture-taking.

Light and Distance

Sunlight comes down to us from a very great distance, so small changes in subject position don't affect the light's intensity and the effect it has on the subject, assuming nothing blocks the light. In other words, the light reaching the person standing 10 feet in front of you doesn't change even if that person were to move a short distance closer to or farther away from you, or to step down a hilly embankment or up on a ladder. Even when we stand on a mountain, the mediating factors to light intensity do not result from the seemingly closer proximity to the sun, but from atmospheric conditions.

The same can't be said for artificial light. From the source to the subject, the light diminishes—and it does so in a very prescribed and calculated manner. Move closer to or farther away from the light and its effect on the subject is readily perceived. In fact, light diminishes considerably with increasing distance, to a point where it becomes negligible or even nonexistent far from the source. This loss of light is explained by the Inverse Square Law, which states the following: The amount of light falloff is inversely proportional to the square of the distance. So, at 2 feet away from the source, only one-fourth the light actually reaches the subject. This applies whether the light source is a desk lamp, overhead fixture, neon sign, fireplace, or flash—essentially, any artificial light source. But it applies equally to a natural light source that is bounced off a nearby surface, such as sunlight reflecting off a building or a bounce card.

Light falls off with distance, to state it mildly. We don't notice it with sunlight, since the light source is so far away, but we do notice it when using artificial light sources, such as flash, as in this case. (To further emphasize the falloff, I darkened the background tonality.)

The Color of Light

Light comes to us as the aggregate of various wavelengths. These wavelengths—call them *colors* or *hues*—further define the subject. But there are other characteristics that help define the subject we record. Each surface absorbs and reflects light to some degree. Light may also be bent, or refracted, as it passes through a medium, say water or moisture or glass.

Now think of the layer of moisture and airborne particulate matter in the sky as a giant filter. The light reaching this filter from the sun is one color, and quite another as it emerges out the other side. This refracted light mixes with reflected (or scattered) light, minus any wavelengths that may be absorbed, and we have the color of the sky.

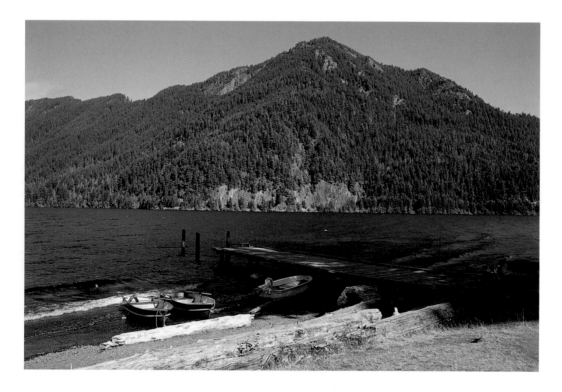

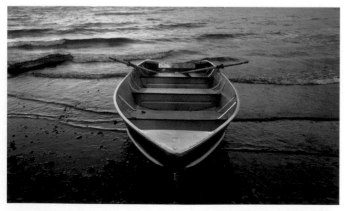

Bright sunlight bathes Lake Crescent on Washington State's Olympic Peninsula (above) in a neutral white light. In contrast, shade and overcast enshroud this boat (left) in a bluish cast. Moving to a different location and time of day—a Coney Island, New York, sunset (opposite, top)—captures a tapestry of warm colors as the atmosphere works its magic on the remnants of sunlight. (Atmospheric conditions affect the colors we see.) The blue glow of magic hour has a palliative effect on the senses, while allowing us to confidently capture night scenes with good shadow detail, as in this scene along Curaçao's waterfront (opposite, bottom).

Volcanic eruptions and everyday smog work to color the sky even further, especially at dusk and dawn, when the sun is low in the sky. Some of the richest sunsets occur after major eruptions. Massive forest fires, sadly, will have a similar effect. You'll even notice that the moon takes on a certain color when it lies low in the sky.

In photographs produced with subjects in shade or under overcast skies, daylight takes on a bluish tint. That's because this light has been filtered, allowing a preponderance of blues and UV (ultraviolet) to tinge colors reproduced in the image. Yet to the human eye, thanks to the interpretive powers of the brain, the grass remains green, whites are white, blues blue, yellows yellow, and so on. The bluish tinge occurs both on daylight film and with a daylight (or even an auto) white balance setting on a digital camera.

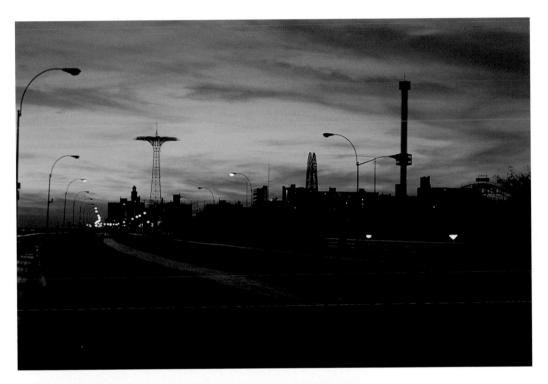

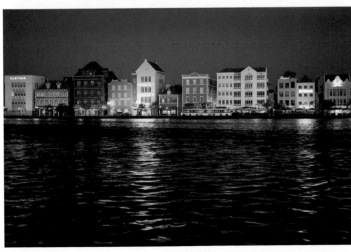

Color Temperature

We define color temperature as a hypothetical measurement in degrees Kelvin that defines sensitivity of a film emulsion or the color emission characteristics of a light source. Different light sources will each emit light with a different color temperature. The higher the value in degrees Kelvin, the "cooler," or bluer, the color appears; the lower the value, the "warmer" the color of the light—in the yellow, orange, and red range. Sunlight, together with a smattering of clouds in a blue sky, dictates the color (or more correctly, the *color temperature*) that we use as our standard for *daylight*: 5500 degrees Kelvin, or 5500 K. But the color temperature of daylight is not an absolute, in that it varies with time of day and meteorological conditions, in bright sunlight or shade.

The color temperature of artificial light sources may be readily known, or not. And it can even vary as a bulb ages. For the most part, we accept tungsten as having a color temperature of 3200 K. Household incandescents fall somewhere around 2800 K to 2900 K, making them warmer than tungsten (translation: pictures may have more of a yellow-orange color cast). Fluorescents, even those labeled "daylight," are tougher to pin down. Even so-called full-spectrum lamps may not be a true daylight source when it comes to photography. Often, pictures exposed by fluorescent lighting take on a greenish cast.

We accept electronic flash as exhibiting a color equivalent to daylight, but you'll find that the color temperature varies from unit to unit, ranging from 5000 K to 6000 K (the upper limits are decidedly on the cool side, producing a bluish tinge). What's more, varying the output on a flash unit through onboard/internal controls will affect its color temperature, with shorter flash duration (decreased output) producing cooler results.

Is all this important to exposure? Yes, in any number of ways. But for now, let's just worry about how light performs on a broader scale and tackle the intricacies of color temperature later on.

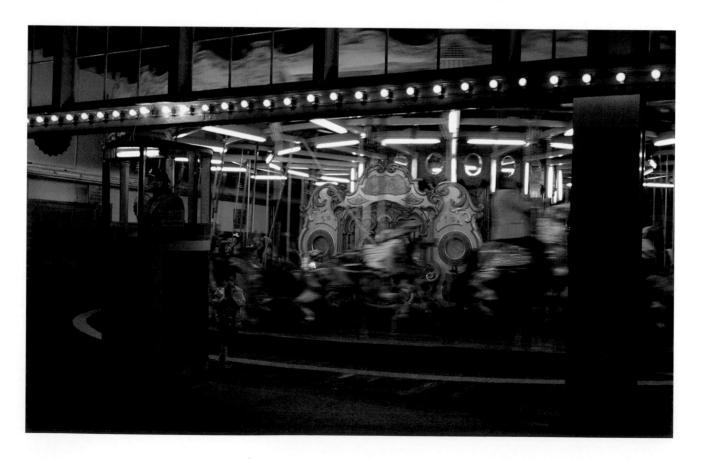

Fluorescent lighting is often a photographer's least favorite form of illumination, since the bulbs used in industrial and home settings are of unknown color temperature. The characteristic greenish tinge (on daylight film) casts a pall on a cheerful children's ride opposite. The divi-divi tree in the image at left takes on a more intriguing character as sodium-vapor streetlamps enshroud it against a dusky backdrop on windy Curaçao. And at Coney Island, the bumper-car ride is awash in a flurry of colors from a mix of light sources, some obviously filtered.

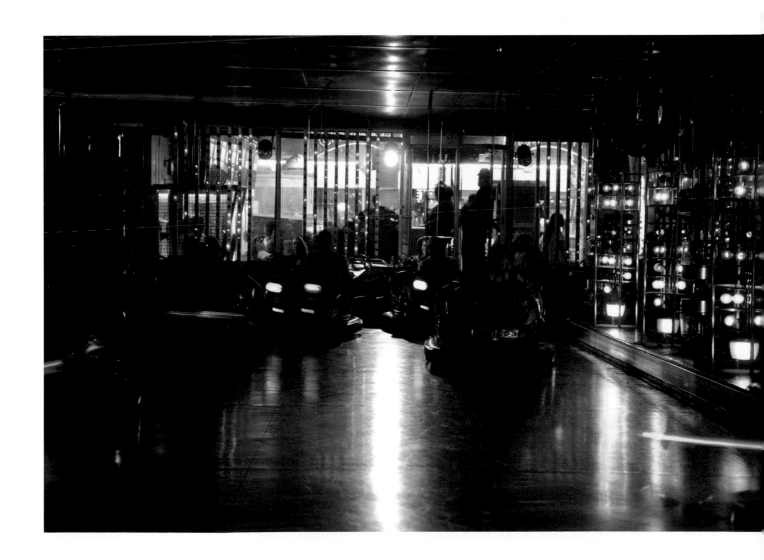

Light and Exposure as Tools of Composition

The beauty of light is that it is many things to many people. Photographers use it to mold and shape a subject and give it dimension and character. Light can reveal little or it can reveal much in the process of defining the subject. It can convey a mood. A little twist or turn may change the entire complexion of a photograph, as the angle at which the light hits the subject relative to the camera position begins to change what we see.

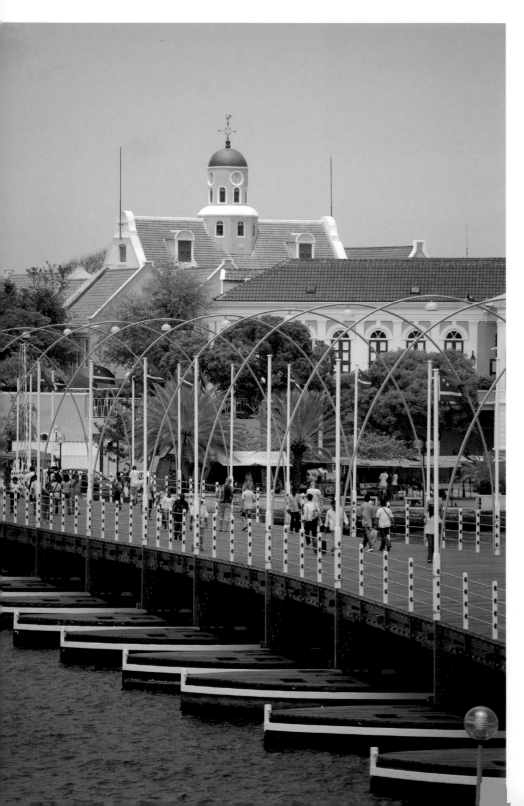

The midday sun leaves little hidden from view in this scene of the pontoon bridge between Punda and Otrabanda, Willemstad, Curaçao. It also helps to bring out the colorful tapestry that characterizes the island.

Lighting Angle and Direction

As the sun moves from horizon to horizon, the shadows it casts move accordingly. But let's now look more closely at the subject itself, not only the shadows, to see exactly how the sun's movement and the direction of the light affect that subject. Look at a face illuminated by natural daylight. Its angular geometry catches the rays of light to form a distinctive pattern. Also note where the shadows fall as the sun hits it. More to the point, watch as the movement of the sun molds the face.

Sidelighting. When light strikes the subject on axis, the effect is akin to a half-moon: Half the subject is in light and half is in shadow. This lighting angle can have dramatic consequences in a portrait, when half the face is mysteriously in shadow. What is the picture hiding? we wonder.

Overhead lighting (toplighting). Coming from above, the light tends to render some scenes, such as landscapes, flat looking, owing to the resulting shadows that fall directly downward and seemingly disappear. On a person's face, however, such shadows are disturbingly obvious. Despite many words of caution to the contrary, overhead lighting does have its benefits, such as the ability to uniformly illuminate an expansive area and, when fairly intense, to bring out the brilliant hues of a colorful landscape. And it can give a face an ominous feel by the deep pockets of shadow formed.

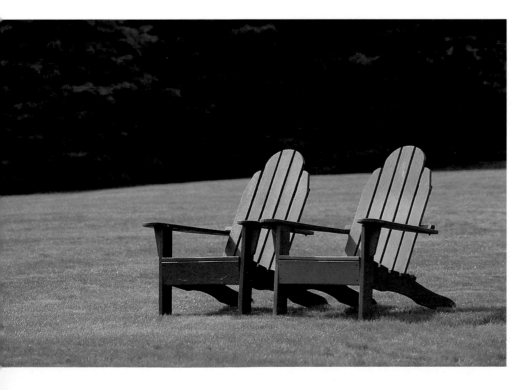

When I saw these chairs, seemingly abandoned, I was struck by their plight. But more to the point, I liked the way the sidelighting was hitting them and the resultant shadows, giving the scene true depth. Had the light come more from in front, it would have brought up the levels of the trees to the rear, spoiling their role as supporting backdrop.

Frontal lighting. When sunlight comes from directly in front of the subject, it lights the entire surface more or less evenly, thereby largely or entirely obliterating any shadows. The result is often viewed as flat and lifeless, much like with toplighting. However, this form of lighting should not entirely be shunned either. Frontal lighting helps hide lines and wrinkles on a person's face, and helps to fully illuminate the facade of a building.

Backlighting. When sunlight hits a subject directly or largely from behind, it may hide the subject's features entirely. More often, however, the angle is not that severe, and there's enough light to wrap around the subject, with some additional light bounced back to prevent the loss of all details in a facade or face.

Oblique lighting. When the sun is at any point between the horizon and the highest point in the sky, sunlight strikes the subject from an oblique or glancing angle. This helps to define the subject by highlighting certain features and casting shadows. This interplay of light and shadow adds character to the subject's fea-

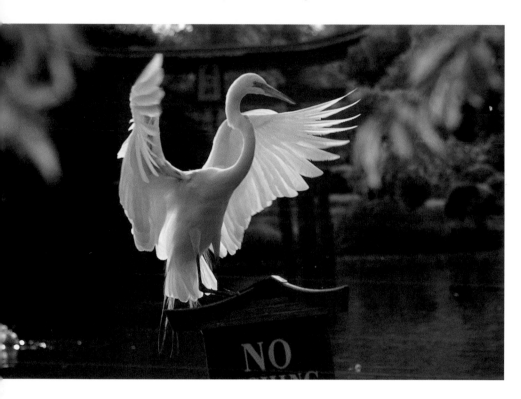

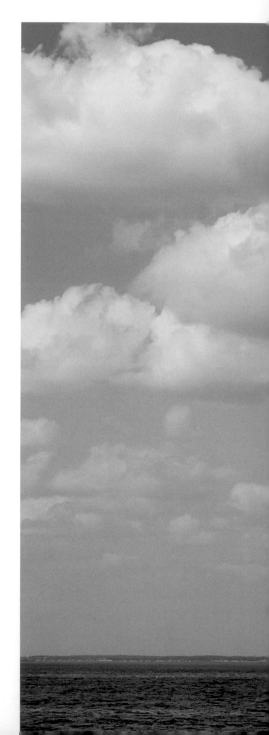

Backlighting can be used to highlight translucent objects, such as the far wing on this great egret.

Oblique lighting strikes the subject at a glancing angle, creating an interplay of light and shadow that helps to bring out form and texture. Here we see how the lighting angle molds the clouds, as well as the lighthouse.

tures, molding them, or the sweeping shadows alone may help frame the subject or add depth to the scene. A less obvious use of this form of lighting is to more fully bring out the texture in a weathered and aging face.

Lighting from below. This is more of an intentional light, since nature doesn't normally place lights at a low angle pointing upward. Still, it comes to the fore in studio applications, filling in dark recesses in a product shot or still life. Lighting from below is also the typical horror-movie lighting effect because it's unnatural,

especially when it paints distinct upward-sweeping shadows on a face.

Dappled lighting. A special form of lighting focusing on the interplay of light and shadow, this light results from nearby or overhead leaves and branches partially blocking sunlight. It can also result when a "cookie cutter" (a flat sheet with leaf-shaped cutouts) is placed in the light path. It may create a romantic, even transcendental effect or simply imbue the scene with a more natural feel.

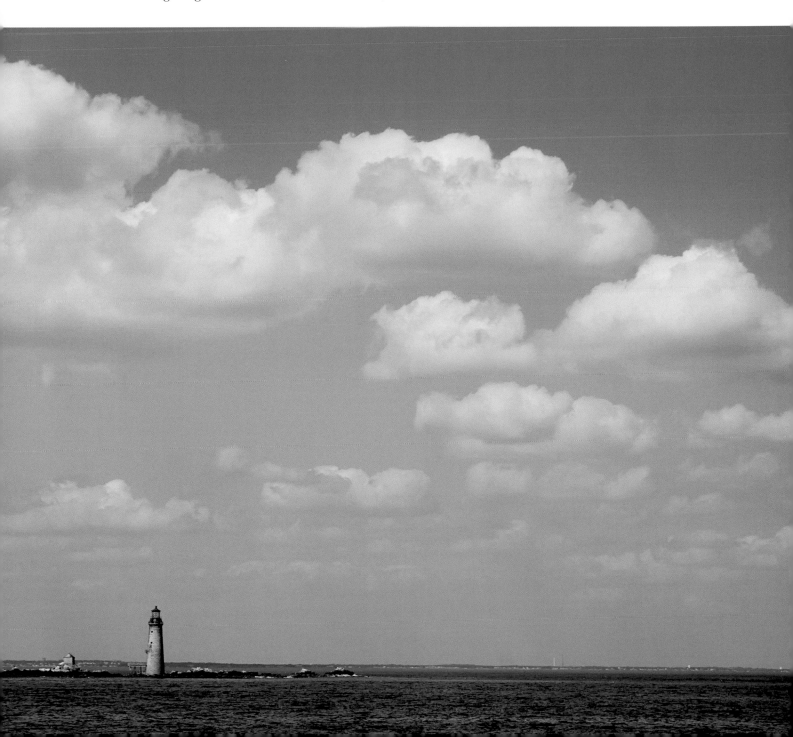

Light, Texture, and Form

A surface has texture. We can feel it. Broadly speaking, it can be smooth or rough. In describing photographic and inkjet papers, we use additional terms to describe the feel of the media: glossy, matte, luster, canvas, and so on. The texture of that paper affects our visual response to the photograph. It also affects how dyes or pigments interact with the paper when forming the image.

But from a photographic perspective, the smoothness or roughness of a surface also affects the light it reflects. Smoother surfaces reflect more light; rougher textures reflect less light. The actual visual sensation of texture goes beyond the physical: We see the texture because of the way light molds itself around the surface—the minute peaks and troughs that create equally minute shadows that we do not even perceive as shadows. Shine a light on an orange peel at a glancing angle, and look at the skin closely to see how the shadows contribute to the sensation of texture we perceive. If the light is hard, the shadows are deep, and the texture appears rougher. If the light is soft, the shadows are faint or virtually nonexistent, and the surface texture appears fairly smooth. Likewise, study the paint on the wall in your bathroom. Very likely it is a glossy coat, in contrast to the matte paint covering the living room walls. The glossy surface will bounce back considerably more light and do so in a specular fashion, with a hard edge. In contrast, the matte surface will provide a softer illumination. So, texture actually has two important qualities: one from an aesthetic standpoint, the other from a technical standpoint.

Now we move on to form. When light wraps itself around a tree trunk, for example, so that the subject tones gradually move from lighter to darker as the light reaches the other side, it has helped to mold the character of that tree trunk, giving it a sense of three-dimensionality. Light does the same with a basketball, a person, or an animal. When the shape is more angular or disrupted, we see the form as emerging more abruptly, as with chiseled cheekbones or a prominent nose. The form stands out more against the background when the light is hard than when it is soft.

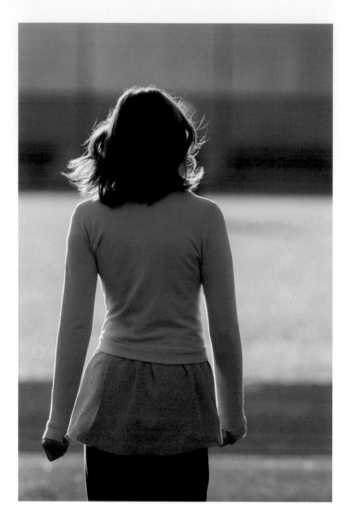

Backlighting creates rim lighting on this young woman, which helps to separate her from the background. For rim lighting to work, the subject must be slightly underexposed. Overexposing, which in this instance would mean exposing for the subject, would seriously burn out the bright highlights.

Rim Lighting and Silhouettes

The loss of subject details may be critical to the success of the photograph. But it can also be the defining element that makes the shot a winner, and the lighting may be the critical factor. Backlighting can be used to create interesting effects. As the light catches the outer edges of the subject, it may illuminate these edges. This *edge lighting*, or *rim lighting*, seemingly frames the subject in light or helps outline the subject against the background. To emphasize the rim lighting, the subject should be a hair underexposed—but not to the extent that it begins to look like an exposure error. You can use this lighting with faces, clothing, tree branches, or practically anything.

Sometimes, you can use strong backlighting to constrain the subject to two dimensions—a silhouette, in other words. Silhouettes are captivating and intriguing. A shadowy figure, whether lurking in the background or featuring as a prominent element of the photograph, adds a sense of mystery and intrigue, or it can simply redefine the image as a study in shape, pure and simple. The exposure is entirely made for the background brightness. It helps when the subject is dark-toned to begin with.

Since this raven was black, I knew I stood little chance of capturing any detail in its form. So, I opted to photograph it in silhouette and did so by exposing for the cloudy sky instead of the bird. The tricky part was getting the bird in focus and sharply rendered.

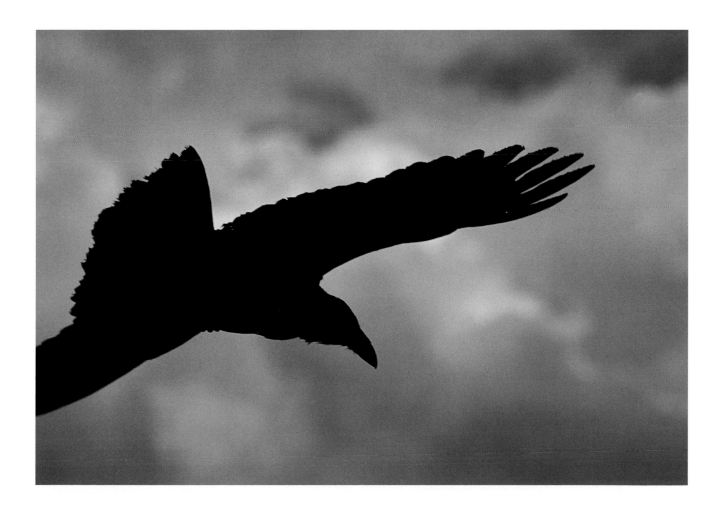

Light, Exposure, and Mood

Mixed together in appropriate proportions, the quality and quantity of light can imbue the subject with one more characteristic: namely, *mood*. Lighting that is bright and airy—or cheerful, if you will—may impart those attributes to the subject it embraces. When the lighting is muted, the subject may take on a more sullen and brooding appearance.

We can take the concept of mood one step further by defining it as *low-key* or *high-key*. A low-key mood is subdued and is dominated by darker and deeper tonalities: namely, black and gray values. A high-key mood is elevated, dominated by lighter tones and brighter colors, perhaps evoking a sense of ethereal fantasy. Having said that, the image may be high-key yet evoke mystery and foreboding, as in a fog-enshrouded scene.

Owing to the prevalence of bright tones and colors in our daily lives, it is much easier to unintentionally underexpose than overexpose a scene. Granted, today's camera metering systems do a better job of getting it right more often than not, but they aren't foolproof. And they certainly can't read your intentions. So, when you purposefully want to retain the light values and bright colors in a scene for a high-key effect, you often have to make a conscious effort to do so.

Still, we can take that high-key effect up a notch—through controlled overexposure. In the process, we strive to avoid the loss of critical detail by preventing these important highlights from burning out. A contrasting dark tonality might benefit the picture, provided it's not overwhelming. While less popular these days, soft focus (via lens or filter) will spread the highlights and enhance the high-key effect, again bordering on ethereal. Interestingly, it can also be used to make low-key exposures more pronounced. A fog or diffusion filter might also do the trick. Even sheer white gauze can elevate the mood, and a sheer black stocking can help tone it down, with either held over the lens.

Low-key effects are, in my view, more difficult to create than high-key ones. Add a contrite facial expression or a stooped posture and the mood becomes downcast or even forlorn. (If you have trouble seeing a color image as low-key, revisit it after converting the photograph to black and white—a simpler task, admittedly, with digital imaging.)

You can further enhance the low-key effect through controlled underexposure—and the key word here, again, is *controlled*. In contrast to exposing for a silhouette (when you still want part of the scene—the background—correctly exposed), in this instance you may not want any part of the scene to appear properly exposed. However, at the same time, you don't want to create the impression that the image is underexposed or that the underexposure was unintentional. You have to draw a fine line. It's very subjective. The thing to avoid is a muddied and muddled look, with a loss of critical detail, in which the message behind the photograph is lost.

In the final analysis, the mood is defined more by your own mind and personal associations than by your will in imbuing the subject with certain qualities. Sometimes the image is high-key or low-key simply by virtue of the predominant tones and nothing else. The image may evoke no mood at all. The subject itself plays the defining role in any mood you associate with the picture.

This scene of a sailboat adrift on an azure sea off Curaçao's coast is filled with light tones and contrasting dark values in just the right proportion to reinforce the high-key mood. For a low-key mood, see the bottom picture on page 23.

The Qualities of Subject and Surroundings

We've already discussed the physical nature of texture. Subject qualities go even further. Pigments in leaves give the characteristic green color, but in autumn, other pigments take over, allowing different wavelengths of light to pass through and bounce off.

While it may seem obvious, it bears mentioning: Black and other dark tones absorb light—hence the use of black velvet backdrops and black cards to prevent stray light from hitting a subject. White and other light tones reflect light, hence the use of white cards for bounce lighting. Of course, metallic surfaces take light reflection one step further, but because of the specular nature of these surfaces, this light may be too hard, leading to the use of *textured* metallic surfaces when it comes to portable reflectors.

The surroundings also play a role in the visualization and depiction of a subject. White or off-white ceilings and walls reflect light well and can be used effectively to bounce light back onto the subject. As mentioned, black velvet backdrops soak up the light, providing a stark surround for the subject. Aesthetically and technically, each backdrop—whether a dark alley, a bright pavement, a dimly lit interior, a brightly lit building, a harbor at dusk, a snow-covered landscape—plays a defining role in the images you create. You might make the exposure for the subject, but the background is never really that far away as an integral component of the photograph.

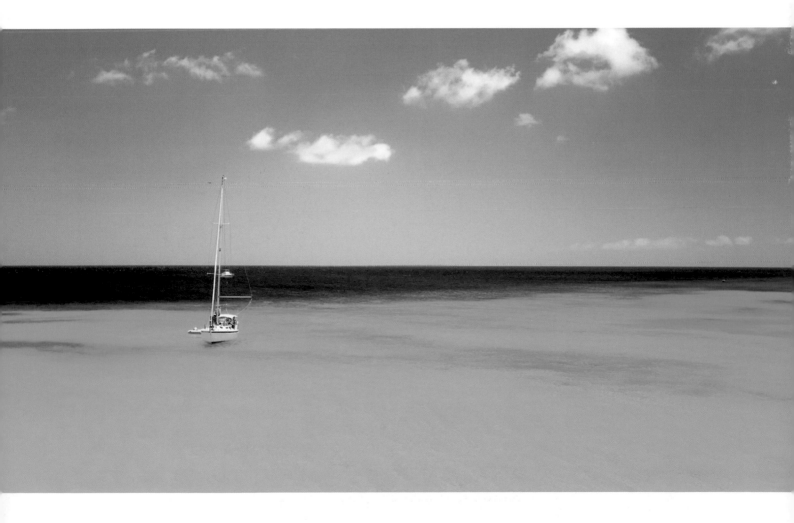

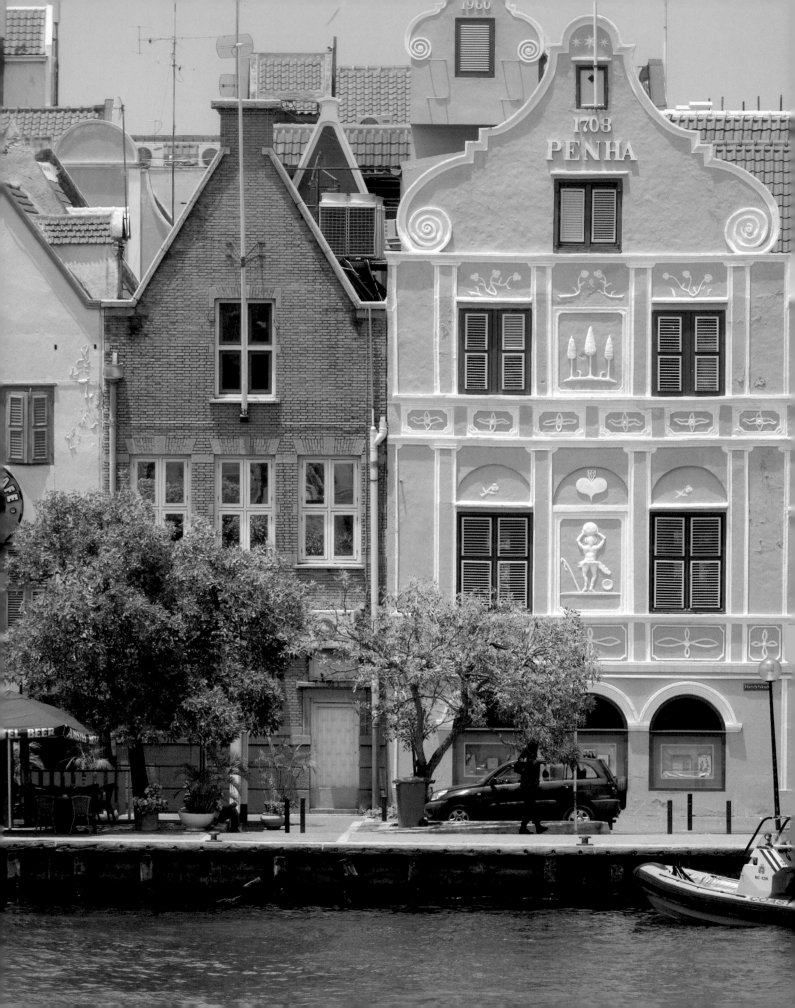

THE TOOLS
OF EXPOSURE

The exposure you arrive at should be the same regardless of the tools used. Yet these tools will influence *how* you arrive at this exposure setting, and will do so primarily by the *way* you choose to use them. When you allow the camera, in its most basic shooting mode, to dictate the exposure, you'll produce a "best guess" scenario. On the other hand, if you take a more studied approach—using an exposure meter, a "creative" camera shooting mode, or a specific light metering pattern within the camera—you take destiny in your own hands. You are one step closer to capturing a telling portrait, a unique moment in time, or a captivating study in design.

Creative Camera Modes

When you want to challenge yourself to use originality and vision, you enter the "creative zone." Here, there are several modes, each offering the photographer a great deal of control over how the camera sees the subject and captures the image. You may find yourself leaning toward one mode or another for most of your exposures, but you should recognize when another mode may do the job better and be prepared to use it. (Note: Each camera offers a selection of operating modes, one or more of which may be unique to that model, brand, or manufacturer in design or name alone. This discussion centers on cameras with some degree of technological sophistication.)

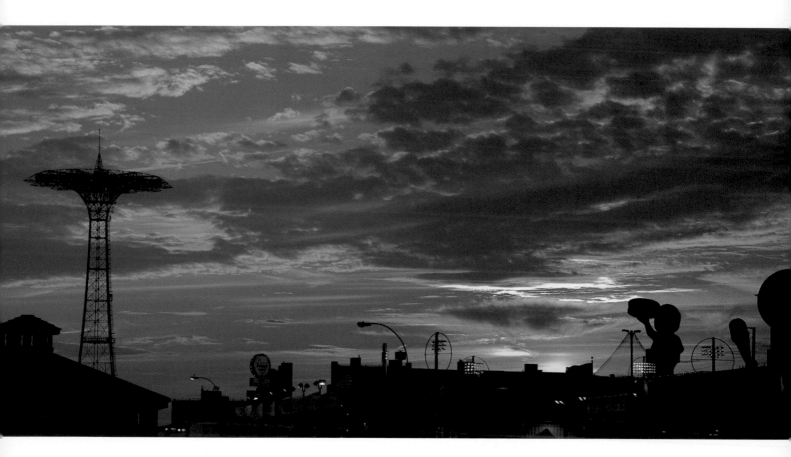

I set the camera to Aperture Priority mode for an exposure of *f*/8 at 1/250 sec. (ISO 200). At this shutter speed, I easily handheld the 24–105mm lens, which was set to 96mm, without fear of camera shake.

Program Mode

A major step above fully automatic operation, Program mode still lets you shoot with as much ease or complexity as you'd like. Based on existing lighting conditions and subject qualities, the camera's microprocessor determines the correct combination of lens aperture and shutter speed for a given film's speed or imaging sensor's light sensitivity rating (referred to as ISO, or ASA in old-school parlance). The camera may be programmed to allow you to bias the exposure further, namely toward a faster or slower shutter speed; if not, you might have to switch to a more appropriate mode.

One possible downside to Program mode is that it may set a slower flash sync speed than you might like when either the built-in flash or an external strobe is used, even with dedicated TTL (through-the-lens) connections. For instance, maximum allowable flash sync may be 1/200 sec., but Program mode may set it to 1/60 sec. This only becomes a problem when ambient light levels are sufficient to record a secondary and possibly blurred background or subject image when some movement is involved (but by the same token, this can also be used for effect).

WHEN TO USE: Practically anytime, anywhere—especially when you need to be spontaneous but still want to stay on top of the situation. This mode lets you shoot street and party candids without thinking about anything but the subject. It also comes in handy for scenic views. I find myself turning to this mode more frequently than I care to admit, shifting gears when necessary. Ambient autoexposure compensation is usable.

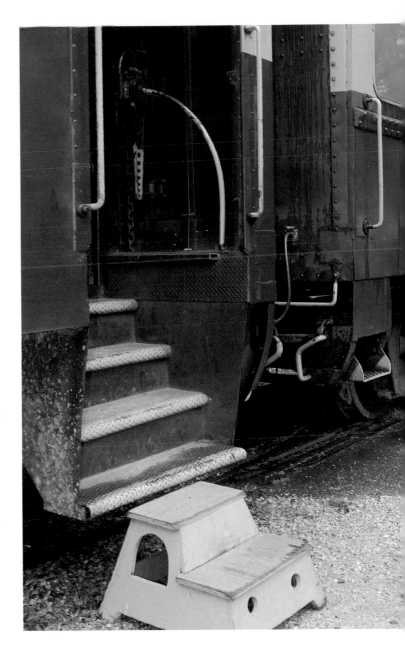

When shooting in Program mode, you have to watch the aperture and shutter speed settings the camera makes. Here, shooting from a stationary position, it was easy to get a sharp picture of a detail of this Great Smoky Mountains Railroad scenic train car with the camera handheld at 1/60 sec. (at 24mm).

Aperture Priority Mode

In Aperture Priority mode, you set the lens aperture, or *f*-stop, which then determines the shutter speed the camera uses, producing what the metering system assumes is a workable exposure. If you set a small aperture, that may result in a relatively long shutter speed (as the camera tries to allow the necessary time for the light to expose the image). On the other hand, set a large aperture and shutter speed will be shortened to a corresponding degree.

WHEN TO USE: I'll use Aperture Priority for my close-up and macro work with flash, when I often prefer to work with very small lens apertures for greater sharpness from front to back in an image. On the other hand, when shooting close-ups by available light, I opt for wider lens apertures for selective focus (to focus attention on the subject and soften the background), which, at the same time, delivers faster shutter speeds to prevent motion blur—allowing me to handhold the camera. By the same token, I may shoot at wider apertures with telephoto lenses for portraits and wildlife, while stopping down for landscapes shot with wide-angle lenses. Ambient autoexposure compensation is usable.

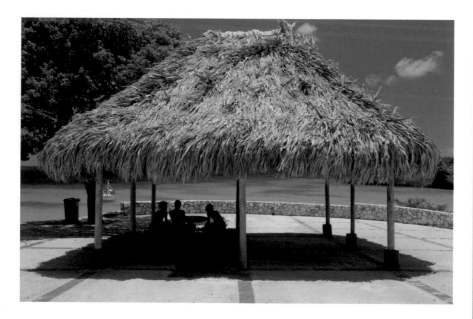

When I came upon this scene at a beach on Curaçao, I was immediately drawn to the *palapa* and the azure sea beyond, with the boat adding a nice touch. So I exposed at *f*/16 in Aperture Priority mode for extended depth of field (to get as much in sharp focus as possible). By contrast, in the image opposite, I wanted to focus attention on the iris bud in the foreground, letting the other buds blur out through selective focus at *f*/4.5, which was fairly wide open.

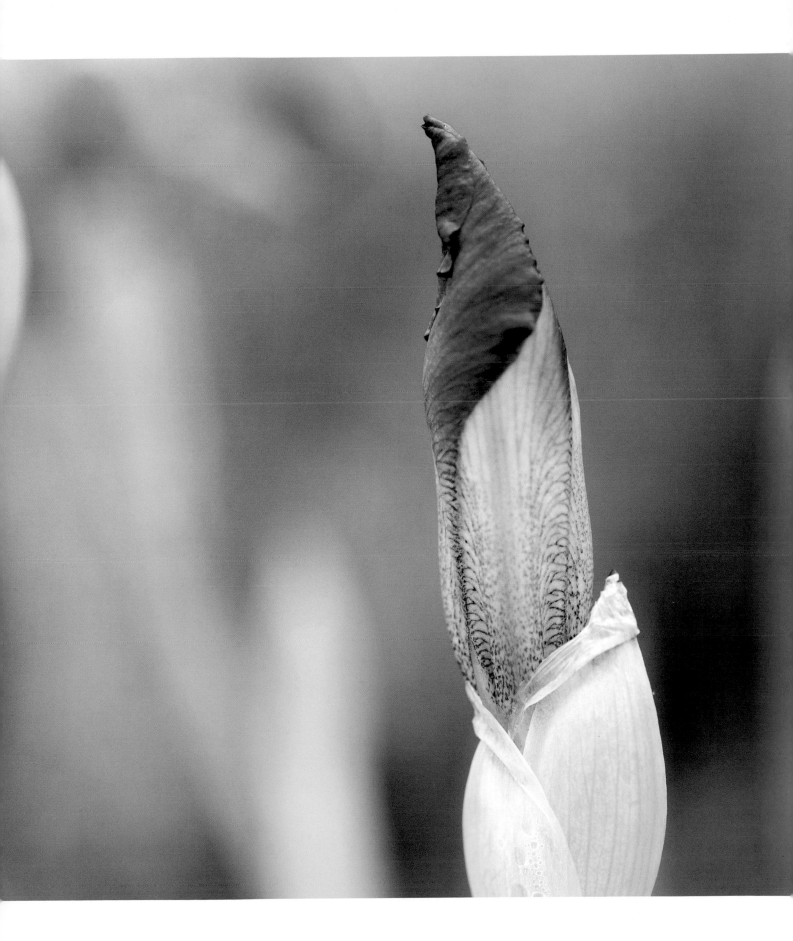

Shutter Priority Mode

Here, the shutter time is prioritized, meaning you choose the shutter speed for the exposure while the camera selects the most suitable lens aperture. Increasing shutter time results in a corresponding shift in lens aperture to smaller *f*-stops to avoid overexposure while the shutter remains open longer; decrease shutter speed and the lens aperture will grow larger to compensate.

WHEN TO USE: To freeze action with fast shutter speeds or, conversely, to blur movement with slow shutter speeds, as in panning. Great for sports and action photography, as well as wildlife involving breaking action. Or, to ensure an adequate shutter speed to prevent camera shake. Ambient autoexposure compensation is usable.

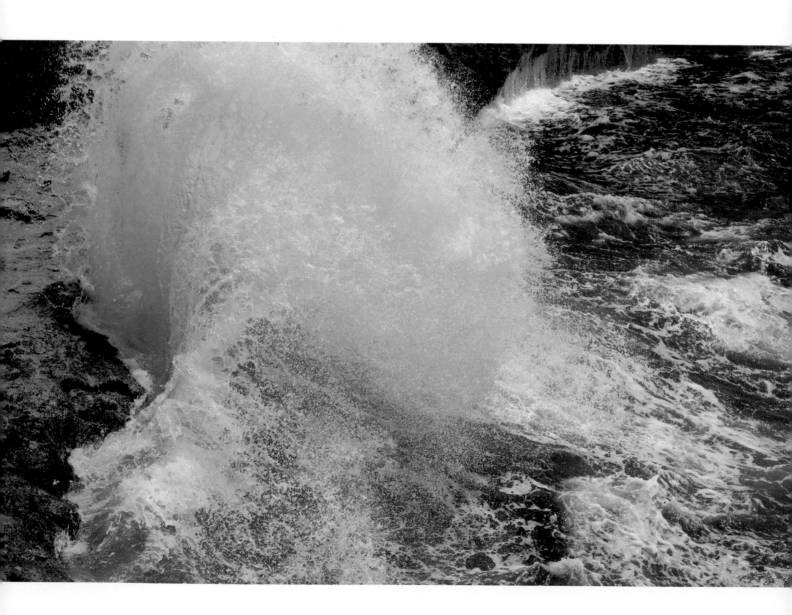

It required a shutter speed of 1/1000 sec. in Shutter Priority mode to freeze pounding surf. That wouldn't have worked well to capture the milky flow of water, for which I needed a half-second shutter speed.

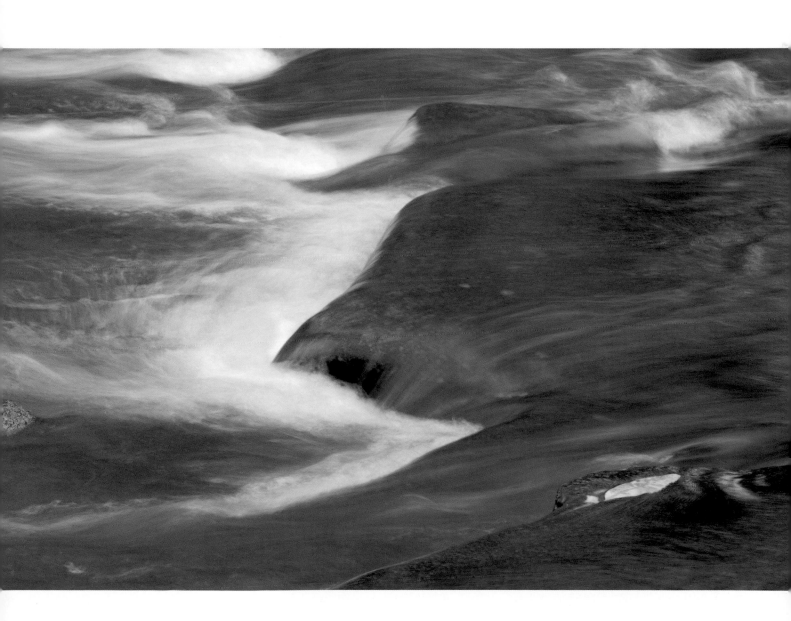

Manual Mode

This mode puts the camera totally under your control. Lens aperture and shutter speed must each be set manually. The camera will not attempt to compensate when you change either value. However, the camera may display the exposure in a quasi-match-needle form, attempting to guide you toward a correct exposure by matching up aperture and shutter speed values. (See the glossary for an explanation of match-needle metering.)

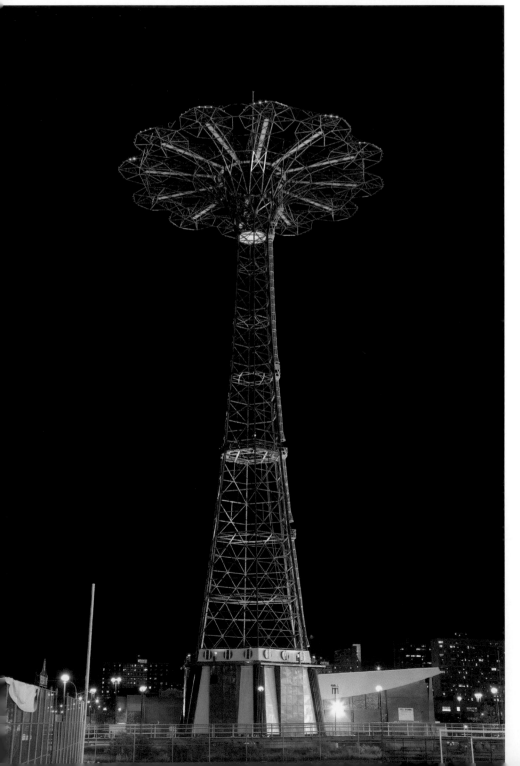

WHEN TO USE: Working with handheld exposure meters practically mandates this mode, especially if you're a Zone System aficionado or using studio flash (or any external flash lacking internal light-measuring circuitry). Ambient autoexposure compensation has no effect.

I had decided to shoot this Coney Island landmark in manual mode so that I could employ a long exposure. I used an electronic cable release for this 8-second exposure at *f*/8 (ISO 200, with the camera and 24–105mm lens on a tripod.

Bulb Mode

To make very long exposures, beyond the range of shutter speed settings normally available, set the camera to B, for *bulb* (or T, for *time*, on some cameras), and hold down the shutter button for as long as necessary. Electronic cameras can be set for long exposures, often negating the need for you to use Bulb mode, but mechanical and electromechanical cameras top out at 1 or 2 seconds, or just a bit longer. The optimum lens aperture and shutter time combination is often arrived at through experimentation (which is where a digital camera is especially handy). A mechanical, electronic, or wireless release should be used with the camera set on a firm support, such as a tripod.

WHEN TO USE: To capture numerous bursts of fireworks in one picture, lightning at night, nightscapes, moonlit scenic views, and star trails. Watch for bright light sources in the scene, as they may create glaring distractions.

Custom Mode

My Canon EOS digital SLRs take the creative shooting modes one step further by allowing me to implement a range of settings tailored to any one situation. It's analogous to the user-defined picture scene on other cameras.

WHEN TO USE: When time is of the essence, and you expect to return to a specific subject or scene and don't want to start messing with the camera settings from scratch. Establish the necessary settings in advance, save them in Custom mode, then later engage this mode for a quick start, and tweak settings in response to changing conditions.

Basic Camera Modes

Sometimes you want to revel in the moment and keep things simple, whether you're using a sophisticated SLR or a compact point-and-shoot camera. Toward this end, you can make use of various "basic" exposure modes that let the camera take control. You can use full Auto mode to quickly capture a fleeting memory or get more specific with a Picture mode (variously known as Scene mode or Image mode or several other monikers). This mode is tailored to the situation, such as portrait, night portrait, action, landscape, and so on. Manufacturers have different names for these settings and apply their own sets of operating parameters, all with the same intent: namely, to simplify things. One picture setting may ensure good depth of field, another may provide stop-action or anti-camera-shake shutter speeds, and yet another may force the flash to come into play. There may also be a custom picture setting defined by the user.

Exposure Basics

Not all cameras come with the same degree of exposure control. Today's electronic cameras largely, if not entirely, automate exposure measurement. But that doesn't mean they're always right. In fact, they're often wrong.

Exposure control within the single-lens-reflex (SLR) camera, whether film or digital, begins with through-the-lens (TTL) metering. Although perhaps oversimplified, a basic explanation of TTL metering goes as follows: Light enters through the lens, reaching a photosensitive cell, which then guides the choice of *f*-stop and shutter speed. When shooting by ambient light, this applies to any SLR. Some variables may enter the picture when certain types of electronic flash are employed, specifically those with dedicated electronic circuitry.

Older (pretechnological) SLRs employed match-needle metering, requiring you to match up an indicator needle with a pointer in the SLR's optical viewfinder to arrive at the camera-determined exposure. In today's microprocessor-controlled cameras, TTL metering goes beyond the simple incorporation of a photosensitive cell to give you an exposure reading in *f*-stops and shutter speeds, with a direct digital alphanumeric readout that bypasses the more tedious match-needle operation, enhancing response time to the situation and to breaking action. While the principle of in-camera exposure measurement is largely the same now as it was then, the process has added new layers of complexity while attempting to simplify things.

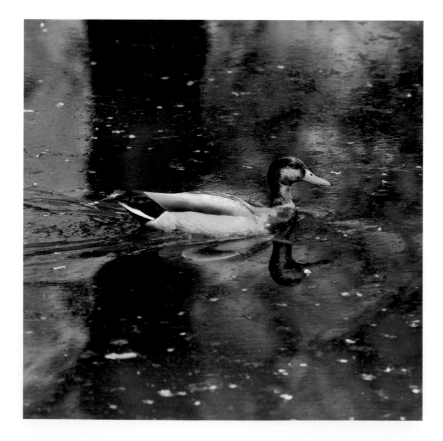

Autoexposure is a great tool, as is auto-bracketing. Even though I bracketed at normal, + 1/3 (the exposure shown), and + 2/3 EV, in the end what mattered most was seeing the iridescent feathers on the head—and in the "failed" exposures, the duck's head was turned just enough to ruin the shot.

Exposure by the Numbers . . . Well, Not Entirely

We define photographic exposure as the aggregate amount of light required to form, or which actually has formed, an image, whether film or digital. Exposure is, technically, a set of numbers—an equation. While mathematical by definition, exposure is, more practically, a visual and conceptual percept. We judge the success of the exposure by the detail captured and revealed, the information conveyed, the sensations we perceive. It is largely subjective.

Still, exposure demands a starting point, and that starting point brings us to that mathematical formula, defined by the Law of Reciprocity:

$$E = I \times T$$

[E = exposure, I = intensity (measured by the *f*-stop),
and T = time (duration or shutter speed)]

The *f*-stop controls the size of the lens aperture. It's similar to opening a channel for water to flow through. Use a wider channel (think of broadband communications) and more flows through more quickly. Narrow the channel (or switch to a narrow-band telephone modem) and the flow slows to a trickle. The amount of time the water is allowed to flow before it's cut off will further contribute to the overall volume. Now, if you replace water with light, the *f*-stop becomes the channel opening and the shutter speed becomes the amount of time that light has to impress itself upon the film emulsion or digital imaging sensor to make the exposure and form the image.

We can extend the Reciprocity Law by stating that a change in intensity requires an equal but opposite change in time to maintain a constant exposure. In other words, if you add light (increase the water flow), you have to expose for a respectively shorter length of time (restrict the time the water flows) to arrive at the same exposure (volume of water). Likewise, if you subtract light, you would have to increase the time of the exposure by a corresponding amount. It's a very clever balancing act, but one that becomes second nature to us all. Does the equation falter? Yes, under certain conditions, but let's leave well enough alone for now.

Quick Tip: Fathoming F-Stops

Think of the *f*-stop as a reciprocal value. Simply replace the *f* with a 1, which means that *f*/4 (1/4) is a larger value than *f*/8 (1/8).

This series of images shows how the Law of Reciprocity works. You can see that the aggregate exposure remains the same even though shutter speed and aperture change in corresponding increments, going from 1/1000 sec. at *f*/2.8 to 1/30 sec. at *f*/16 (in full stops). Note how the cascading water is transformed from razor-edged to milky soft, with depth of field changing accordingly.

f/2.8, 1/1000 sec.

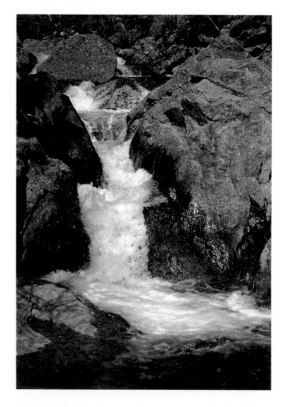

f/8, 1/125 sec.

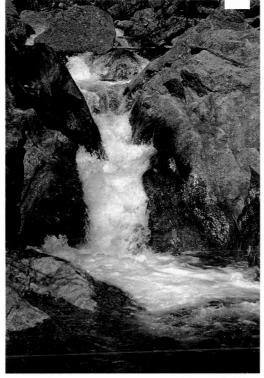

f/4, 1/500 sec.

f/5.6, 1/250 sec.

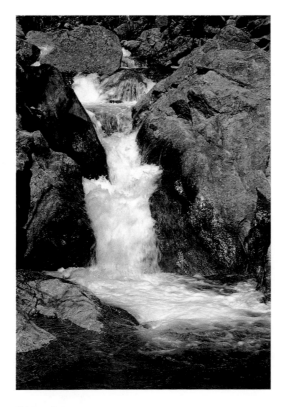

f/11, 1/60 sec.

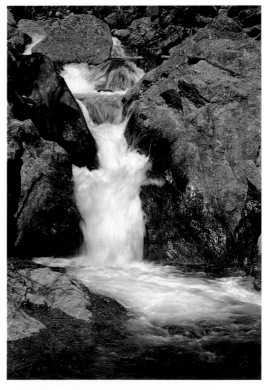

f/16, 1/30 sec.

Light Sensitivity

However the camera (or an exposure meter) takes a light reading, it all begins with setting what is popularly referred to as the *film speed*—whether the camera in your hands is film-based or digital. Traditionally, film speed measures a film's light sensitivity (we'll get to digital technology in a minute). The higher the film speed, the more sensitive the film emulsion is to light. That means that you can use a smaller lens aperture, a faster shutter speed, or both to take the picture. Films with higher speeds are also referred to as *faster* films. By allowing for the use of faster shutter speeds, high-speed, or fast, films are effective for capturing action or, when shooting handheld, for avoiding camera shake. Low-speed, or slow, films are designed for more deliberate picture-taking, often with stationary subjects but particularly with such things as scenic views, architecture, and still life. Many film emulsions fall into a middle category of medium-speed films—all-purpose.

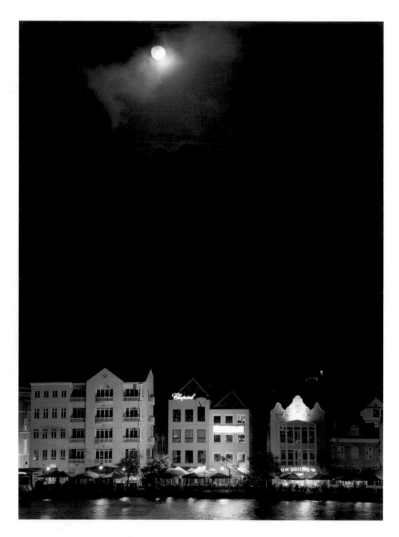

A heavily overcast day along North Carolina's Blue Ridge Parkway mandated a high ISO setting for the right handheld exposure of 1/60 sec. at *f*/8. Light levels were considerably lower when I spied the moonlit scene above from my hotel room on Curaçao, so I set up a tripod and set ISO to 800 for an exposure of 0.4 sec. at *f*/4. For the moonscape, I bracketed extensively and chose the -1.3 EV exposure. I had to watch for building lights burning out and the exposure going too long, which would have resulted in a visibly oblong moon.

The concept of film speed carries over to digital. Here, film is replaced with the imaging sensor, and when we speak about light sensitivity, we are, more technically, talking about *gain* (although the term is rarely used in this context). The concept of gain derives from the audio and video worlds. (It comes to the fore when we begin to discuss noise resulting from an increase in gain level, just as an audio signal gets noisy when you turn up the recording level on a microphone.) However, to keep things nice and tidy, we've borrowed the terminology that applies to film emulsions and extended it to digital, applying the same abbreviation for film speed rating to both: ISO (ASA to old-timers). Still, there are noteworthy differences in how we use film speed with film and with digital capture, as we'll soon see.

Exposure Index

The rated film speed, or ISO, is often—but not always—the one photographers use (when working with film). You have to think of film speed as a guide recommended, and provided, by the manufacturer. The actual film speed employed, especially when you choose to modify it, is called the *exposure index* (EI). If the ISO is 400 and you instead set this value to 200 or 800, for example, you more correctly refer to it as EI 200 or EI 800. This concept has special relevance when pushing or pulling film. However, no one will look askance at you if you continue to refer to the number as film speed or ISO. In fact, considering that many of us still call it ASA, who are we to judge! (The term *exposure index* is rarely used with digital capture regardless of the speed rating; more preferred is *ISO* or even *film speed*. Keep in mind that with digital there is no manufacturer-recommended speed setting involved.)

The reasons for adjusting ISO value relate to our need for speed—to stop action or prevent camera shake. If you've got to have it, you may speed up; but there's a certain wear and tear when you push any vehicle too far—with film or digital—and a price to be paid. On the other hand, the situation may call for you to ease up on the throttle and slow down—to blur action or blur backgrounds—which may lead to other problems when you pull back too far, and for which you'll pay a price as well, at least where film is concerned. With digital, shooting at the lowest available ISO (at least with regard to current technology) has decided benefits. (More information can be found in the Film & Digital Media chapter.)

Exposure Value

Abbreviated EV, *exposure value* is an expression of exposure measurement under available light (but can, more broadly, also be applied to flash) that combines the *f*-stop and shutter speed as a single value. It simplifies such things as contrast measurement (for example, a 3 EV difference between highlights and shadows). Some handheld exposure meters only provide a reading in EV values, whereas on other meters it is an optional function, with readings made in Aperture or Shutter Priority mode (depending on the meter). When the reading is made in EV, the value is transferred to a scale that shows equivalent *f* stop and shutter speed values for a given ISO. Digital meters may provide all the needed information in one display window.

EV can also be applied to exposure corrections—for example, a +2 EV exposure override (which equates to an increase of 2 stops in exposure).

AE Lock

With today's autoexposure cameras, once you press down partway on the shutter button, you effectively lock in the exposure (regardless of autoexposure mode). With autofocusing cameras, this goes one step further. Once you press halfway down on the shutter release, you lock in both exposure and focus. This is one form of AE lock. However, this may not always lead to the best exposure. To get around this tie-in to autofocusing (or to otherwise select the tonal area that is most important to the picture), the camera offers a separate *AE lock* function button that you engage prior to releasing the shutter to simply lock in exposure and nothing else. This way, you can carefully meter for the subject, from a close distance if necessary, frame the shot, and press the shutter release to separately lock in focus and take the picture while retaining the set exposure reading. Although you could switch to manual shooting mode, AE lock allows you to remain in any AE mode with the convenience of faster response to the subject and prevailing ambient conditions. (Note: Be sure to cancel AE lock if this function is not autocanceling.)

WHEN TO USE: The separate AE lock function should be engaged in any situation in which surrounding light levels and tonalities may adversely affect the exposure. That would typically apply to backlit subjects, as well as a subject surrounded by bright tonalities (such as foliage under sunlight) or a well-lit subject standing in front of a shadowy building facade.

Autoexposure Compensation

Exposure compensation is a means by which you correct for misleading brightness and tonal values through an exposure adjustment to a meter reading. You can manually compensate exposure by increasing or decreasing the ƒ-stop and/or shutter speed (within the limits placed by flash sync). However, the concept more aptly relates to user corrections applied to ambient-light measurements involving the camera in any autoexposure mode. At this point it is more correctly referred to as *autoexposure compensation*, and sometimes AE (autoexposure) override.

Autoexposure compensation is the most efficient resource at your disposal. We often encounter situations that do not recommend themselves to blind obedience to the camera's built-in metering system, no matter how sophisticated and computer-driven it is. AE override—either via an onboard button, lever, or dial or by a menu option (on some digital cameras)—lets you shift the exposure in the right direction to avoid under- or overexposure. This manual adjustment increases or decreases the exposure in measured increments, usually in 1/3 or 1/2 stops, usually up to a maximum of 2 or 3 full stops (increments and maximum shift vary with camera model). The camera usually displays AE compensation in one or more of its display panels. Autoexposure compensation continues to function even while AE lock is engaged.

WHEN TO USE: Autoexposure compensation comes in handy when you have an inkling that a subject's surroundings might throw off the exposure in one direction or another. When a person is standing against bright foliage, you can hold your position and maintain the framing of the subject in the viewfinder and take the picture—after first setting an AE override value on the camera. (Note: Be sure to return the camera to the default setting, or all your pictures from then on will reflect this exposure compensation step.)

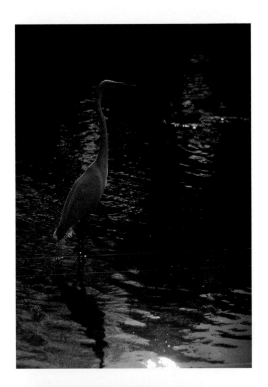

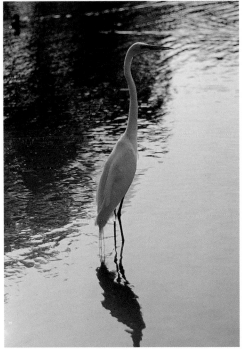

Centerweighted metering on daylight film reflected the influence of the glinting sunlight kicking back too much light, causing the camera to seriously underexpose for the great egret. First, I recomposed to eliminate the glint and then gave a +1.5 EV boost to the exposure to reveal the bird in all its glory, with rim lighting thrown in for good measure.

Exposure Bracketing

Bracketing exposures is a strategy designed to ensure that you produce at least one usable image by shooting several. The technique is simple: You make an initial exposure at the reading the camera (or a handheld light meter) recommends, followed by additional frames that give the subject more and less exposure. That gives you several images from which to choose. There's a good chance that one of them will be on target (or near enough to be usable).

Now, here's the tricky part: knowing to what extent to bracket, in what increments, in which direction, and where to start bracketing. I tend to look at the world as brighter than normal, so I immediately take my exposure compensation to the plus side to compensate for bright tonalities—just a bit for starters, for instance, + 1/3 or +1/2.

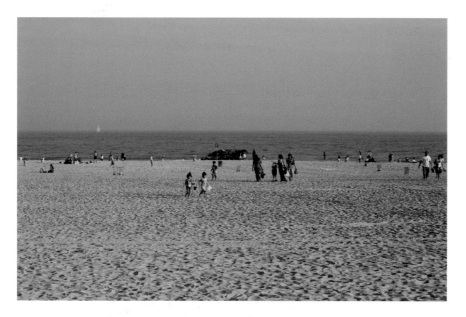

Shooting digital, I manually bracketed exposures in 2/3 EV steps to compensate for the brightness of this beach scene in late spring, eventually going to +2 EV during the course of four exposures. Clearly, +2 EV was too much, with the sailboat almost absorbed into the background. My choice is the image made at +1.3 EV (opposite, top): It feels like the Coney Island beach, although I would pull it back a little (-1/4 EV) and perhaps add a tiny bit of contrast. The first exposure gives the scene a subdued look, whereas the second exposure is passable but needs about a +1/3 EV boost.

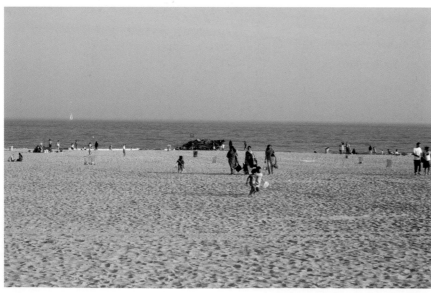

Then, I decide in what increments. If I'm looking for subtle distinctions, then I'll lean toward 1/3-stop increments. Less subtle? Then I opt for 1/2 stops. Really going for the gusto? Then—but rarely, I might add—it's full-stop increments. Finally, how far should I take this? Three frames is the norm: the base exposure, over, and under (not necessarily in that order). But keep in mind that you can't go beyond the maximum exposure compensation level, so if you start with an exposure compensation value of +1.5 EV and bracket from there in full stops on the plus side, that will only take you as far as +2 EV on most cameras. On the other hand, you still have considerable ground to cover in the opposite direction. By the way, if you don't feel the need, you don't always have to bracket in both directions, and experience with a specific location or situation may tell you bracketing is no longer necessary or that only one bracketed exposure (besides the first one) is needed.

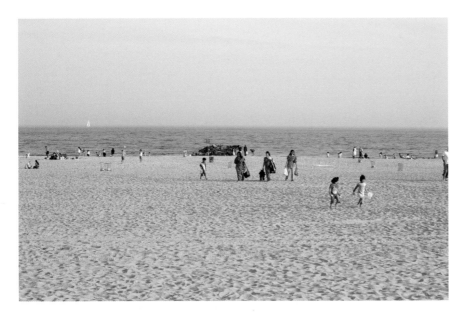

WHEN TO USE: Bracket exposures when confronted by tricky lighting situations.

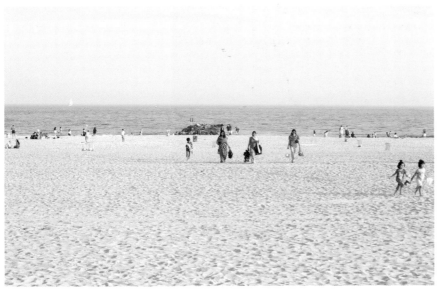

Autoexposure Bracketing

With today's technological marvels, you can take exposure bracketing to new levels, largely automating the process. You still have to decide on a starting point and the increments. Beyond that, the camera may give you the option of exposing three consecutive bracketed frames or it might extend that to five bracketed exposures, thanks, in large measure, to the built-in motor drive. When this *autoexposure bracketing* (AEB) is engaged, some cameras will drive the complete sequence with one press of the shutter button. With others, you have to hold the button down, keeping track of the sequence in the viewfinder. In fact, the camera may wait for the sequence to be completed before it returns to the original exposure setting, unless otherwise disengaged. If you only shoot two of the three exposures and then redirect the camera at another subject, the next frame may be made at the wrong (that is, compensated) exposure rather than what you intended. (Note: Engaging TTL-flash may disable this function.)

We used to say that film is cheap, so bracket away. These days, as we deal more and more with digital files, we might want to rethink that stratagem. While you can certainly shoot a lot more on a 1GB flash memory card than on a roll of film, you can also run out of flash memory much faster. Also keep in mind that the camera's memory buffer may fill up during this process, which then slows down picture-taking. On the other hand, don't shortchange yourself by thinking that all the necessary corrections can be made on your computer. They often can, but not always, and getting it right (or within a usable range) in camera is the more efficient approach. So use autobracketing, but not to excess.

Base exposure

WHEN TO USE: Use AEB to speed up the process of bracketing, provided you're prepared to expend the full sequence of exposures (three or five frames) to the same subject.

-2/3 EV

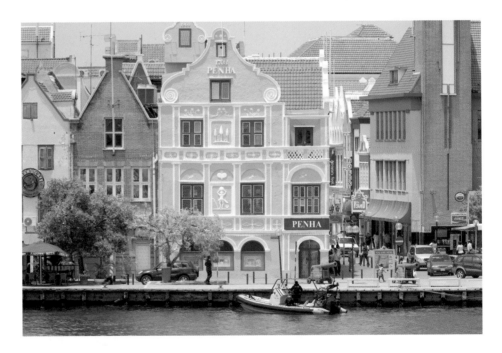

+2/3 EV

Autoexposure bracketing gives you several images with which to work. Here, bracketing increments were set at 2/3 EV, with the base exposure of f/8 at 1/500 sec. (ISO 200). I was shooting handheld, with my EOS 5D and 70–200mm lens with 1.4X converter, giving me an effective shooting focal length of 280mm. Using evaluative metering, I found my base exposure to be satisfactory. I could adjust the other images in postproduction to arrive at a similar result, but doing so with the underexposed image might generate some digital noise.

TTL Metering Patterns

The ability of the camera to deliver the necessary exposure depends on one integral component: the photocell. Today's cameras, as well as handheld meters, by and large employ SPD photocell technology, which in itself has led to great strides in exposure metering. The way this light sensor was designed, or "weighted," to evaluate a scene and the way you use it are critical factors leading to success or failure.

No camera meter sensitivity pattern is perfect. You have to learn to evaluate the scene in front of the camera and take corrective measures when necessary. Besides, there are subtleties beyond the ken of any camera. I gave this colorful building a +1/3 EV exposure increase and then made some subtle adjustments in post.

Evaluative Metering

Also known as *multi-pattern averaging* or *matrix metering*, *evaluative metering* mode is now the default metering pattern in practically every electronically governed camera. Complex computer algorithms programmed into the camera's brain interpret a scene based on simultaneous individual readings from a multi-segmented array, or grid, that is slanted according to scene content, attempting to balance exposure for the subject with that for the surroundings based on relative tonalities and brightness levels. Or to put it another way, the viewfinder is divided into zones, with each zone roughly akin to a voting district. What determines the outcome of the election depends on the constituency of each district, with some districts weighted more heavily than others. With evaluative metering, the camera's computer brain casts all the votes based on its evaluation of each zone (based on countless computer algorithms) and determines which zones are of greatest importance. In other words, technology tells the camera what to expose for. Good thing it doesn't determine elections.

Evaluative metering is a function of an autofocusing camera. That brings another factor into play: focusing or, more precisely, the active focusing point. The metering sensor is tied in to the AF sensor to deliver an exposure leaning more heavily toward the subject in focus. Now, returning to our analogy, we find that each zone gets at least one vote, but some carry more weight because their constituency is deemed to be more important at this moment—they are the focus group. In fact, you should count on this, because it will become increasingly important when you undertake fill flash with one of these cameras (assuming the use of the built-in flash or a dedicated external strobe). The camera is still calling upon all those computer algorithms to evaluate each of those zones, but it's now willing to accept your input, defined by the subject area targeted by the focusing sensor—that is, unless AE lock is engaged, at which point metering is more heavily biased toward the area you select with this function.

Evaluative metering does a great job of doing what its name implies: evaluating the entire scene and exposing accordingly. In these two images from Tera Kora, Curaçao, evaluative metering determined that less exposure was needed for the vertical, by 2/3 EV to be exact, apparently taking foreground brightness into account.

WHEN TO USE: When the application is broad-based, and given that the algorithms the camera uses are based on thousands of exposures, you can rely on it to deliver reasonable results. However, years of experience with evaluative metering have shown that it's not foolproof, so I continue to engage exposure compensation and AE lock when the situation demands, which is often. Moral: Don't be a slave to multi-pattern metering—it can fail you.

I set my EOS 5D in Shutter Priority mode to freeze this tugboat's movement as it guided the freighter out of Curaçao harbor. From the Willemstad ferry, I shot with a 24–105mm lens at ISO 200 for an exposure of 1/800 sec. at f/4 (evaluative metering engaged). Even though I bracketed, I opted for the base exposure, which had the boats aligned perfectly.

Centerweighted Averaging

The former standard in metering patterns, *centerweighted averaging* sports a sensitivity pattern that is weighted toward the middle of the frame, falling off toward the periphery. In essence, it assumes the subject is centered in the frame. Some cameras use a variation of this (*bottom-center-weighted averaging*), assuming you'll be shooting horizontals with the sky in the upper part of the frame. To compensate for the undue influence of this bright tonality, sensitivity is directed toward the darker, lower part of the scene, where, presumably, you'll find the subject. By this means, the bright sky can't overly influence the exposure. The downside to this modified approach is that the sensitivity pattern doesn't realign its chakra, so to speak, when you're shooting verticals. Centerweighted averaging continues to be an option in many cameras. However, I can't remember the last time I switched from multi-pattern metering to this mode with my high-tech cameras, except to purposely illustrate a point.

WHEN TO USE: When the subject's surroundings aren't too bright or too dark to throw off the exposure. It works especially well when there's a more or less even distribution of light and dark tones in the viewfinder. AE override (or AE lock) is still necessary against potential exposure error.

Back when I photographed these children's pails at Coney Island, my camera offered only one automatic metering choice: centerweighted. I didn't need to bracket, leaving the camera to do its thing.

Spot Metering

This sensitivity pattern is relative to the lens focal length, making it less effective than using a handheld spot meter. Still, spot metering has its uses by allowing you to key the exposure to an important subject area, such as a skin tone, foliage, or a point in the sky—or any highlight, shadow, or midtone value, to be more precise. You can roughly identify the area being measured by the circle in the center of the viewfinder. This option may be limited to higher-end SLRs, both digital and film. Point-and-shoot cameras may not offer spot metering, or if they do, it may be difficult to use with any accuracy, since the LCD display may not outline the area of coverage. *Partial-area metering* may be offered in lieu of or in addition to spot sensitivity. This metering mode covers a broader area, making it less effective. Still, if you can move in close enough to take a directed reading of a key tonal area, it should work as well.

WHEN TO USE: With longer telephoto lenses and subjects in tricky lighting situations, or when you want to create dramatic contrasts of light and dark, particularly in scenic vistas and black-and-white photography. Exposure compensation (or AE lock) may be necessary against potential exposure error when the exposure is based on a bright highlight or deep shadow value.

Multi-Spot Averaging

In contrast to multi-pattern metering, *multi-spot averaging* or *metering* is a much more deliberate and labor-intensive process. It involves taking two or more spot readings of key areas shown in the viewfinder to determine the final exposure. Again, it's a feature of more technologically advanced—and often more expensive—cameras. After you lock in each spot-metered exposure, the camera then averages them for you. Depending on the camera, the number of individual readings varies, but often, it maxes out at eight or nine.

WHEN TO USE: With longer telephoto lenses and subjects in tricky lighting situations, but especially when you want the ultimate control over exposure. Will this approach deliver more reliable results than multi-pattern metering? Hard to say. If you're a control freak, you'll take this route.

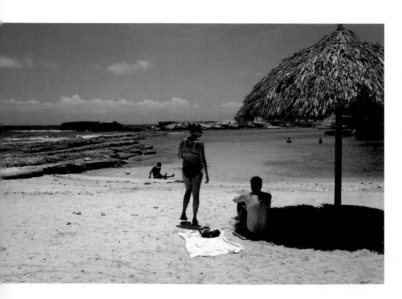

My approach to metering these two scenes differed: For the left-hand image, I aimed the camera at the man's back, which determined not only focus but exposure, with the camera in Shutter Priority mode and evaluative metering engaged, for an exposure of *f*/5 at 1/1000 sec. with a +1/3 EV boost (ISO 100). However, focusing on the bright, distant clouds silhouetted the foreground opposite and made the solar rays more pronounced—exactly my intent. (I added a blue tone in postproduction.)

Autofocusing & Exposure

While older SLR cameras rely on mechanical couplings between lens and camera, today's high-tech autofocusing cameras utilize electrical or electronic contacts and sophisticated circuitry, allowing lens and camera (and even a dedicated flash) to communicate with each other. This has a profound effect on exposure systems built into these latest-generation cameras.

Normally, when you press down halfway on the shutter button to activate the camera's autofocusing and autoexposure system, you're also locking in both focus and exposure. However, there are work-arounds and situations when this may not hold true.

AF point selected. You can have some control over the area the camera is targeting for exposure measurement by selecting an AF point other than the default. Depending on the camera, this may only work when metering is set to spot or partial-area metering. A select few cameras employ *eye-controlled AF*, for which the eye actually controls where the lens focuses, and you can use this approach to center exposure on a desired focusing point.

AE lock engaged. This will allow you to separately target one area for exposure and another for focusing, with each maintaining individual integrity.

Continuous AF engaged. When the camera's focusing system is set to continually track a subject, the exposure may be locked in only at the moment when the shutter is released and the picture is actually taken. This allows you to hold the shutter button down halfway for as long as necessary to track a moving subject before committing to the shot. AE lock and exposure compensation can still be engaged.

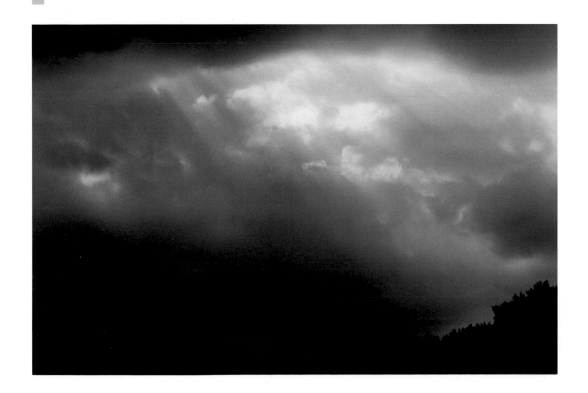

Handheld Meters

As refined as in-camera meters are these days, they can't address every photographic situation. Not to mention that some of us still work with cameras employing more primitive exposure systems, or none at all. And there are many among us who work with studio and other non-TTL-dedicated flash gear. The bottom line is that we need something to fill the gap.

Of course, many pro photographers working in the studio let experience with a specific lighting system dictate their exposures. And increasingly, numerous photographers make use of the immediacy of the digital camera to provide a working preview, replacing the once ubiquitous Polaroid, which is still used a good deal with film-based cameras.

Handheld exposure meters (commonly called *light meters* when used with ambient illumination and continuous light sources, and *flash meters* when used with strobe) shouldn't be dismissed simply because not everyone uses them. For the majority of us, a handheld exposure meter remains *the* tool to have at hand for any number of reasons. The meters I own range from a simple but still-functioning ancient relic to a wildly exotic, multifunctional, twenty-first-century digital flash meter. While I don't use a handheld meter often, I wouldn't be without one, even when traveling.

Exposure Meters from the Ground Up

At the heart of the handheld exposure meter, as with any camera meter, is a light-sensitive cell to measure levels of illumination. As with everything technological, these devices have evolved, originating with the primordial selenium cell. The advantage to the selenium-cell meter is that it is entirely light-powered and battery-free, but these measuring devices are relatively sluggish and not very sensitive under low light.

Once we accepted the fact that the world runs on batteries, that cleared the path for the next generation, the CdS (cadmium sulphide) photocell. Exposure meters were considerably more responsive, although there was still room for improvement. The major drawback to the CdS cell was something called "memory," when the cell would be temporarily blinded by sudden or prolonged exposure to extremely bright light, much as a person is. A rare phenomenon, but recovery could take hours.

Enter the next generation: silicon technology, heralding microprocessor control, embodied in the silicon photo sensor. The SPD (silicon photodiode) exhibits absolutely no time lag, at least none that we can humanly detect. (SBC, or silicon blue cell, is a variant moniker, with no practical difference.) For a brief period, the gallium photodiode, or GPD, tried to grab center stage but failed miserably.

Exposure meters incorporating silicon technology knew no bounds. Metering systems moved away from traditional match-needle operation

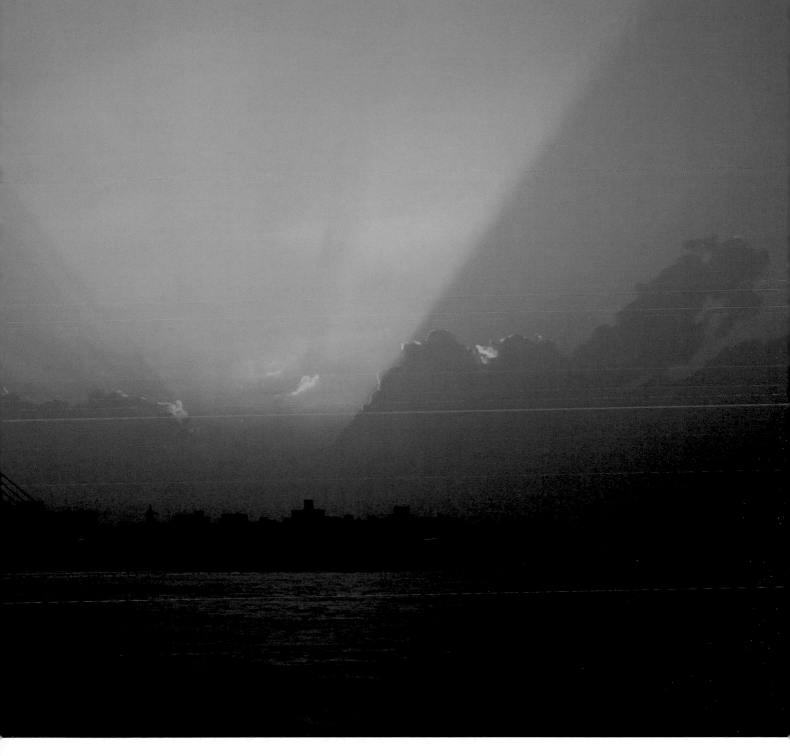

Shooting in manual mode, my intent was to focus attention on the sun's rays shooting out from the western horizon over the New York skyline late in the day. For this highlight-biased reading of *f*/18 for 1/125 sec., I used a spot meter to determine exposure, aiming the meter's lens at the brightest area above the horizon.

and culminated in full alphanumeric digital LCDs that provided an immediate readout with easy-to-read numbers. And we were introduced to "memory" in a good way, when the meter could memorize a reading for later reference, extending to averaging multiple readings and helping to analyze contrast. This new technology also gave us handheld (and camera) meters that could finally read electronic flash.

To a Light Meter, the World Is Gray

Handheld exposure meters are no better than camera meters when it comes to defining which subject areas are important to the picture, and which are too bright, too dark, or just right. That's entirely your decision. These meters can be equally unduly influenced by the subject's surroundings, not only by subject tonalities.

There is one inescapable fact: No matter how fancy a handheld meter or camera's integrated exposure metering system is, it relies on one basic value—a medium-gray tone of average reflectance defined as 18% gray. Exposure meters are tied to this standard value, whether they make their measurements by reflected or incident light. To an exposure meter, light is light, and the meter seeks to interpret that light the best way it can. But as we all well know, best intentions don't necessarily make for best results.

Now, since the exposure meter sees the world as gray, it attempts to correct for anything that deviates from this "neutral" tonality. Blue sky, bright foliage, white skin tones, a white wedding gown, brightly lit sidewalks, sun-drenched sand—these are all brighter than that 18% standard. A dark alley, black velvet, a black tuxedo, or a darkened computer screen are all subjects that soak up light. The same applies, whether it's a reading made with the camera or a handheld reflectance meter. The meter wants to bring down the light values and bring up the dark tones and render them all gray. You have to be the arbiter of good taste and restore order. You have to define which tones are rendered white, gray, and black through exposure control. It's a ship gone adrift, and you have to set the right course.

Reflected-Light Meters

The only values that meters of yore could read were reflectance, or reflected light. To make a reflectance reading, the photocell is first directed at the subject. Light that hits the subject is bounced off, and this bounced, or reflected, light is what reaches the photocell for a meter reading. Typically, this is the way camera exposure systems operate. And there is nothing wrong with it, provided the subject reflectance doesn't deviate appreciably from that ubiquitous 18% (in other words, that all or part of it is not lighter or darker than a neutral gray). If the meter is aimed at a person, skin tones will affect the exposure, as will glistening skin under a hot, noonday sun and light and dark clothing, not to mention the person's surroundings, which the meter cell may also see.

Even if you took two handheld meters and pointed them at the same exact spot, you might not get identical readings. That's because the photocell may sport a different angle of acceptance, reading a wider or narrower area. If the field is a uniform tone, it shouldn't matter, but if there are wet rocks reflecting sunlight just within the field of acceptance of one sensor but not the other, that glinting rock could very well throw off that one meter. Roughly, the sensor acceptance angle is equivalent to the field of view of a 50mm lens on a 35mm camera. The readings won't necessarily match exactly from handheld to camera meter, because light passes through and bounces off many more interfaces and surfaces in a camera than in a handheld meter—not to mention variations in the cell's sensitivity pattern and subtle variations in the acceptance angle between the two.

WHEN TO USE: Anytime, anywhere in place of, or in the absence of, a camera meter. But the use of a handheld reflectance meter does require more time, since the data must be transferred to the camera's lens aperture and shutter speed controls.

HOW TO USE: First set the camera to manual mode. Then set the ISO value on the meter (to match the film speed or digital ISO setting of

choice). With more advanced meters, you may also have to select the necessary operating mode. Point the reflectance cell at the subject from the camera position or, if necessary, by moving the meter closer to the subject to take a reading of a more definable area. Because you're reading reflected light, you may have to compensate for bright and dark tonalities. Finally, transfer the reading—aperture and shutter-speed values—to the camera. (Note: Don't adjust the meter reading for tonality and brightness when taking and averaging multiple readings—it would defeat the purpose of making the additional measurements.)

EXPOSURE CORRECTIONS: It may be necessary to compensate for lens extension, filter usage, and subject tonality. Such corrections can be made on the meter. The easiest way is by adjusting the ISO setting in the necessary direction (setting a slower value compensates for less light contributing to the exposure with the use of a filter or extender). Or, make the adjustment when transferring the readings to the camera.

Incident-Light Meters

Most handheld meters (except for dedicated spot meters) offer a combination of reflectance and incident reading capability. The incident meter sports a white dome—the light collector. This dome allows the meter to read light falling on the sensor below from all around (technically, an angle equal to 180 degrees of arc, much like the view a fish-eye lens takes in). More compact meters have smaller domes than full-size meters, but there is no practical difference (provided you keep the dome free of dust and dirt). The simplest designs require you to slide the dome into place for incident readings, or back again to allow reflectance averaging measurement.

A select few meters replace the reflectance averaging function with a full-fledged spot meter. That also does away with the sliding dome, necessitating an activation switch to go from one function to the other. It also results in a redesign of the dome, which is now retractable. The recessed dome comes into play when making lighting contrast readings. With other incident meters, the dome has to be replaced by a flat diffuser for contrast measurement. With a sliding dome, you would have to shade the dome from secondary light sources when making these readings—a methodology that, while it may not be as accurate, appears to work in practice.

WHEN TO USE: While reflectance readings are great for scenics and distant subjects, incident-light readings excel when it comes to portraiture, still life, and tabletop photography—i.e., controlled situations, especially those involving studio lighting.

HOW TO USE: As before, set the camera to manual mode and set the ISO value on the meter. With a more sophisticated meter, you may again have to select the necessary operating mode. Point the incident dome toward the camera from the subject position; with a person, that translates into holding the meter right in front of the face. (If the dome is recessed, raise it to the full position to read all the light falling on the subject; if it slides in and out of position, make sure it's in the proper position to avoid a serious exposure error.) Then transfer the reading to the camera. Note: If the lighting is the same at both the subject and camera positions (for example, both under bright sunlight or in the shade), you don't really have to approach the subject to take an incident reading. Simply stay put and hold the meter so that the dome faces the camera, and you can take a reliable incident-light reading for the subject.

EXPOSURE CORRECTIONS: Normally, no exposure compensation is needed for bright and dark tonalities. That said, when shooting slide or transparency film, it might be advisable to reduce exposure for excessively bright tonal values (such as a glimmering wedding gown) and increase exposure for excessively dark tonal values (such as a black tuxedo)—between 1/3 and 1/2 a stop, respectively—in order to capture subtle details, which might explain why wedding photographers shoot negative film as a way of getting around all this. With digital and with print film, this step is largely unnecessary.

Here, my friends' older daughter holds up an exposure meter in preparation for an incident-light reading. This multipurpose handheld exposure meter can function as both an incident meter and a spot meter, whereby it uses built-in optics to make readings with pinpoint accuracy for reflected-light measurement. The meter reads both available light and flash.

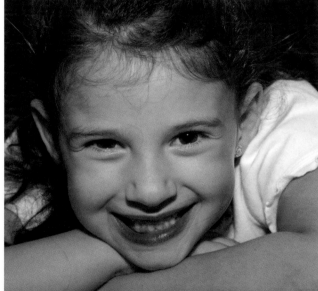

This calibration target has, in addition to a middle gray patch, light and dark areas for setting white and black points when shooting digital. Also, the gray strip is used to customize white balance. The candid portrait to the right reflects the combined use of an incident meter (to read bounced flash lighting) and the calibration target to lock in a usable tonal range and white balance. (Note: For the actual meter reading, the incident meter is held closer to the face, usually right in front.)

Spot Meters

A spot meter is a very special kind of reflectance meter with a sharply defined, finite measuring angle. This allows you to key the exposure to any small spot. Read a shadow value, a highlight, or a midtone for the final exposure; average highlight and shadow readings; or measure and average multiple spots of varying tonality in order to arrive at the optimum exposure needed to capture vital detail. Because the measurement angle is small, the spot meter lets you reliably read tonal values off distant scenes and determine contrast.

A true spot meter reads an area measuring 1 degree of arc. Some meters may offer spot reading but in fact read a larger area, say 5 degrees. A few meters even feature variable-angle measurement, so you can fine-tune the area to be measured, much like working with a zoom lens. They may not, however, read as small an area as a true spot meter or do so as reliably.

Older spot meters were dedicated to this purpose, sporting a reflex design akin to a single-lens-reflex camera, pentaprism and all. Newer designs are much more compact. As mentioned, true spot metering capability has been incorporated in a select few handheld meters, allowing incident and reflectance measurement from one device.

WHEN TO USE: Wherever you need the tightest control over exposure; to best determine subject contrast in high-contrast situations; keying exposure for dramatic effect with scenic views. This is standard fare for many Zone System followers.

HOW TO USE: Unlike the typical reflectance meter, which is aimed almost blindly at the subject, the spot meter sports an optical viewfinder, like a camera, permitting you to home in on the target. You can use it with equal assurance from near and far, although it may still be necessary to move closer to the subject to read a very tight area. Otherwise, use the spot meter as outlined for reflected-light meters.

EXPOSURE CORRECTIONS: Again, adjust for subject brightness, except when basing exposure on a combination of highlight and shadow values or when averaging multiple spot readings.

For this manual exposure, I aimed the spot meter at a key shadow value (the building with the chimney stacks) for one reading (f/4.5) and next took a highlight reading off the brightest point on the large cloud (f/20). With these measurements in memory, the meter averaged the two readings to deliver the final result: f/10 at 1/125 sec. (ISO 400).

Flash Meters

Conventional light meters are designed to read continuous light (which more broadly applies to fluorescent and metal discharge lamps). The flash meter takes the next step up by measuring electronic flash, as well. It can do so in reflectance (averaging or spot) or incident mode.

The handheld flash meter is, perhaps, the most sophisticated exposure tool available. It can be used with any flash unit—provided output is *manually controlled.* This manual setting ensures consistent strobe output, resulting in a reliable reading. To avoid exposure error, the flash output must not change from the moment it's read by the meter to the moment the shutter is released (after transferring the reading to the camera). Any adjustments in the lighting will require a corresponding adjustment in the exposure.

A flash meter can be used with one or more strobes simultaneously. The first strobe is directly triggered by a press of a button on the meter, which triggers any other strobes that may be synced to the first one. The meter then takes a measurement of all the lights at one time.

There are actually several ways to trigger the strobes for a reading. For simplicity, we'll assume we're working with one flash unit. *Cord* mode means that the strobe is hardwired to the meter with a sync cord and triggered by the meter's activation switch. When the flash can't be connected to the meter (it's too far, or there's a misplaced or broken sync cable), *cordless* mode puts the meter in standby, waiting for you to trigger the flash either by a remote switch or by hitting the Test firing button. Radio triggering (an option on selected meters) is entirely wireless, but here the meter must be specially equipped with a radio transmitter and the flash with a radio receiver, with both tuned to the same channel (frequency).

WHEN TO USE: With studio flash lighting or location lighting employing strobes or any flash set to manual operation (essentially, any light of fixed output); not for use with portable strobes where light output is controlled by an autosensor or TTL automatic operation (in other words, where flash output is variable).

HOW TO USE: Incident readings are taken as they are for incident-light meters; reflectance readings are made as they are for reflected-light meters. One proviso: Set the meter to the appropriate operating mode (cord, cordless, or wireless radio) and use Shutter Priority readings, setting the same flash sync speed as on the camera.

EXPOSURE CORRECTIONS: As outlined for the applicable operating mode: incident, reflectance averaging, or spot reading.

Gray Card Readings

Since our exposure meters are keyed to an 18% reflectance value, we can readily turn to the gray card as a means of achieving the optimum exposure. When handled correctly, this reading essentially gives you the equivalent of an incident-light reading—except that it involves a reflectance reading. It works with any reflected-light meter, including a dedicated spot meter, and consequently works equally well when read by the camera or a handheld meter. What's more, it's an economical alternative to an incident meter and can be used with existing light or flash.

WHEN TO USE: In the absence of an incident meter or simply to key the exposure to a standard gray tone.

HOW TO USE: As with the incident dome, position the card at the subject position facing the camera and point the camera, or a reflectance meter, at the card. Then take the reading and treat it as one taken with an incident meter. (Note: Angle the card appropriately to avoid glaring reflections in the surface, which will throw off the reading. Collapsible fabric targets seem to work best. And don't cast a shadow over the card as you make the reading.)

EXPOSURE CORRECTIONS: As noted for incident metering.

The Canon EOS 30D is among the latest generation of digital cameras to offer all the bells and whistles. Governed by microprocessors and countless exposure algorithms, the camera offers the photographer numerous exposure controls.
Photo courtesy Canon USA

Contrast Measurement and Control

There is *subject contrast*, also known as *scene contrast* or *brightness contrast*, and there is *lighting contrast*. They are not the same.

Brightness contrast measures the difference in reflected-light values between a key highlight and key shadow, regardless of the type of lighting used. It represents the recordable "brightness range." To measure brightness contrast, you use a reflectance meter. That could be a handheld averaging or spot meter or the camera (in evaluative, centerweighted, or spot mode). The greater the variance between the key highlight and key shadow readings, the greater the contrast. Brightness contrast tolerances are a function of film contrast, tonal range, and the level of lighting falling on the scene. The best way to judge this contrast is with testing. With digital, you can use a target that includes both a white and a black patch (reading what translates into white and black points, respectively, on a histogram), as well as a gray patch, and examine the histogram. Moreover, you can readily see when you've exceeded the brightness range by highlight or shadow clipping in the visual representation of the image in the display.

Lighting contrast measures the difference between the illumination falling on the subject from two light sources: key light and fill light. To measure lighting contrast, we use an incident meter, or a reflectance meter (or the camera) with a gray card. We generally think of this as a lighting ratio between the *main light plus the fill light* and the *fill light alone*, and subsequently as something over which we have more control. As such, it is easy to quantify. It's often best not to exceed a 1.5-stop difference (for a 3:1 ratio) in the lighting hitting the subject, so as not to obscure important details. A 1-stop difference (2:1 ratio) produces a more sedate result, whereas 4:1 (with a 2-stop difference between the two readings) adds a dramatic effect. You can employ various means to control contrast, effectively adding or subtracting light falling on the subject. The simplest way to reduce lighting contrast is to add fill light, or reduce fill in order to enhance contrast. You can also use screens or diffusion material positioned in the path of the key light source (especially with bright outdoor lighting) to reduce contrast. Movie sets use this approach constantly.

Contrast Ratios

The difference in EVs between two readings, whether lighting contrast (key light plus fill and fill light alone) or brightness contrast (highlight and shadow), can also be expressed as the contrast ratio. A *lighting contrast ratio* of 1:1 represents flat lighting and an absence of lighting contrast. However, this doesn't mean there's no subject or tonal contrast, which may very well exist, although not in dramatic proportions. A penguin under flat lighting still exhibits *tonal contrast*, and the *subject contrast* would reflect these contrasting tones. The relationships are as follows:

EV/Step Difference	Contrast Ratio
0	1:1
1	2:1
1.5	3:1
2	4:1
3	8:1
4	16:1
5	32:1

Metering Tips

REDUCING CONTRAST

Some of these steps may be obvious, but we often forget the obvious under pressure. Be practical in your choices. For the most part, this addresses lighting contrast, but certain stopgap measures reduce brightness contrast, as well.

- Use a bounce card or collapsible reflector to fill in the shadows. Keep in mind that a white surface throws back a neutral and softer light, a gold tone adds warmth and specularity, and silver is specular and possibly on the cool side. Sometimes, small mirrors are used for very finite areas.

- Use a fill light for deep shadows.

- Hold back light from the brighter areas with a scrim (a special type of screen) positioned in the light path, or position a black card adjacent to the subject area to soak up the excess light. Or, where applicable, you might try diffusing the light source.

- A neat trick with portraiture involving two or more people is to place the person wearing the brightest clothing or with the fairest complexion farther away from the light, while bringing the person with dark clothing or a deep complexion closer.

- Use a graduated neutral-density (ND) filter over the lens if there is a fairly clear line of demarcation between the brighter and darker portions of the picture.

- With artificial lighting, lower or increase light output on directly controllable light sources as needed.

- With artificial lighting, move the light farther back or closer to the subject, as applicable.

THE SQUINT FACTOR

Bright subjects—such as sky, white sand, snow, pastel buildings, and bright lights—cause you to squint. The eye is trying to block out all that brightness and make it easy for you to view the scene. Now consider: If you're squinting, a reflectance exposure meter, either handheld or in camera, is doing something very similar. The meter takes a slightly different tack, however, trying to bring that brightness down to a medium-gray tonality, or 18% reflectance value. The harder you have to squint, the harder the meter tries to compensate for the brightness, as well.

If the scene isn't that bright, you'll squint less, and the meter sees less of a need to reduce the exposure to compensate for the excessive brightness. When the meter reduces the exposure to compensate, it's rendering that scene a dull gray—unlike the eye, which has the brain to compensate so that you see the scene normally. With an exposure meter, you have to consciously step in and make the exposure adjustment, by increasing exposure. By how much? Enter the "Squint Factor."

The Squint Factor tells you that, if you're really, really squinting, a sizable exposure adjustment on the plus side is necessary. That exposure adjustment may be as much as +1.5 to +2 EV. If you're squinting just a bit, the exposure correction need be no more than +1/3 or +1/2.

SOMETHING'S WRONG WITH MY METER

You may find that a handheld exposure meter is consistently delivering erroneous readings. You've ruled out incorrect meter settings (ISO, shutter speed, or operating mode), faulty use of meter data, camera malfunction, film or digital RAW file processing, viewing conditions, and, specifically with digital images, monitor brightness. What's next? First, test the meter in a simulated setting, bracketing exposures. With results in hand, and after having determined the degree and direction (over/under) of the exposure error, you can correct the problem easily enough by inputting a calibration correction factor. Failing that, adjust the ISO setting accordingly to compensate for the error. Simpler still, routinely make the correction each time you input the exposure settings on the camera. (Note: The error is likely not due to a mechanical fault but to the way you use that meter. Even when readings are used correctly, you may want image tones to be brighter or darker than those dictated by the meter.)

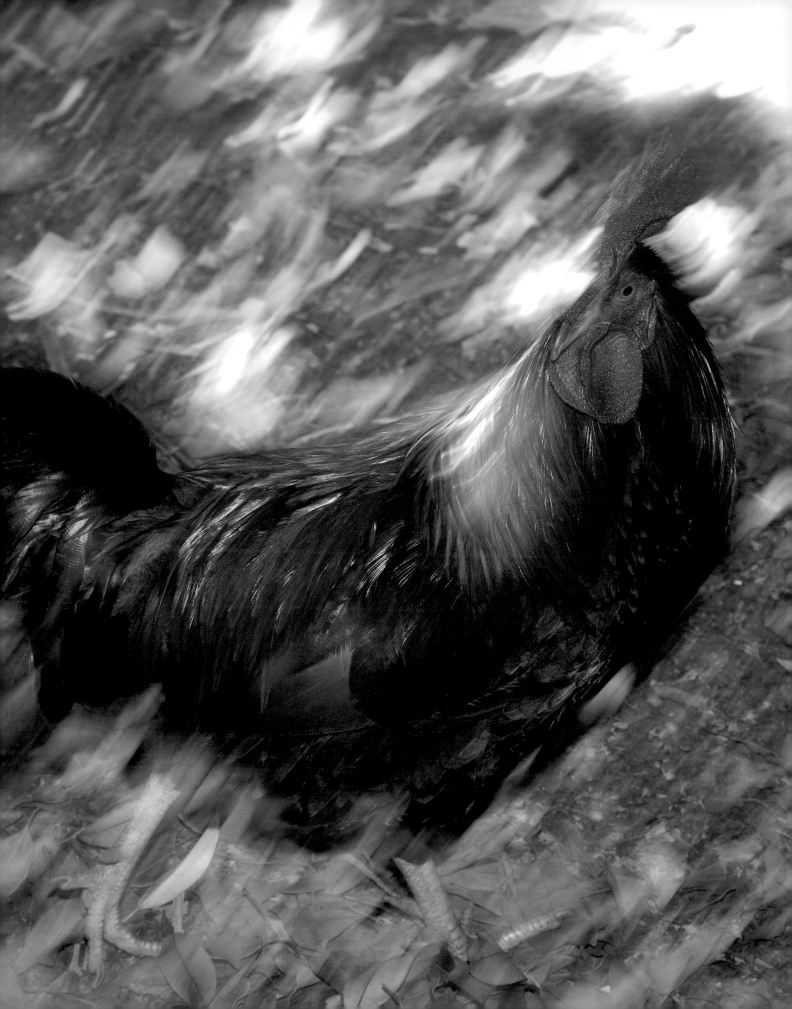

MASTERING FLASH EXPOSURE

Flash photography can be as simple or as complex as we make it. Activate the camera's built-in flash and electronic flash becomes as effortless as opening a container of ice cream. But what if you have whipped cream, cake, maraschino cherries, sprinkles, and other toppings around? Suddenly, making something out of the ice cream, as tantalizing as it originally was, becomes work. The same with flash. You can make more of it if you like. And like a gourmet ice cream, sophisticated flash units add a distinctive flavor to the dish you prepare.

On-Camera Flash

There's a time and a place for on-camera flash, whether it's built into the camera or attached by way of a hot shoe. There are many conveniences and advantages to on-camera flash, but there are also drawbacks and limiting factors dictating against its use. Far too many of us see this form of lighting as a quick expedient, without bothering to examine the alternatives. And there are others among us who shun it when it could easily make the difference between capturing the moment and getting no picture at all.

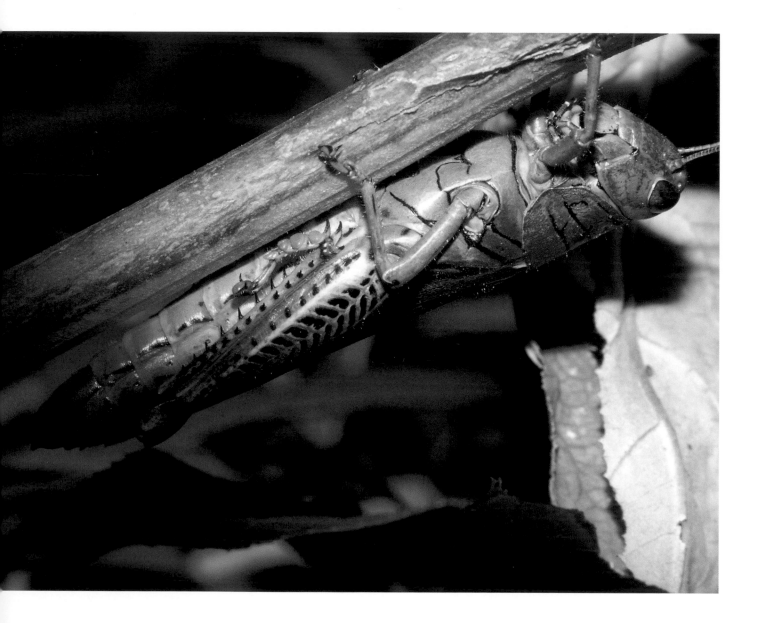

I photographed this grasshopper with an EVF SLR—the kind with built-in zoom optics and built-in flash, both of which came in handy. Note that you don't always need an interchangeable-lens SLR to capture close-ups.

Built-in Flash

Most cameras today sport a tiny flash unit as an integral part of the system. Depending on the operating mode and system programming, the flash may be activated automatically or only at the user's discretion. Flash units that physically pop up are deactivated until in the upright, active mode. Many cameras provide different modes of operation once the built-in flash is activated (these modes are applicable also to an external flash, when it's attached). Depending on camera design, use of an external flash may bypass the internal flash circuitry, or the internal flash and external strobe can work in tandem (usually the built-in flash would be a fill light).

STRENGTHS: Simple to use; practically always at the ready; nothing extra to schlep around.

DRAWBACKS: Weak reach (to maybe 10 or 15 feet); draws a lot of battery power; slow recycling (may not be ready to capture the moment); limited coverage (unsuitable for ultrawide lenses); lens shade or very long lens may block the light; unsuitable for tight close-ups; red-eye (unless red-eye reduction mode is used, and even then it's not a certain remedy); direct light may prove unflattering with portraits; hard-edged light produces harsh shadows directly behind subject; direct light produces glaring reflections in glass and polished surfaces.

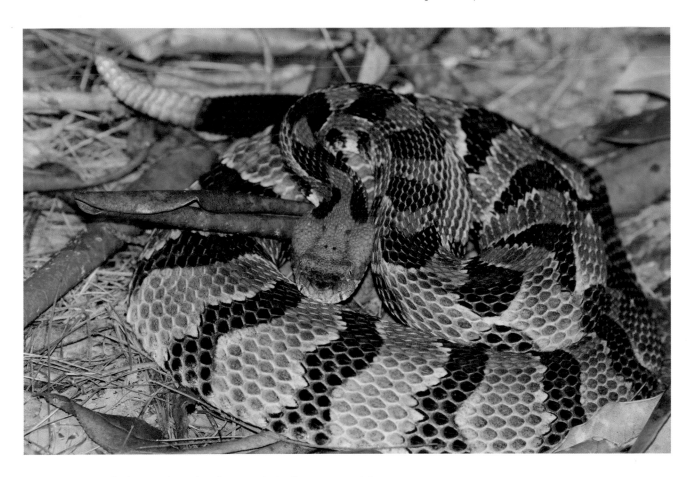

This full-grown timber rattlesnake characteristically announced its presence with its rattle as I approached within 10 feet on a trail in western North Carolina. I grabbed my camera, attached a 200mm lens, and decided to shoot with the built-in flash since light levels were low and the snake was holding its ground. The camera was in Aperture Priority mode for a 1/250 sec. exposure at f/5.6 with a +2/3 EV boost. Despite that, I needed to boost the exposure a little in post.

Hot Shoe Flash

Attaching an external flash unit to an SLR extends your ability to take pictures under a wider range of conditions. These flash units often have the oomph needed to capture fleeting moments on demand. Moreover, today's SLRs feature a hot shoe that maintains an electrical contact with the camera so that pressing down fully on the shutter button triggers the flash properly seated in the hot shoe.

Once the accessory du jour, the conventional hot shoe flash sported a single "hot" contact, which matched the "hot" contact in the camera foot. The beauty of the old-style hot shoe flash is that any make of flash would work with any make of camera.

The external flash may make use of an X-sync terminal on the camera in place of the hot shoe, provided a sync cable is used to connect flash to camera. This approach allows more varied lighting with off-camera flash or with, simply, the use of a flash bracket, which may itself house its own hot shoe (in which case, the connecting cord would be attached to the bracket, not the flash).

STRENGTHS: Faster recycling than built-in flash, with more flexible choice in f-stops for greater depth of field; light reaches considerably farther than built-in flash; draws on its own batteries; head may rotate and tilt for bounce flash operation; may be used off camera alone or in conjunction with several other flash units (with triggering via sync cable or optional photo-optical, infrared, or radio triggering systems—a flash meter may be needed with multiple lights).

DRAWBACKS: Manual activation required (it's very easy to take the picture and later realize you forgot to turn the flash on); red-eye still possible, especially with more squat designs; produces the same flat lighting, harsh shadows, and glaring reflections as built-in flash when on camera; often unsuitable with nearby subjects when flash is seated in the hot shoe and used with telephoto and macro lenses or with any lens to which a deep lens shade is attached.

TTL Auto Flash

TTL (through-the-lens) flash, as dedicated flash is popularly known today, draws on all the computing power behind the camera to deliver the best possible exposures under a variety of conditions. It applies both to the numerous external flash units designed to work with a particular camera system and to the built-in flash. TTL flash designs vary widely, with either a separate sensor in the camera dedicated to reading flash illumination (apart from ambient light) or the same sensor reading both flash and ambient.

The abundantly popular external dedicated flash unit has an array of contacts that coincides with a like arrangement of contacts in the hot shoe (in contrast to the standard, single-contact hot shoe flash). The hot contacts must match those on the camera to avoid the possibility of shorting out either the flash or the camera, or both.

A few add-on TTL flash systems employ an interchangeable module that operates with specified camera models or brands. The module attaches to the base of the flash unit. You would only need to take a modular approach if you work with different camera systems, since it's more economical—and space-saving—to buy different modules for a trusty strobe than to buy a whole new flash unit for each camera. (Mostly, the modular approach is European, and these modules go by the designation SCA.) The external TTL flash may make use of a dedicated terminal on the camera in lieu of the hot shoe, provided a dedicated TTL cable is used, or the cable may connect to the camera by way of the hot shoe itself. TTL flash offers lots of advantages, but the extent and range of these benefits depends on the model and camera system.

STRENGTHS: Designed to automatically deliver the correct exposure under a variety of conditions; exposures may be tied to focusing point; may add such features as auto/manual zooming, wireless flash, high-speed sync, flash exposure compensation, flash exposure bracketing, and second-curtain sync; standby/activation through camera; customizable functions tailored to your needs

or style of photography; improved color balance control through camera; automatically compensates for filters and lens extension, making it ideal for macro flash; fill flash made simpler (often automatic) without cumbersome calculations; automatically compensates for use of wide and tele accessory panels; wide panel may be built in; kicker panel (to add catchlights to the eyes with bounce flash) may be built in, as well; fast recycling under most conditions.

DRAWBACKS: None, in theory, provided you don't take a slavish attitude and assume the TTL flash exposure is always right; in fact, bright and dark tonalities will throw off the TTL flash exposure just as they would an ambient light exposure.

Autosensor Flash

Today, it makes more sense to refer to the simpler automatic strobe and corresponding mode of operation, which utilizes an onboard sensor and thyristor circuitry, as *autosensor flash* to readily distinguish it from TTL flash. Also known as auto-thyristor flash, these simpler strobes employ energy-saving circuitry to dump excess charge (when a smaller amount of light is needed) and thereby reduce recycling times and enhance battery life, which in turn increases the number of flash pops produced. More importantly, they sport a light-sensitive photocell (the autosensor) on the front of the housing to read the light emitted by and bouncing off the subject, thereby controlling the duration of the flash output and flash exposure and, consequently, the recycling times. As with any flash, when more light is needed, more energy is drawn from the capacitor that stores the charge, resulting in longer recycling times until the flash unit has built up enough power for the next burst. The difference between autosensor and TTL flash is where that determination is made. In autosensor flash, it's made in the flash unit itself (not the camera) once the shutter button is fully depressed and the flash unit receives the triggering voltage from the camera. Select autosensor strobes may be dedicated to a specific camera system, with multiple contacts conveying information to the camera, but on a very rudimentary level.

Because the sensor reads light bouncing off the subject when the strobe is operated in automatic mode, it must be aimed directly at the subject to deliver a reliable exposure. It's something to keep in mind when you're working with the flash off camera, to avoid serious exposure error.

Autosensor flash gives you some leeway in flash-to-subject distance at a given *f*-stop. Toward this end, these flash units provide an onboard calculator (a dial or slide-rule-type device, or a graphic chart) to help you determine the *f*-stop needed to cover a specified range of distances from flash to subject at a given ISO. For example, if your subject is 12 feet away (we'll assume camera and flash positions coincide), checking the calculator may reveal that $f/5.6$ covers a distance of up to 15 feet, making it the suitable *f*-stop to use for this exposure. The subject may move farther away (but not beyond 15 feet in this case) or nearer without necessitating a change in *f*-stop. Selecting a smaller *f*-stop on the camera will shorten the throw of the light so that it falls short of the subject, leading to underexposure, as would moving the subject to a distance that falls beyond the specified range of coverage.

One more important variable: ISO. Since the autosensor flash unit is independent of the camera, ISO must be specified on the flash calculator in order to arrive at the proper flash exposure settings.

STRENGTHS: Highly reliable exposures; fast recycling in automatic mode under most conditions.

DRAWBACKS: Unless you stick to one *f*-stop for much of your flash photography, can be time-consuming (and sometimes confusing) to interpret the flash calculator; limited to a choice of three or four *f*-stops (other *f*-stops must be extrapolated from the calculator data); requires exposure compensation on the plus side when used in overly large spaces or outdoors at night; often not suitable for macro photography.

I photographed these tree forms first by available light, then with flash. Program mode yielded an exposure of *f*/6.3 at 1/80 sec. for the available light shot (above) and *f*/5 at 1/100 sec. for the flash exposure that followed (opposite, left). As is obvious, the flash filled in the bark. Switching to Aperture Priority, I boosted flash sync to 1/250 sec. (at *f*/5.6) via a Custom Function setting on my Canon EOS 20D, which cut back dramatically on the available-light portion of the exposure, throwing background areas largely in shadow (opposite, right). That helped to focus attention on the tree forms in the foreground.

Manual Flash

Manual flash mode gives you total control over the lighting, especially with multiple strobes on a set. While portable strobes might make use of an onboard flash calculator to determine exposure in this mode (matching *f*-stop with flash-to-subject distance), manual flash practically means bringing a flash meter into the picture. In manual flash mode, output at a set power level is constant, provided the flash has had ample time to recycle to full power.

Manual operation is the de facto standard on studio strobes. While multiple TTL flash units may be fairly reliably controlled by the camera, the same can't be said of autosensor flash: The calculator dial only works for that one flash unit, and extrapolating the exposure to account for additional flash units is a tricky business. (Assuming you're using identical flash units placed at the exact same distance from the subject, a rule of thumb is to add 1 stop to the exposure—use the smaller *f*-stop—for each additional flash unit. For example, if one flash unit yields an $f/8$ exposure, two identical flashes will give you $f/11$, three strobes $f/16$, and so on. Obviously, using a digital camera gives you an instant preview and more leeway in working with the added strobes.)

Even TTL flash isn't foolproof. There were occasions when I put the flash in manual mode and metered separately with an incident flash meter. Or, you may want to calibrate a custom white balance setting on your digital SLR by reading a calibration target. To do so, you'd have to set the flash in manual mode so that output remains constant from the flash exposure used to the set white balance to the actual flash exposure that follows.

STRENGTHS: Tight lighting control that eliminates variables, especially when the flash is used off camera and with multiple studio strobes.

DRAWBACKS: Time-consuming and often requires the use of a flash meter; when the flash is set to full power, manual mode draws considerable energy and recycling may take several seconds.

Guide Numbers

The guide number, or GN, is a rating given to a flash unit that defines its efficiency under a given set of conditions at a specified ISO setting. Popularly applied to shoe mounts, it provides an indication of the strobe's reach at a given *f*-stop: Higher numbers equate to a longer throw of light. Alternately, the GN lets you know how far you can stop down and still get a usable amount of light from the flash at a given flash-to-subject distance. Zooming the head or bouncing the light or doing any of a number of things to modify the light will likewise affect the effective GN rating. Essentially, anything done to soften the light will lower it; anything done to increase its reach, such as using a telephoto panel, will increase the rating.

The guide number is a pivotal value in calculating flash range for any lens aperture. The fancy flash calculator on the unit is grounded in this value. Hence, you'll notice that the calculator yields one set of numbers when the flash is used raw and an entirely different set with the wide/diffusion panel attached and yet another for the telephoto panel on the flash

head. If you mistakenly use the wrong set of data, you may get an exposure error. With TTL flashes that feature an LCD panel, what you find instead is a graphic display of the distance the flash will reach.

As with any rating, you have a choice of using or overriding the GN. If the flash consistently fails to deliver the correct exposure, the GN may be off (manufacturers' testing procedures vary and may not reflect your usage of the flash). Make a series of bracketed exposures from a fixed distance, say 10 feet for simplicity, and see what works and what doesn't. Then apply that correction to all future flash exposures with this strobe—under similar conditions. Keep in mind that the GN rating is based on a flash unit used in a normal-size room, with fairly reflective walls. Consequently, when shooting in wide-open spaces or outdoors at night with autosensor, as well as manual, flash, increase exposure by 1/2 to 1 full stop—and do this solely when basing exposures on the guide number (not with readings obtained with a flash meter).

Quick Tip: Flash Reach

At any given ISO, the *f*-stop determines the reach of the flash. Specifically, you can use small apertures to limit the throw of light to the subject to keep a distracting backdrop dark and unobtrusive, obscure background shadows, and keep stray light off reflective surfaces behind the subject. So, remember:

Small Aperture = Limited Flash Reach

I photographed this rooster with a shoe-mount flash in Shutter Priority mode (1/200 sec.) and Program mode (1/60 sec.), with the Canon EOS 5D automatically setting the flash sync speed. In the first frame, the flash takes over, illuminating everything and casting a distinct shadow. In Program mode, the flash plays a supporting role as fill, producing a less imposing shadow than in the first shot.

Bounce Flash

Typically, the flash head on a more capable shoe-mount (and handle-mount) strobe rotates and tilts. This feature allows the main body of the strobe to remain in a fixed position while you employ bounce lighting. When using autosensor flash, this has the added benefit of keeping the sensor trained on the subject for more accurate flash output.

Bounce flash tends to spread the light out in depth over a broader area, making it useful for crowds and things of that nature. But its primary purpose is to produce a less harsh light or, more to the point, a soft and inviting light, especially with portraits. With that, however, may come undesirable shadows, such as deep pockets under a person's eyes when the light is bounced off the ceiling, and it may give the eyes a dead appearance, owing to the lack of catchlights. The kicker panel on many newer strobes can help alleviate this problem and possibly also fill in the shadows. You can also attach your own kicker card to the flash head—for instance, a white index card positioned behind the flash head and secured with a rubber band or, alternately, a store-bought kicker panel. Otherwise, a fill card or fill light may be needed.

Bounce light also picks up colors from the reflecting surface, so it's generally good to avoid anything other than white or off-white walls and ceilings. What's more, heavily textured surfaces and high ceilings are inefficient for bounce, resulting in considerable light loss. Mirrored surfaces are other things to shun, since the light will be hard and specular, instead of soft and diffused—unless such surfaces are used to fill in small, finite areas (commercial shooters often use tiny mirrors as more directed light sources in place of white cards). Finally, door frames, archways, vaulted ceilings, chandeliers, and ceiling fans can pose obstacles to bounced overhead lighting, so watch for them.

When you bounce strobe, the GN changes dramatically, and flash calculators generally get tossed out the window: You can roughly expect a 2-stop loss of light. Since TTL flash reads all light through the lens, it doesn't really matter where the flash head is pointed or what's attached and modifying the light. With autosensor flash, the sensor must be pointed in the direction of the subject to avoid an exposure error. Manual flash operation would be best served with a handheld flash meter in incident mode to avoid errors and extensive bracketing.

STRENGTHS: Softer, more flattering light for portraits; avoids harsh shadows behind subject; may prevent glaring reflections and red-eye; extends reach of flash.

DRAWBACKS: Deep shadows forming in the face, especially from overhead bounce; lack of catchlights gives eyes a lifeless look (so use a kicker panel); requires larger *f*-stops to compensate for light loss; reflective surfaces may color the light; vaulted ceilings, fixtures, and doorways may contribute to a loss of light.

Electronic Flash: A Word of Caution

A flash unit's capacitor stores a high-voltage charge. Under ordinary conditions, it is perfectly safe to work with any strobe. However, moisture and wet conditions should be avoided. When water comes in contact with the electrical contacts on the flash, the unit may short out. Always keep the flash turned off in the rain, and better yet, keep it tucked away safely in your camera bag in wet weather—there may still be a stored charge in the unit even when switched off. Most important, a wet flash unit can be hazardous and lead to personal injury.

Red-Eye: A Glowing Concern

Most cameras and flash units these days provide a means to combat that intrusive red-eye phenomenon. The question is, How effective is red-eye reduction in a camera really? People posing for pictures find it annoying, frankly, and it takes away from the spontaneity of the moment. The biggest problem with red-eye reduction is that it wastes precious time. By the time the flash has gone through all its red-eye-reducing machinations, most often as one or more pre-flashes, that fleeting expression is gone, the attitude has changed, or the subject has moved on. There are also fixes written into the camera's software, but the efficacy of these methodologies has yet to be proven—and, fact is, they take time to implement and must be done in camera.

Red-eye comes from light originating on-axis with the lens—in our case, on-camera flash—that is then reflected off the retina (the back of the eye with all the blood vessels, hence the redness) back into the lens. Oddly enough, this can even happen with people standing in the periphery, so the central figure might be free of this phenomenon while others are stricken with it. Generally, the problem is exacerbated in darkened environments, which lead to wide-open pupils (the more dilated the pupil, the more pronounced the effect). Red-eye is said to be more common with fair-complexioned and blue-eyed people, and babies, but that's not a given. Oh, and vampires—but on Halloween, use the effect to advantage. Red-eye is almost certain to strike someone staring wide-eyed straight into the lens/flash, but each situation is different and not entirely predictable. Sometimes red-eye is intense, other times mild.

With animals, red-eye isn't always red. It can appear as a greenish or yellowish glow. In fact, in many animals—notably those with good night vision—it doesn't stem directly from light reflected off the retina. Instead, light bounces back off the tapetum lucidum, a reflective layer behind the retina, contributing to the color we see. From a distance, the eyes may appear white. On the other hand, the eyes of reptiles, amphibians, and fish generally exhibit a glazed look when flash light hits them directly.

Practical Steps to Red-Eye Reduction

There are several expedient ways to reduce and even eliminate red-eye:

- Use bounced lighting.
- Employ off-camera flash (held aloft and to the side, and angled down toward the subject).
- Feather the light (meaning the light, usually off camera, is aimed away from the subject so that only the edge of the light catches the subject, producing a soft but weak light).
- Increase ambient light levels (where practical) so that the pupils are constricted, producing a smaller entry/exit point.
- Avoid the built-in flash with people in dimly lit surroundings whenever possible; very small shoe-mount strobes are no better.

Bounce flash helped capture this quiet moment without any harsh shadows or red-eye intruding on the picture. A kicker panel on the flash alleviated the deep pockets in the eyes.

Advanced Flash Exposure Control

TTL flash has opened up a new stream of photographic consciousness, so much so that the older autosensor flash pales in comparison and has largely been relegated to a passing phase that we mention only briefly. (Having said that, autosensor flash appears to be making a resurgence—when something works, it never completely goes away.) Manual flash, on the other hand, continues to be as viable as TTL, while relegated more to studio and professional applications. So from this point on, our exploration into the world of flash photography will focus primarily on TTL and, to a lesser extent, manual flash. TTL flash offers many features that set it apart from the crowd. These features may be found on the flash itself or on the camera, and sometimes both—at which point the story gets even more interesting.

In contrast to the previous rooster shots, this time I photographed the rooster in Aperture Priority mode at 1/4 sec. (the camera defaults to slow sync mode unless set to the higher flash sync setting). Now he appears to be dancing in a blur of motion, thanks to the slow exposure (and camera movement).

Flash Exposure (FE) Lock

Actually a function of the camera, flash exposure (FE) lock does for TTL flash what AE lock does for ambient light photography, correcting potential flash exposure errors before they happen by keying the flash output to an important subject area. This way, regardless of whether the person is wearing a black wool coat or standing amid fresh snow or sitting before a glowing sunset, FE lock can help bring out the necessary facial features with flash without affecting background tonalities.

Once you hit the FE lock button on the camera, the flash emits a short blip that the camera uses to determine the flash component of the exposure. That reading is then stored, and you're free to recompose the shot and take the picture, knowing both the subject and background will be correctly exposed. Note: On some cameras, once the flash is switched on, the AE lock button may effectively convert to FE lock, whereas on other models, it may be a separate and distinct function. Remember that any and every adjustment to flash output affects only the flash portion of the exposure.

Flash Exposure (FE) Compensation

As with autoexposure compensation on the camera, flash exposure (FE) compensation with TTL flash corrects for misleading tonalities and brightness values, especially strongly backlit subjects—but without affecting the ambient portion of the exposure. In contrast to FE lock, this feature may be found on both the camera and the flash. You can use FE compensation and FE lock together, combining their effect. Note: When FE compensation is set on both camera and flash, the flash setting may take precedence.

Flash Exposure (FE) Bracketing

Analogous to autoexposure bracketing for ambient light, flash exposure (FE) bracketing lets you bracket TTL flash exposures—or, more precisely, the flash portion of the exposure. However, this is solely a function of the flash unit (on select TTL strobes). Use FE bracketing in tricky or uncertain situations as insurance.

The sequence may be predetermined by the camera system: three exposures in a given order. It may be necessary to disengage sequential shooting on the camera and set the drive to single-frame mode to give the flash time to recycle. Once the bracketing cycle is completed, FE bracketing may automatically cancel. FE bracketing can be used together with FE compensation and FE lock.

Slow-sync flash at 1.6 seconds created an otherworldly effect: Long enough to burn in the darkened sky and surrounding street, it also recorded as a double image—with the flash exposure superimposed over the ambient exposure. The flash-sync shot (bottom) appears dull by comparison, although well exposed.

High-Speed (FP) Sync

Another means for controlling fill with TTL flash is to set a faster shutter speed on the camera than the recommended flash sync setting. This applies only to focal-plane cameras (the typical film and digital SLRs) and flash units that support this high-speed, or FP, sync feature, with the setting made on the flash unit. When activated, high-speed sync lets you shoot at any shutter speed up till the limit available on the camera. What this effectively does is reduce the amount of light reaching the subject.

So, why take this approach? Normally, if you use a large *f*-stop with flash, the light will reach farther back while limiting depth of field. Use a smaller *f*-stop and the throw of light is more limited, while at the same time depth of field is increased. By the use of a faster shutter speed, high-speed sync permits you to both limit the throw of light to the subject area and still use a large *f*-stop for selective focus around the subject.

High-speed sync can also be used to freeze motion of anything moving in the background while acting as a fill light, provided the shutter speed is set high enough. Either way, set the camera to Shutter Priority or manual mode so that the full range of shutter speeds is at your disposal.

Slow-Sync Flash

Often an optional setting on point-and-shoot cameras, slow-sync can be applied to any SLR by simply setting a slower shutter speed setting (long enough to record the ambient light as part of the exposure) than recommended for flash sync. Usually, you engage slow-sync flash when you want to show both the subject and the background in the same shot, such as a person standing in front of an evening skyline, or to capture movement along with a sharply defined image on the same frame, such as a ballerina doing a pirouette under the lights. All it takes is flash and an exposure setting sufficient to record the ambient low light levels. The camera can be set to any shooting mode that will deliver the desired result. A tripod may be necessary.

Oddly enough, under bright ambient conditions, subject movement might even be captured at the flash sync speed, especially if it's something like 1/60 sec. What you may get is a ghostlike shadow behind, or surrounding, the subject if there's even the least amount of movement by either the subject or the camera. Fashion photographers often use this to make a model stand out even more strongly on a beach setting, for example.

Second-Curtain Sync

We've all seen flash pictures of moving cars and people walking, and in each case, the subjects appear to be trailed by a blurry ghost image. That phantom image is caused by the flash firing in sync with the opening of the shutter curtains. This is referred to as *first-curtain sync* (or sometimes as *leading-curtain sync*). It's the normal flash mode of operation.

If you delay the flash, causing it to fire in sync with the closing of the shutter curtains, you reverse the effect. This is called *second-curtain sync* (or *trailing-curtain sync*). The result is a naturally trailing blur. (Note: When a TTL flash provides this setting, it should be activated on the flash unit itself, as this status is communicated to the camera, overriding the camera sync setting.)

The length of the blur depends on the shutter speed used. In order to focus attention on the primary subject, it may be best to employ selective focus, softly blurring out the background, but perhaps not to the point where it conflicts with the blur created by the moving subject. Artistic preferences and the type of movement being photographed will always dictate the approach you take.

Essentially, all you need is the same set of conditions you used with slow-sync flash, with one added twist: activating the second-curtain sync setting. Again, a tripod may be necessary. (Note: It's also possible to simulate the effect in a digital image, with the right software or plug-in. However, it should be fairly subtle, or it will look fake.)

Given the low level of lighting, the only reasonable way to capture these talented folk dancers in Funchal, Madeira, was to employ flash slow-synced to the camera. To get the trailing motion from the available-light portion of the exposure, I employed second-curtain sync.

Fill with TTL Flash

Simply using AE compensation to increase the subject exposure and prevent it from sinking into a drab gray miasma is not always the solution, because you are also increasing the background exposure at the same time and likely compromising the tonal integrity of the background in the process. The way around that is to use fill. A collapsible reflector can be used to throw a little more light onto the subject and soften shadows, but only when contrast is not excessive.

The more prudent solution may be *fill flash* (also known as *flash fill*), which also allows you to leave the background tonalities largely intact. And that is exactly what you're doing when you key FE lock, FE compensation, or FP sync to, say, a portrait subject standing in front of a colorful sunset or a brilliant blue sky. You are striving to give the person the necessary flash exposure, while maintaining the ambiance of the colorful supporting vista. All the while, the camera remains in one of its autoexposure modes.

An extension of this approach is to set the camera in manual mode. Then, read the background exposure (preferably with a handheld reflectance meter), set the *f*-stop provided by the meter on the camera, and set the appropriate flash sync speed (as set on the handheld meter) on the camera, as well. Next, target the subject with the camera lens for a TTL flash exposure, with flash on or tethered to the camera. The flash can still be used in TTL flash mode, even with the ambient camera exposure set manually. Employing FE lock (targeting the subject) will help.

With backlighting, we often aim for the flash exposure to be less than the ambient exposure to give the picture a more natural feel. Some cameras employing TTL flash, either built-in or external, automatically reduce flash output accordingly. We can usually defeat this setting, or otherwise get around it with the controls at hand, if the reduced fill doesn't meet our needs.

To restore a bright background tonality with TTL flash, a little exposure compensation may also be called for—as much as +1 stop (don't take it too far or you may wash out the bright tonalities and thin out the colors).

Fill flash goes beyond backlit portraits. In the studio or on location, the lighting may not adequately cover the set. Additional lights are brought in as fill, where bounce cards and collapsible reflectors won't do the trick.

Off-Camera and Studio Flash

Now that you've had your fill of on-camera flash, let's move on. Will you need that flash meter? Not if we stick to TTL flash, but keep it handy. We'll begin by working with one flash off camera. More specifically, we'll start with a very routine form of off-camera flash involving a flash bracket and conclude with a brief discussion of studio lighting.

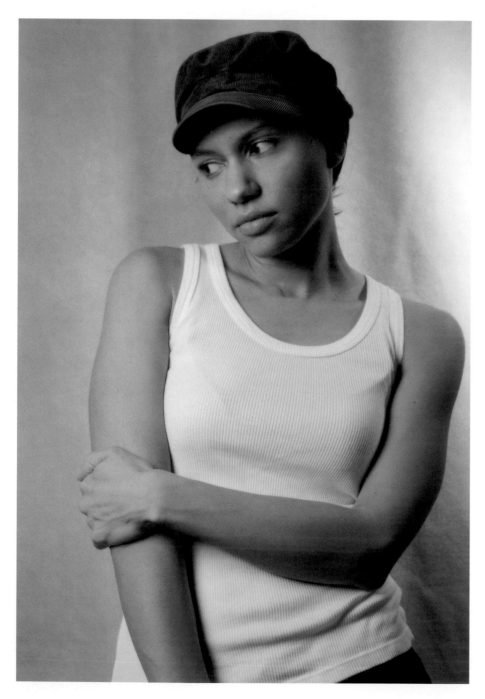

Studio portraiture requires you to take a studied approach to the subject and the lighting. To capture this young woman's beautiful features, I positioned one studio strobe inside a softbox to the left, with a second strobe aimed at the backdrop from the right side of the set. And to fill in shadows on her face and to lower contrast, I added a collapsible silver reflector to her left.

X-Sync but Not Extinct

Flash and camera need to talk to each other. If the strobe can't be seated in the hot shoe, or if there's no hot shoe to begin with, then the two need another way to communicate. Traditionally, that was done via the camera's X-sync (or PC-sync) terminal and a connecting sync cord (or PC cord). The sync cord plugs into the flash at one end and into the camera's X-sync terminal at the other.

A few inexpensive flash units come with a permanently attached sync cable—not very practical for the long haul, since you can't replace the cord if damaged. Inexpensive PC cords may come loose, but better cables use some kind of locking mechanism that works in tandem with a locking mechanism on the camera. When working with dedicated TTL strobes off camera, a special cable is used instead of the PC cord. This cable connects to the camera at the hot shoe via a dedicated hot foot or by way of a dedicated multipin terminal. And should the need arise, extension cords are available.

While found on more advanced film and digital models, the X-sync terminal is not part of many of today's amateur electronic SLR cameras. Fortunately, a hot shoe adapter is often available as a viable replacement. X-sync becomes especially necessary when working with studio strobes, and it may be possible to use one flash that is seated in the hot shoe and another, operating in tandem, connected to the X-sync terminal. A valid X-sync setting (or slower) must be set on the camera.

The meerkat and this desertlike setting (at the Prospect Park Zoo in Brooklyn, New York) required an increase in both ambient exposure and flash exposure. I had one TTL flash seated in the camera's hot shoe (as a fill light) and a second TTL flash (the main light) attached to a tabletop tripod that stood on the shelf outside the enclosure to the left of the animal. I set the remote flash to a 105mm zoom setting for a tight beam of "late day" light with a corresponding shadow falling to the right. In contrast, I set the on-camera flash (which triggered the main strobe) to a wide zoom position to help reduce its intensity and prevent secondary shadows.

Going Wireless with TTL Flash

Quite often, I prefer to shoot flash without being hampered by sync cords of any kind. I might want to hold the flash aloft, for a better lighting angle. Or I may even place it on a tabletop set and leave it there, gaining the ability to move around freely with the camera. Or I may just want to avoid all those wires that get in the way when multiple strobes are employed.

Many of today's TTL flash units come equipped with a built-in wireless transmitter and/or receiver. It's actually an infrared triggering system. Each flash is, respectively, designated as *master* (transmitter) or *slave* (receiver) with the activation of the appropriate function switch. One flash sits atop the hot shoe, forming a direct connection with the camera, and acts as the transmitter or triggering device, while a second flash sits anywhere within range of the transmitter. As soon as the shutter button is pressed all the way, the on-camera flash fires and so does the remote flash. A few cameras even provide for the built-in flash to be the triggering mechanism. This chain of triggered strobes can encompass enough lights for practically any studio situation.

Having to schlep around two strobes just for wireless flash isn't always convenient or desirable. Not to mention, the triggering flash is often a more expensive model. A more economical and more compact alternative is to use a special infrared transmitter designed to work with your TTL flash system. This transmitter essentially looks like the part of the TTL flash with the red plastic filter over it, except that this module also plays host to all the controls.

To prevent inadvertently triggering other flash units (or to limit triggering to specified strobes), the triggering device—whether the separate transmitter or the triggering strobe unit—can be set to one of several channels, or frequencies. The receiving flash units are set to the same frequency, so they fire in sync. (Note: Wireless systems from different flash manufacturers may be incompatible with one another, even though specifically designed for your camera. Each works on a specified set of frequencies.)

This fine china is very bright and reflective—and posed a challenge in terms of lighting and exposure. I placed the tableware inside a diffusion housing to prevent glaring reflections. The lighting consisted of a combination of window light from the right and flash on the left. I used incident metering (the meter is in position near left) to get the necessary exposure that would not burn out the predominant light tonalities.

Studio Lighting

We often think of studio lighting as expensive and overly complicated. That isn't necessarily the case. You can start small and work your way up. Most studio lighting systems are modular to begin with, and even when they're not, there's a ton of stuff you can add to shape the light to your needs. Besides light stands, you may want to add photographic umbrellas or softboxes to produce a softer light, barn doors to control spill, and lighting gels for color balance or effect, among other things. Fortunately, many studio lights come in kits complete with all the accoutrements you'll need for starters, and for some time to come.

While an increasing number of professional photographers may rely on TTL flash in the studio, the vast majority look to robust studio flash systems to deliver the power, flexibility, consistency, and, most important, control required on a shoot. When buying studio strobes, you can choose between monolights and powerpack systems. Monolights are self-contained, housing the flash head, power circuitry, and controls in one integral component and are the easiest studio strobes to work with, and the most economical. A powerpack is the generator and central control unit that drives the accessory flash heads that are plugged into it Powerpack systems are generally more complex and expensive to run. Most studio strobes are driven by AC, but some also use battery power.

If studio strobe sounds too expensive or too complicated, other options include hot lights (tungsten lighting) and fluorescent lighting, which is becoming increasingly popular, especially with digital imaging. But that same list of accessories may still be needed. The only difference: You won't need a flash meter with tungsten and fluorescents.

I photographed this attractive young woman in a photo studio, again employing flat-panel lighting, only with a small but significant twist: I had one small flash behind her as a hair light, with the main light coming in on her from the right. Then I added a fill card in front.

Admittedly, I ate the first one before I had a chance to photograph it, so the second time around, I prepared the sundae and immediately placed it inside a diffusion housing to prevent both reflections on the glass from the lighting and my succumbing to temptation. I used two flat-panel studio strobes—they output a softer light than traditional studio strobes.

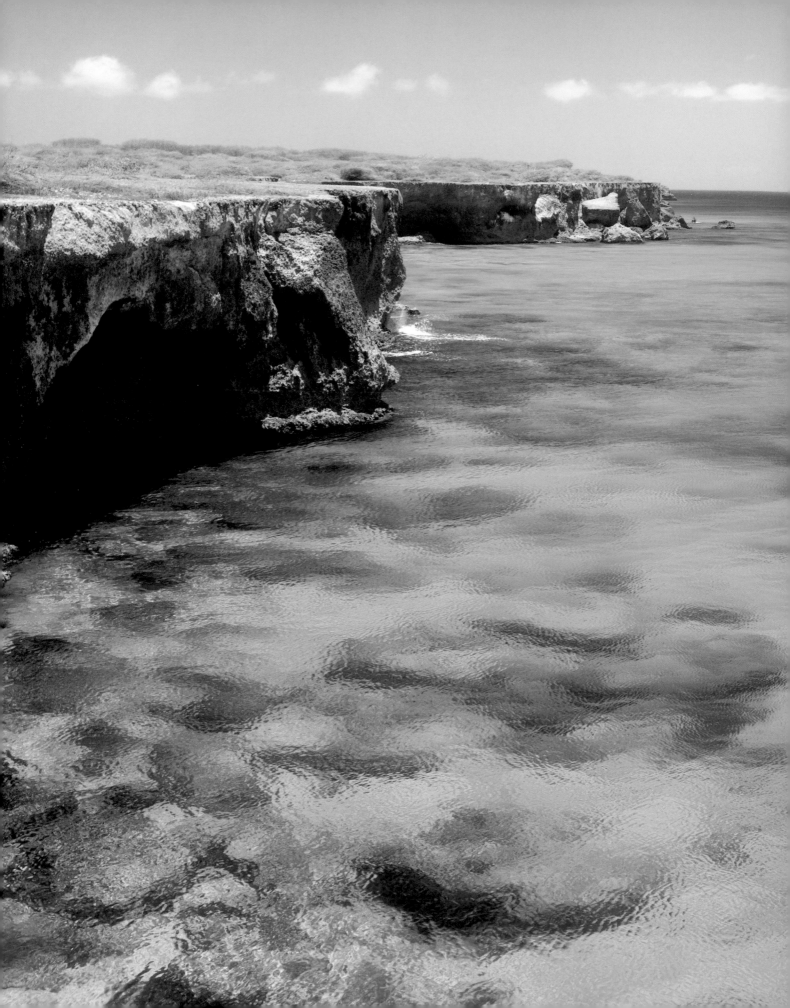

FILM &
DIGITAL MEDIA

The road to a good exposure on film and a successful digital image may meander in different directions, but the two paths are never really far apart for very long. In fact, they run parallel much of the way, often crisscrossing en route to their final destination as the photograph we view on a screen or hold in our hands. While we may apply different criteria when shooting film or digital, we still have to follow the basic precepts that govern exposure with any medium.

Working with Film

The films we use and the conditions under which we take pictures play a major role in the exposure techniques we employ. The choices of color or black-and-white (silver or chromogenic) film and the final medium by which we choose to view these images, whether as transparency or print, play an equal role in guiding exposure. Beyond that is processing, another major variable. In fact, we might even choose to process film in the "wrong" chemistry (or *cross-process*, namely to process negative film in chemistry designed for transparency/slide film or vice versa, transparency film as negative) to create an unusual blend of colors.

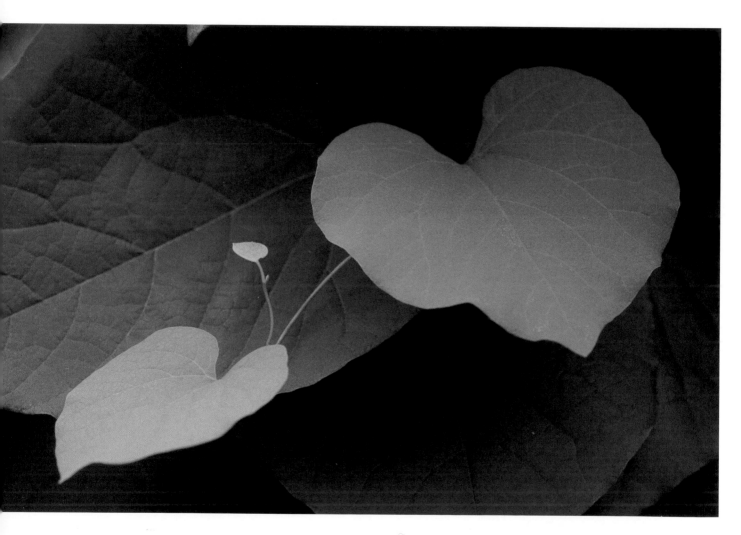

Color slide film does an excellent job of capturing the subtleties and nuances that are in this scene. I still get a certain pleasure from slapping my slides down on a light box and reviewing them.

Film and ISO

Photographic emulsions are given an ISO rating by the manufacturer as a measure of the film's light sensitivity (or speed). You can choose to abide by this rating or manually override it. However, once the film speed is set on the camera, it should remain in effect for the entire roll of film.

Setting film speed may be an automatic function of an electronically governed camera with suitably encoded consumer films. Many older or largely mechanical cameras and some special-purpose films still require manual film speed settings. And of course, handheld exposure meters require you to input the effective ISO value, as do non-TTL shoe-mount and handle-mount strobes.

The less sensitive a film is to light (or the slower it is), the smaller the ISO number. The more sensitive the film to light (or the faster it is), the higher the ISO number. ISO ratings of 400 and above are considered "fast"—that is, they are very sensitive to light by comparison and, relatively speaking, require less light to make a usable exposure. These films also tend to exhibit a grainier quality. The grain clumping tends to obliterate fine detail, at times making it difficult to determine if the image is actually tack sharp. Modern films are much less grainy than their predecessors, to the point where graininess may no longer be objectionable. However, graininess does have its benefits, the most noteworthy being that it imparts a certain texture to the picture, which might be viewed as quasi-pointillist. Films rated below ISO 100 are said to be "slow" and generally exhibit a tighter grain structure. Some people are sticklers and define *slow* films as ISO 50 and below.

General Speed Rating Usage Guidelines

WHEN TO USE FAST FILM (ISO 400 AND HIGHER)

For low-light photography; stop-action photography; wildlife; available-light close-ups; with long lenses when camera shake may be a potential problem; for coarser textures, to give the picture a quasi-pointillist effect or a softer mood.

WHEN TO USE MEDIUM-SPEED FILM (ISO 100 TO 200)

Use ISO 200 for general purpose; travel and candid shots of people; indoor parties photographed with flash. Use ISO 100 for studio portraits.

WHEN TO USE SLOW FILM (ISO 64 AND LOWER)

Outdoors in bright light; for scenic views and architecture, where fine detail is often beneficial to the picture; macro and close-up exposures made by electronic flash; still life and tabletops with studio lighting; panned shots and other blur effects.

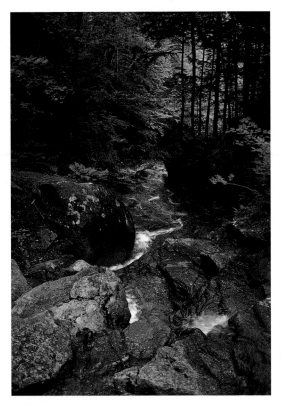

Films in the range of ISO 25 to 64 are great for architecture and scenic views. A tripod may prove helpful, as in this picture of a cascading stream in New Hampshire.

Film Considerations: Emulsion & End Use

The film emulsion batch itself is an important factor. Film emulsions vary from batch to batch. To produce consistent results on any job or project and eliminate this variable, it's important to stock up on enough film from one batch for an entire project. Batch differences account for film speed differences and color shifts.

One other thing to consider is the end use. Something gets lost in translation from film to print (which is also true of digital). The tonal range in magazines and newspapers is compressed, leading to a potential loss of detail in high-contrast scenes that might not be as evident in a glossy photographic print. Consequently, you may have to light and expose with the end use in mind, making choices that may lead to less dramatic results—but results that will print better. Additionally, when shooting film for print publication, film usage should be consistent—same film type, same emulsion batch—to avoid problems with color balance later on and to maintain an unwavering texture (vis-à-vis film grain). Consistent film usage will give slide shows an air of uniformity and contribute to a smoother workflow when film is scanned.

ISO 400 films are well matched to the demands of long lenses and wildlife photography. Additionally, sometimes you need them to deal with low-light situations or simply for the grainy texture they impart.

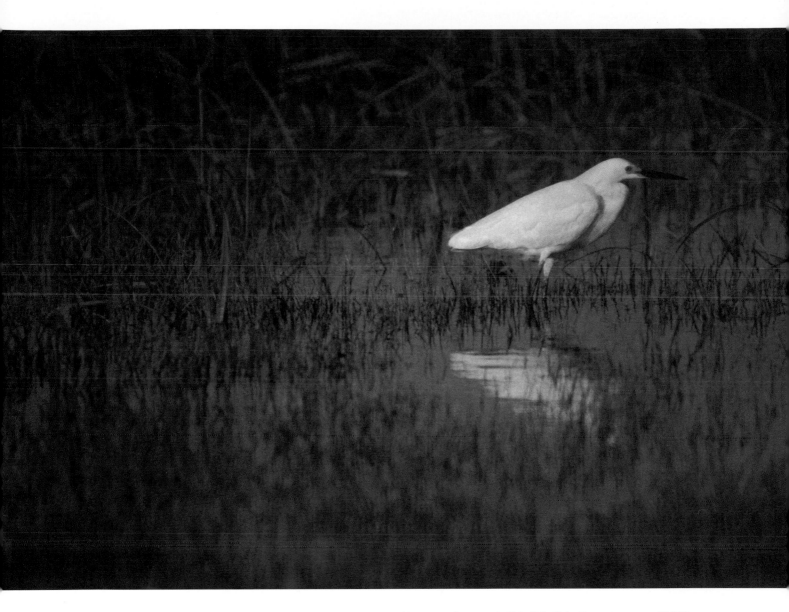

You can often push ISO 400 slide films 1 stop to EI 800 (and sometimes more) without undue effects. Pushing the film 1 stop helped with this handheld telephoto exposure of a snowy egret. Even with a tripod, windy conditions would have made it necessary to shoot at the fastest possible shutter speeds to prevent blur.

Professional Films vs. Consumer Films

Today's films are sold to two different markets: the professional photographer with more exacting demands and the consumer, who often leaves a roll of film sitting idle for months before getting it processed. Films labeled "professional" have a short expiration period, and are designed to be used fairly soon and refrigerated when not used or if not processed immediately. In addition, the stated film speed rating for a particular film batch may be more accurate, as the film is designed to meet tighter standards.

More importantly, color balance, as well as film speed, is optimized on professional film when used no later than the expiration date. Film emulsions change with time. Color responsiveness in particular shifts. If the film sits around past its expiration date, it may lose speed, as well. Refrigeration retards these shifts. As with food, these films will leave a better taste in your mouth when used as directed.

Consumer films give you much greater freedom to use them at will, with expiration dates far down the road. These films don't mandate refrigeration, although I'd still keep them in the fridge in case your home gets uncomfortably warm or humid. Consumer films aren't optimized for color balance or film speed, so don't expect exacting results. In fact, they may provide considerable leeway when exposed under the "wrong" lighting (meaning, lights of the wrong color temperature for that film) or with less accuracy.

My white cat stood near the window, playing her version of hide-and-seek. I didn't mind the coat washing out on the side of her that was facing the window. What was important was her facial expression, and that I managed to capture.

Keep Your Cool

If you're heading for the tropics, keep film cool until you use it, carry silica gel (desiccant) to keep it dry in your camera bag, and open the padded compartment holding film only as long as absolutely necessary. The padding serves as insulation and, in a good camera bag, will keep film cool for a reasonable amount of time.

Also, if film is kept in the fridge, whether at home or away, it needs time to acclimate to room temperature prior to use. Allow at least a half hour. The best method is to intermittently hold it in your hand. There should be no condensation on the film canister when you're ready to load film in the camera.

Note: Kodak advises that you not freeze processed film. I personally don't even like to freeze *unprocessed* film, although some photographers disagree. To me, freezing and refreezing unprocessed film is the same as refreezing food: Some foods seem to lose their taste and consistency. Besides, the wait for the film to thaw seems endless, assuming you know how long to let the film sit at room temperature in the first place.

Color Film: Negative and Slide/Transparency

Color negative emulsions are far more forgiving when it comes to exposure than slide emulsions, especially since the end medium—the print—has built-in safeguards, as well. However, there's no coming back from a really bad exposure even in the printing stage, and you should give it your best shot in camera from the get-go.

These days, color negative films are promoted not only for their usability under varying lighting conditions (especially fluorescents and mixed lighting), their tighter grain structure at higher film speeds (compared with slide films of the same speed), and their almost unfaltering skin tone rendition, but for their ability to scan well.

Since the color slide, or chrome, is often the final image we see when shooting slide film, exposing for slide film requires diligence and practice. Still, there's a lot to be said for shooting transparency film. Once the film is developed, you see exactly what is in the picture—from highlights to shadows—and when exposed under lighting of the correct color balance, this medium shines like no other, especially when viewed on a light box or with a slide projector. Scanning from slides is usually carried out on a film scanner, as is normally the case with 35mm negatives. Some film scanners will also handle larger-format materials, and an increasing number of flatbed scanners will scan film. The appropriate adapter must be used, followed by software settings that correspond to the film type.

Both negative and slide films may come in emulsions designed to deliver punchier results than comparable films at the same film speed. Designated "high contrast," such films are best suited to scenic views and architecture than to fashion or portraiture. There's also a variety of slide film aimed at reproducing warmer skin tones, obviously targeting fashion work. While this may seem like a film to be used for portraits and weddings, those markets tend to favor prints as the end product, hence the use of negative films. Color films may also be marketed to reproduce "vivid" or "natural" colors, respectively exhibiting medium and low contrast, each targeting certain applications or to suit a photographer's taste. A few print films come in both warm-tone and standard varieties, respectively suited to portraiture and everyday shooting. Certain films have a reputation for their colors and vibrancy without any labels attached, but personal experience with any emulsion should always be the final guide as to its use.

Convention has it that color negative films are designated with the word *color* in their names, and color slide films with the word *chrome*. That is not always the case. If the film is new to you and the name unfamiliar, the best indicator to look for is "C-41" for color negative process and "E-6" for slide film process. Select films, such as Kodachrome, employ a unique commercial process, but the "chrome" in the name in this instance clearly defines this emulsion.

One more important point: In general, negative film tolerates overexposure to a greater degree, up to 2 stops, possibly tolerating up to 1 stop underexposure, if that. Slide film has a higher tolerance for underexposure (1 to 2 stops), but very little toward overexposure (maybe half a stop). This exposure latitude is as much a function of the film emulsion as it is of outside factors, all revolving around contrast. Scanning may revitalize film exposed poorly, but it can't bring the dead back to life.

Color Film: Daylight vs. Tungsten

Each color film is optimally designed to be exposed by a certain type of light or, more correctly, by light of a specific color temperature. Popular usage has defined two types of color balance in film: daylight and tungsten. The differences are, literally, like day and night. Daylight-balanced film works best under lighting that is 5500 K; tungsten-balanced film is at its best under 3200 K light sources. Each film emulsion, or, specifically, the film emulsion layers, will respond to light of each color temperature in a more or less predictable fashion. When film is exposed under other than the designated color temperature,

these emulsion layers start to act up, as if they weren't being fed properly: Some become sluggish and others hyper—hence color crossover and the resulting color casts that we see.

Ideally, daylight film should be exposed on a sunny day, with a smattering of clouds in the sky. That defines 5500 K. Early and late in the day, when the sky is overcast or you are in shade, the color temperature shifts considerably. That's why sunsets, for example, take on their orange-red brilliance and scenes shot on a gloomy day have that characteristic blue cast. When daylight film is exposed under tungsten illumination or household incandescent lighting, the resulting pictures exhibit that characteristic orange tinge.

Electronic flash was designed to deliver a color temperature of 5500 K, which makes it ideally suited as the illuminant for daylight color film. That number, however, is rarely attained, with some flashes operating at color temperatures as high as 6000 K. At 6000 K, these light sources produce noticeably blue results on daylight film. Gold-tone flash tubes are designed to produce more natural or warmer results.

Tungsten film (normally designated by a *T* in the name, such as 64T) is designed to be exposed under halogen light sources. When tungsten film is exposed under daylight or electronic flash, a blue color cast results. When shot under household incandescent lighting, the images take on a warmer glow, but not nearly as pronounced as with daylight film.

The ISO rating for each film also takes into account that it will be exposed under the correct color light source. When the lighting deviates, the film speed deviates, as well. Film data sheets normally provide the film speed setting with corrective filtration in place for different light sources.

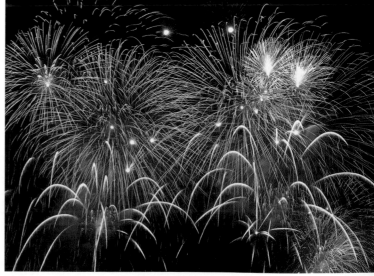

The typical shot of fireworks on daylight film (left) exhibits "hot" colors. Film balanced for warmer light sources lends a different, cooler quality to fireworks (right). If you choose a more neutral color balance, this, in my opinion, is the better alternative, compared to using filters with daylight film.

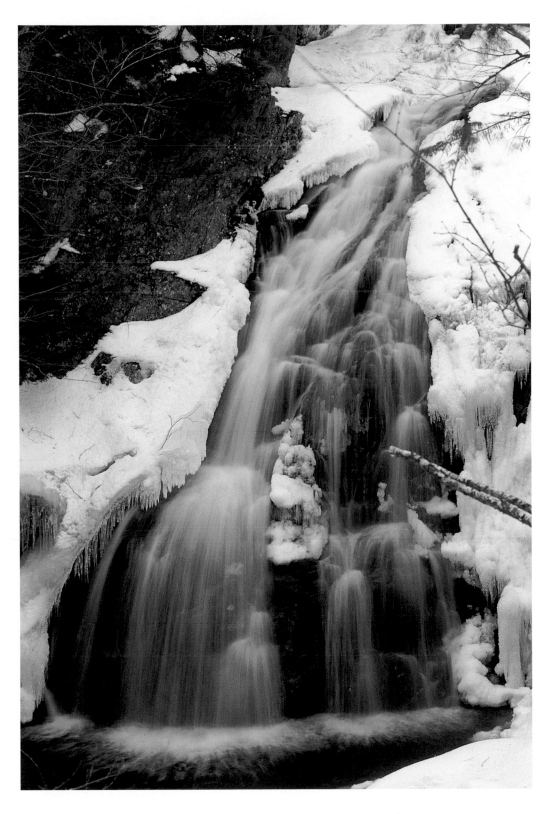

With color slide film, there's no auto white balance (as with digital files) or color corrections in the final product (as with negatives and prints), so this scene takes on a bluish cast. It happens to work for this waterfall. Give too much exposure, however, and the snow would begin to wash out and distort in color.

A skylight filter removed the bluish cast that results when shooting scenes such as this, in overcast light or shade. Note how just a drop of underexposure—perhaps as much as 1/2 EV—helped maintain the texture in the ice.

While this image of Washington's Pacific coast is correctly exposed for the overall scene, there are parts in shadow. Put the slide on a light table or project it, and much of that detail will become visible.

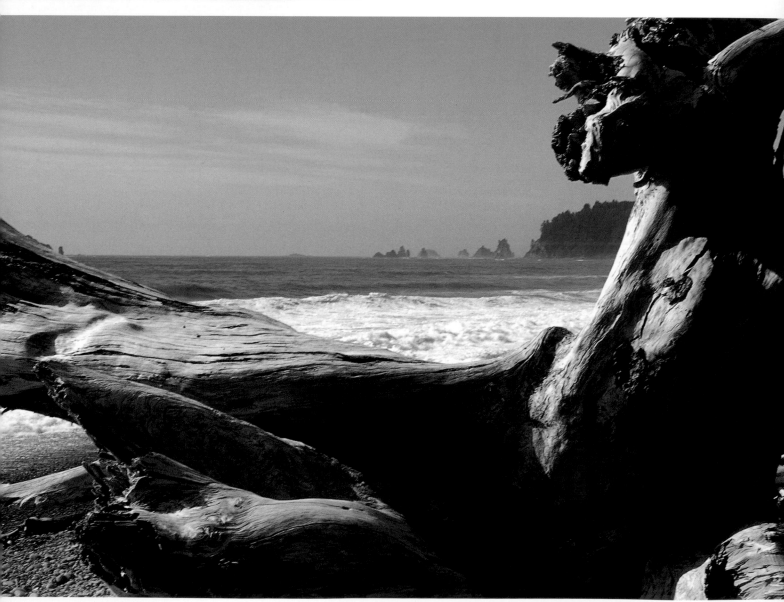

Black-and-White Film: Traditional and Chromogenic

Black-and-white photography will never go away. Photographers devoted to this art form are impassioned by the medium, from the moment they use a spot meter to define the tonal range for the exposure. This passion extends to the processing of the film and the choice of papers and tonal options, culminating in the final black-and-white print. Many black-and-white film photographers are ardent students of Ansel Adams's Zone System. I am not one of these, but then again, black-and-white was never my medium of choice.

There are also chromogenic black-and-white films, which are dye-based and processed in the same color chemistry as color negative films. Chromogenic black-and-white film lacks the intensity of silver-based black-and-white emulsions, but it's interesting to see the color tinge, anything from cyan to sepia, in prints from a chromogenic negative coming out of an automated processor.

While digital cameras, printers, and software may simulate black-and-white film in capture and printing, the resultant images lack the depth of a fine-art black-and-white print made from panchromatic black-and-white film, especially with select papers and processes, such as platinum printing. However, some of that visual quality may be restored by digitally finessing the image and with the proper choice of printer, ink sets, and papers.

Whether conventional (silver) or chromogenic (dye-based), the contrast, tonal range, and graininess of a black-and-white film will determine its use. Generally, the slower silver emulsions find application in architecture, whereas the fast emulsions are noted for their popularity in photojournalism. Chromogenic film has the advantage that it can be exposed over a range of film speeds and exposures without necessitating push- or pull-processing or suffering serious under- or overexposure, hence its wider applicability. It's an all-purpose solution for the black-and-white enthusiast who doesn't have access to a black-and-white lab. Conventional black-and-white negative films have a greater tolerance for overexposure—up to 2 stops—than for underexposure (half a stop, at best), varying with the film product.

Characteristic Curves & Exposure

As light reaches the film emulsion, it builds up density in varying amounts, corresponding in some fashion to scene tonalities and brightness levels. The range of densities reflects the highlights at one end and shadow values at the other, with a core of gray levels in between, holding it all together, as it were.

THE CHARACTERISTIC CURVE

The corresponding densities can be pictured as an S-shaped curve. This "characteristic curve" differs from negative to slide/transparency film and from one brand or type of film to another, and even from one film batch to another. There is a minimum exposure level required before anything is visible in the processed film and a maximum level before detail is lost or obscured. (Even in digital capture, we like to very broadly think of the sensor as recording light levels and tones in terms of a characteristic curve—or more correctly, a *tone curve*.)

To complicate matters even further, within one piece of color film each emulsion layer—the blue-sensitive (yellow dye) layer, red-sensitive (cyan dye) layer, and green-sensitive (magenta dye) layer—has an individual characteristic curve, but we'll view this as simply a composite curve for now. This graphic representation of the film's response to light can prove as useful as a histogram to a digital photographer, providing a deeper understanding of what's at stake. (Characteristic curves and related data are provided by the manufacturer in print or online.)

THE UPS AND DOWNS OF EXPOSURE

The characteristic curve consists of three portions: a "toe," a "shoulder," and a "straight line," which connects toe to shoulder. The slope of the straight line is defined as *gamma*, and is essentially a measure of contrast—here is where you find the midtones (all those grays and gray-equivalent colors).

Next, we have to wrap ourselves around the concept that negative and positive are opposites—easy enough. Negative film responds to exposure in a backward manner. Or to look at it another way, "negative" starts at the "bottom," or "toe." That's a clue to expose negative film for the shadows. You've hit bottom; go

any lower and the outcome is not pretty.

Positive film, namely reversal stock, responds positively—at the "top," or "shoulder." That tells us to expose for the highlights. You've topped off the gas tank—add any more and you've lost valuable fuel. Or put another way, you know what happens when you take something over the top—you ruin it.

Each curve then follows the S-shape to its natural conclusion, moving from left to right. The *positive* reversal film starts at the top (shoulder), with maximum density giving us highlight detail (while requiring the least exposure to do so), and works its way down to the toe, recording shadows with minimum density (while reaching a point of maximum usable exposure).

The *negative* starts at the bottom (toe), with minimum density giving us shadow detail (with the minimum usable exposure level), and works its way up to maximum density (in the shoulder) to record highlights (in the maximum usable exposure level).

DEALING WITH CONTRAST

The straight-line portion of the curve defines exposure latitude, or margin for exposure error, under a given set of contrast conditions. If the straight-line portion is gently sloping, it indicates a low-contrast emulsion, which means that the recordable tonal range is expanded. Translation: This film will tolerate high scene contrast and still produce a full range of tones.

A steep slope compresses the tonal range. A film with this gamma will record a full range of tones only if scene contrast is low—but nudge the exposure just a tiny bit either way and you may lose some of those midtones. What's more, the steep curve also indicates that the least exposure error could also result in lost shadow or highlight detail, or both. Now, if you bump scene contrast up considerably, no matter how "perfect" the exposure, something will have to give. It may be the highlights, it may be the shadows, or it may be both.

BALANCING THE SCALES

On top of everything else, exposure is expressed on a logarithmic scale. Or more precisely, density increases or decreases with a logarithmic increase in exposure. This tells us that each step in either direction does not

simply follow a linear path: It's not 1, 2, 3, 4, 5, 6, 7, 8, and so on. Instead, exposure, specifically the scale of *f*-stops, follows this progression: 1, 1.4, 2, 2.8, 4, 5.6, 8, and so on.

You can see how this works simply enough. Let's say we've got a lamp and we're going to move it farther away from, or bring it closer to, someone sitting at a desk. If you placed the light at 2.8 feet from the subject as your starting position, then moved it progressively back to 4, 5.6, and 8 feet (following the progression of *f*-stops), you'd see that you've effectively reduced the quantity of light reaching the subject (following the Inverse Square Law), respectively, by 1, 2, and 3 stops (or to put it another way, by 1/2, 1/4, and 1/8). If you bring the light closer in the same increments, the reverse happens, and you end up with 2, 4, and 8 times the amount of light reaching the subject, respectively. You can follow the progression in either direction and it continues to hold.

A THREE-FER

Now, let's throw you one more curve—or more correctly, three. Remember how we said that there are in fact three separate curves, one per dye layer in color film (only one in black-and-white), and that we were going to treat them as one? Well, now it's time to revisit the issue and look at these individual curves more closely.

Ideally, we'd like these three curves to run parallel to one another, or better yet to coincide, for the entire length of the curve or for as much of it as possible. They rarely do. What that means is that each curve responds to different light frequencies, or colors of light, at a different rate. And that's where we get color casts from, when the right film is exposed by light of the wrong color temperature. The distorted colors are most pronounced in the shadows and highlights. And when reciprocity failure hits, these three curves seem to have a mind of their own, stepping over one another and giving us color casts and a loss of film speed in the process.

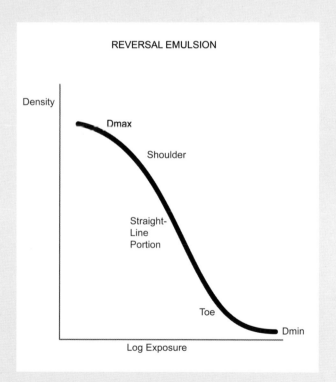

The characteristic curve for negative film (left) moves from lower left to upper right, beginning at Dmin and culminating in Dmax—areas of least and highest density, respectively—corresponding to an increase in exposure. In contrast, the characteristic curve for reversal (slide/transparency) film follows a different path, with density decreasing as exposure increases (right). For both color negative and color reversal film, we would actually find three curves representing the three emulsion layers.

Working Digitally

With digital, you can control the image by way of resident algorithms in the camera before taking the picture, by in-camera postprocessing, through image editing on the computer, and in printing. Printing, too, is not a one-shot step, as various decisions enter into the process that can affect the image: the choice of printer, printer paper, ink set, and printer driver settings. Even the monitor affects your perception of an image. When scanning film, you replace scanner settings for those in the digital camera. After that, the process is much the same, even when you begin with a piece of film or a photographic print.

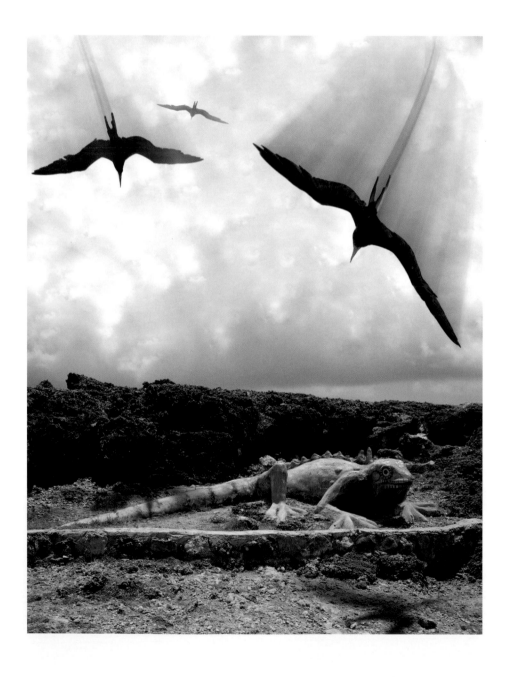

I originally made this picture of a dinosaur-length iguana sculpture on Curaçao as a horizontal, but I wanted to make more of it. So, after stretching the canvas to the necessary dimensions, I painted in the rest of the clouds with a combination of cloning processes to fill the space. Then, I borrowed frigate birds from various pictures I had taken on the island, dropping them in and warping them in perspective. I added a couple of shadows along with the motion trail on the two nearest birds, and that's that. The beauty of digital! Whether or not I succeeded is another story.

Digital Capture in Camera

With the price of digital SLRs coming down so dramatically these days, there's almost no excuse not to own one. The quality of the image continues to improve. While resolution isn't the only factor affecting quality, it's certainly up there, capturing more and more detail the higher you go.

Essentially, a digital SLR (DSLR) should share the same capabilities as a film SLR, beginning with interchangeable lenses; multiple shooting modes, and a variety of metering patterns and focusing and drive modes; and the same ease of operation and handling. And, overall, it should provide a good fit for how and what you shoot. I also demand that the camera be able to work with studio flash and insist on an X-sync socket on the camera, even though there are hot shoe adapters for cameras lacking this terminal (I'm kind of old-fashioned that way).

Another important feature is the memory buffer. When you shoot many frames in sequence in RAW mode—the only way to go when you want to squeeze every drop out of that image—memory gets eaten up fast. When the buffer fills up, the camera basically stops dead in its tracks while it processes the images and free ups enough memory for you to continue. A larger buffer means fewer breaks between takes.

One final issue is frame size. While most of us may not choose a DSLR for the CMOS or CCD sensor employed (although it appears that CMOS is gaining serious ground), we do consider the sensor size. Full-frame sensors, such as the one in my Canon EOS 5D, produce an image the same size as a 35mm frame. Why should that matter? Because the camera is capturing the same exact field of view in digital as on 35mm film, and the focal lengths of my lenses remain the same as on the label. So, when I go out to shoot with a 17–40mm lens on my full-frame DSLR, I'm seeing and capturing the same view I would if I used this lens on my 35mm SLR.

APS-C and Four-Thirds format DSLRs essentially crop the image in camera because their sensors are smaller. That means that you have to multiply the lens focal length by the "lens conversion factor" to arrive at the working focal length. There are other form factors, as well, but for simplicity, I'll limit the discussion to those mentioned. For that matter, even APS-C varies with camera design, so the factor may be 1.5X or 1.6X. Four-Thirds is 2X. That means that a 100mm lens is 150mm or 160mm in APS-C format and 200mm in Four-Thirds format. This factors into your ability to handhold the lens without introducing camera shake at various shutter speeds and may necessitate the use of flash or a tripod. On the other hand, when you add a 1.4X converter to this combo, you suddenly find yourself with a fairly long lens that may be ideal for wildlife photography. But, my fisheye or 24mm perspective-control lens has lost some of its allure with these cameras since the field of view has narrowed considerably.

Scanning Film and Prints

Without going into any great detail on the subject, scanning lets you take an existing image (or document) and digitize it for later use or for digital software manipulation. Two types of scanners are most practical for this purpose: flatbed and film. A flatbed scanner looks like a tabletop copier and is mechanically as simple to operate. It works largely with flat, printed documents, but flatbeds have increasingly become adept at scanning slides and transparencies, as well. A desktop film scanner works only with film. Most are designed to scan 35mm slides and negatives, but some will scan larger film sizes.

Putting a piece of film or a print into the scanner can be as easy as pressing a button if you settle for the automatic settings and tell the software what type of original is being scanned. However, as with any digital image, when you see it on the computer screen, you may want to adjust the scanning parameters to suit your needs. Exposure, contrast, and color adjustments are among the key settings, as are cropping and image orientation (horizontal to vertical). The prints, and especially film, tend to carry dust and possibly scratches, and these have to be attended

to. It's much more difficult to rid the image of these physical imperfections once it's digitized and sitting in the computer. Better scanners have embedded software designed to remove these physical imperfections automatically, once instructed to do so.

Even though a piece of 35mm film arguably carries more information than what a popular digital SLR image can deliver, a scan of 35mm film may not have the same depth and clarity as an original digital camera capture made of the same subject, owing to the interpretive nature of the scanning process. Scanning, like photography, is an art form, and only a well-practiced hand can deliver the utmost quality. The type of film used, under- and overexposure, contrast, and tonal and color balance are key factors affecting results. Of course, it doesn't hurt to have good tools with which to work, and some scanners are decidedly better at the job than others.

Using Software to Improve the Picture

Digital enhancement can take one simple click of the mouse or hours of exasperating and diligent work. Some photographers prefer to work with a digital pen and tablet instead of, or in addition to, the mouse. The pen and tablet give you the feel of working with pencil and paper or brush and canvas: If you press harder, that heavier impression is conveyed to the computer screen as a broader brushstroke.

Whatever tools you work with, the software lies at the heart of the matter. Most photographers I know work with Adobe Photoshop, but Photoshop Elements is a good starting point for the uninitiated.

Another key element is the digital file you're working with. To begin, capture on a digital SLR camera should be in RAW mode, not JPEG and certainly not TIFF (which takes forever to write to memory and eats up a ton of space on the card). RAW format is like a piece of uncooked meat or vegetable: It needs you to add the seasonings and give it the necessary flavor and texture to make it appetizing—and usable. JPEG is like frozen food. It has already lost something that you'll never get back. And when you save JPEG on top of JPEG, it's like refreezing that food over and over again—not a tasty prospect as it continues to lose quality.

When working with RAW files, you define the image parameters in RAW within the software, then convert to TIFF (or JPEG), and save the new file—leaving the original RAW file intact. The software may still show the modifications originally made in the RAW conversion module, but these aren't written in stone and can be modified at any time, letting you go back and create a newly modified TIFF or JPEG. I generally add the letter "a" to the end of a file name to indicate I've modified it, making it distinct from the original.

Now let's step back a moment. In recent versions of Photoshop, when working in RAW you have the option to use Auto settings or to override them. These Auto settings appear more reliable than Auto Levels or Auto Color in Photoshop's main editing workspace (where you work on the final file, usually as a TIFF or JPEG)—but should also not be taken as the final word. I've found it necessary to make some adjustments myself on numerous occasions, while at times accepting the program's recommendations—but rarely without playing around with the parameters first.

While the parameters don't resemble the camera's controls for the most part, they are still manageable even to the novice if, instead of trying to understand each one, you play with the sliders to see what effect each parameter has on the image. Begin with Exposure and uncheck the Auto setting to start fresh, then take it from there. The Auto settings don't go away, but once you click them, any adjustment you made to the slider will be nullified.

As much as we like to think that the converted file is the final version, it is not. There are always some exposure, tonal, contrast, color, or other adjustments you need to make once you convert the file. With scanned images, the Photoshop workspace may be your starting point. I usually begin with a Levels adjustment in Photoshop. Other Photoshop

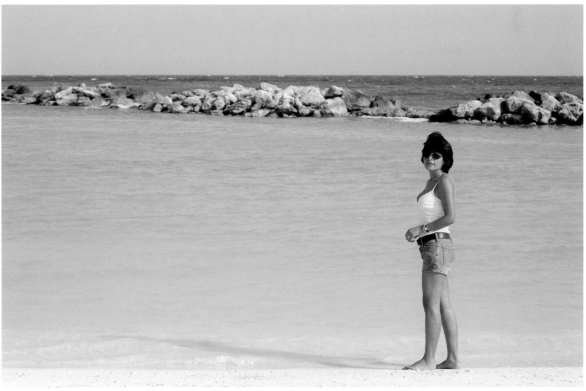

While there is considerable sophistication built into premium digital image–editing software, there are also quick and easy steps you can take to correct an image. Note, however, that they don't always work as well as they did here. From a bracketed series of normal, +2/3 EV, and -2/3 EV exposures, I chose to work with the +2/3 EV image (top). I then applied Photoshop's Auto Color to the photo, which resulted in a richer color in the water and a truer sky tonality.

users may prefer to work in Curves, which can be tricky (the key is to position a place marker at the center of the diagonal line, to temporarily lock it in, and then modify the curve). Or you may use Levels, followed by Curves, or vice versa.

One other thing I do: I use Auto Color, but not religiously, as with auto settings in the RAW module. Sometimes it works, other times not. Even when it provides a quick fix that seems to work, I'll go back and tweak the image manually to see exactly what I'm looking for. If my way doesn't work, I'll go back to Auto Color. I find that Auto Levels is the least reliable, and that Auto Contrast may work, but since it stops short of also making color corrections, I never use it.

A Word about Digital ISO Ratings

Since they make use of an imaging sensor in place of film, digital cameras operate along different lines from film cameras. While we still use the term ISO to keep life simple, we now understand it to indicate light sensitivity of the imaging sensor. And, rightly or wrongly, we may still use "film speed" in this context.

Whether employing a CCD or CMOS chip, the digital camera benefits from considerably greater flexibility with regard to ISO settings than does the film camera. You may let the digital camera's ISO be set automatically in response to ambient light levels, but it's best to take control and set ISO manually. You can not only set ISO for an entire shoot but you can modify it on an as-needed basis, adjusting it upward or downward at any time in response to the situation.

There is, however, one serious downside when you employ higher speed ratings in digital imaging: Beyond a certain ISO level, which varies with camera and sensor, the digital image begins to exhibit a noticeable grainy quality owing to digital noise. This graininess becomes most pronounced at the highest ISO settings. Some of this digital noise can be successfully addressed with noise-reduction software—up to a point.

Which ISO Should I Use?

Use a fast ISO setting (400 and higher) in low-light photography, for stop-action photography, for wildlife subjects, for close-ups by available light, with long lenses, where camera shake may be an issue, and for an intentionally grainy look to the image.

Use medium and slower ISO settings (200 and below) as follows: ISO 200 for general purpose, travel, and candid shots of people; ISO 100 and below for studio portraits, outdoors in bright light, for scenic views and architecture, for close-up exposures with electronic flash, and for panned shots and other blur effects. Most important, use the camera's lowest (or native) ISO setting to keep the image clean and free of digital noise.

The canopy of foliage may have helped protect these doves, but it created poor conditions for photography, especially with the stippled light coming from behind. I had two choices: a high ISO or flash. Employing ISO 1600 helped prevent camera shake at 1/400 sec., given I was using a 70–200mm lens with converter (focal length for this shot: 257mm). Still, curious to see what flash would do, I added a shoe-mount strobe and brought ISO down to 400 and then 100. The flash exposures looked artificial and the birds exhibited red-eye. Even though the high ISO led to a grainier image with increased digital noise (right), I prefer that exposure for its natural feel.

Setting the tone curve during RAW conversion affects contrast, which is most noticeable in the shadow values but can be seen in the light tones, as well. For this image, I set the tone curve to Linear (neutral contrast). Any stronger and there is the danger of shadow values (in the cliff face) blocking up entirely as we increase contrast. Also, it was important to maintain highlight detail in the bow of the rowboat. Overexposing would have blown out the texture in the white-painted wood.

Digital Exposure

Digital photography continues to evolve. Exposing for digital begins with the sensor and computer algorithms embedded in the camera firmware. Capture with the camera is only one part of the picture, as already mentioned. Because you are dealing with dynamic range (the range of tones that can be successfully recorded by an imaging device) and not simply exposure latitude, you have mediating factors to deal with as you attempt to bring out the full tonal range you originally saw in a scene. It's important to get into the habit of capturing in RAW mode. The color space you work in is also important. If you shoot in sRGB, the standard across the digital spectrum, you may want to convert to Adobe RGB, which is designed to deliver more full-bodied prints, with the depth of tone and colors originally envisioned. Adobe RGB is the pro's choice.

When converting from RAW to TIFF (or another file format, depending on your RAW converter), you might also consider color bit-depth. Some recommend working with 16-bit color (which is actually 12-bit capture with many cameras and then interpolated). Others prefer 8-bit. You will likely have to convert to 8-bit when submitting files for publication, since most printing houses are not set up to print from 16-bit files, which also tend to be quite large.

Shooting style and personal (or client) preferences also enter the picture. For starters, when shooting in any autoexposure mode, I often use a +1/3 EV exposure compensation setting. When I use a hand-held incident meter for my digital photography, I routinely add between 1/3 and 1/2 stop to the metered exposure.

Some photographers recommend routinely overexposing, citing that it is better to overexpose and bring the image back down than to underexpose and bring the image up to the necessary exposure level (owing to an increase in digital noise levels that becomes evident in the underexposed or even "correctly" exposed image, notably in the deeper gray tones and blacks when exposure levels are brought

These images are a bracketed series in various stages of exposure. After capture, I directed Photoshop to merge these images to HDR (High Dynamic Range) to recapture tonal values missing in the component images. The final image (opposite) exhibits a fuller tonal range and is a truer representation of the original subject. While this approach is limited to stationary subjects photographed from the same camera position, it is the only practical way to achieve this result.

back up). The rule is popularly referred to as Expose (to the) Right. It is tied into the histogram used to evaluate exposure levels. Pushing the histogram to the right during capture—making sure that you stop short of clipping the highlights—brings up exposure levels overall. With that in hand, you can manipulate the histogram (exposure) in post as needed.

Having said that, I've also found that overexposing the sky and things like neon may result in distorted and washed-out colors that cannot be brought back, notably in high-contrast scenes. As a rule, it's better to initially expose for the highlights and ensure good color readability. If necessary, employ a noise-reduction filter after bringing exposure levels back up just enough to make the darker areas readable.

There's also an alternative procedure, but it, too, has its limitations. If you've bracketed exposures of a motionless subject (movement shows up as ghost images) that you made from the exact same position (namely, perfectly aligned, with the camera on a tripod) so that the images are otherwise identical and provided that you are using Photoshop CS2 or later

A Quick Guide to Exposing for Film & Digital

BLACK-AND-WHITE FILM
Expose for the shadows, leaving highlights to fend for themselves. Lost shadow detail is irretrievable.

COLOR NEGATIVE FILM
Here, too, exposure is normally biased toward the shadow values, sacrificing unnecessary highlights. And as with black-and-white film, lost shadow detail is gone forever.

COLOR SLIDE/TRANSPARENCY FILM
Key highlight values generally take precedence, allowing the shadows to fall where they may. Washed-out highlights are irreversibly lost.

DIGITAL CAPTURE
Digital is an evolving medium. For now, make it a practice to expose for the highlights. However, watch for noise lurking in the shadows. (To reduce digital noise, I may overexpose slightly, provided important highlights are *not* clipped, and I'll bring exposure levels back down in post.)

(other software programs may do this as well), you can take several of the bracketed exposures and merge them using the Merge To HDR command to recapture the full dynamic range (or as much of it as possible) and optimize the digital exposure. The images are merged into a 32-bit file. When you bring the image down to 16 or even 8 bits per color channel, expect some loss, but nothing dramatic. The idea is that you'll end up with more shadow and highlight detail than exhibited in any of the component images, provided you started with a set of images (at least three) that together comprise a wide dynamic range. Ideally, the images you start with should exhibit the greatest color depth and detail (uncompressed TIFF files), but you'll see some improvement even with 8-bit high-quality JPEGs.

A simpler expedient, especially if you only have two images or can't use Merge To HDR, is to create a background copy layer of one of the alternate exposures. Make the new layer from either the under- or overexposed image, and then move it onto the second image. Next, give it some transparency so that the two images blend, with the original visible beneath the new layer. The tricky part, if you weren't using a tripod, is to align the two images perfectly. Examine the image at full size (not reduced) to check for alignment errors before merging or flattening the layers.

Sometimes, only part of the picture is under- or overexposed. If you have two shots, each exposed faithfully for the requisite component needed to produce the final composite image, you can pull out a portion of one, add it to the other using Photoshop's Paste Into command, and then merge or flatten the layers. Or, you can take one shot of an interior and paste it into the cleared-out doorway or window frame from an exterior, after reducing it in size proportionally. Remember to dim the lighting for the interior component so that it appears as one would expect to see it from the outside, adding to the mystery of the fabricated setting or simply adding authenticity. You can even take images that don't belong together and composite whole fantasies by this means, such as a doorway to some flight of your imagination.

You can also take only part of the image, say a dimly lit interior that was captured faithfully, and merge that into a shot of a well-lit exterior (after cutting out the underexposed portion by masking and clearing it) with the help of the Paste Into command. It takes practice and patience, but it should be worth the effort for a meaningful shot.

Some experimentation with your camera is really called for. Shoot exposures involving low-contrast and high-contrast subjects. In each case, expose for the key highlights, key shadows, and a key midtone (or gray card), with additional exposures averaging highlight and shadow readings. Then bracket the exposures

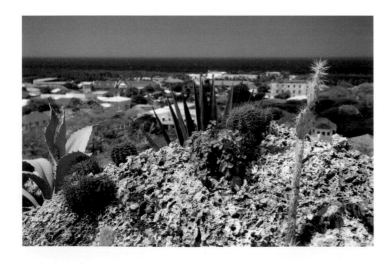

Image-editing software and RAW converters let you do many things to improve an image. These improvements can be more pronounced, as in this shot of the plants growing on lava rock on Curaçao, or more subtle. The choice is yours. Compare the richness of the edited version to the original.

arrived at in each instance. Make whatever corrections you deem necessary in raw conversion and beyond. And, examine the results. You may note that when underexposing shadows and trying to bring them back up in your imaging software, digital noise is introduced. That tells you that the exposure should have been made for the shadows. If, on the other hand, you try to restore highlights and uncover an unusual color cast in the washed-out bright tones, that tells you to expose for the highlights.

Different subjects and shooting conditions may call for tailoring your approach individually to each situation, so don't feel locked in, no matter what anyone tells you. If you encounter both distorted shadows and highlights as a result of making adjustments in post, you have your work cut out for you—assuming they can even be fixed (not every poorly exposed digital image can be corrected with satisfaction). And once you've gone through all this, be prepared to start all over again when you move up to the next version of raw conversion software and, even more so, the next-generation sensor and digital SLR camera.

Some Thoughts on RAW Conversion Software

As a Photoshop user, my first inclination has always been to use the RAW conversion module that came with the program. It's a valuable tool and getting better all the time, but it does take a studied approach. Canon Digital Photo Professional is a simpler, yet very capable, conversion tool. Phase One Capture One is a more robust "workflow" package that many pros use, providing not only RAW conversion but live capture functionality, as well (via tethered camera). The latest RAW workflow software on my workstation is Adobe Lightroom, which has made marked improvement in the way I work with digital files. Apple Aperture is a similar program, but solely for Mac users.

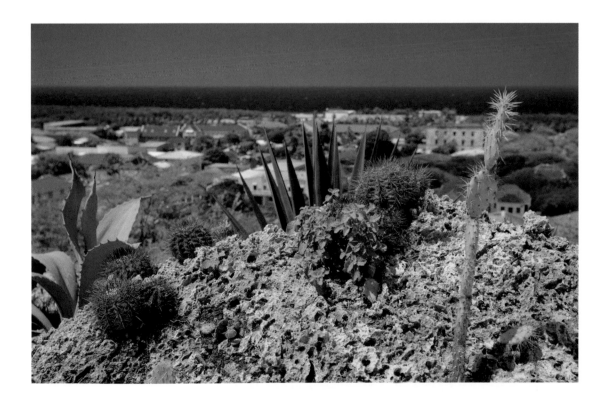

Filters, Plug-ins, and Effects

Those who shoot film are constantly relying on a stable of filters that correct or enhance a photograph. Even those working in digital find some of these invaluable, without equal among software plug-ins. On the other hand, digital photography opens us up to a world of possibilities with "filters" (often more correctly, *effects*) that conventional filters can't deliver.

Don't expect a polarizing filter to produce dramatic results each time. The effect depends on your position and shooting angle. In trying to make this coral rock formation in Curaçao's Tera Kora stand out, not only did I use a polarizer, but I had to digitally remove a pole off in the distance that appeared to be sticking out of the rock.

Traditional Filters: General Purpose

There are a number of useful traditional filters (i.e., filters that you attach to the lens). This first group of general-purpose filters applies more or less equally to film and digital capture.

Neutral-density (ND) filter. This cuts back light without imparting a color cast (inexpensive ND filters may produce a faint bluish cast). It is used when the film in camera is too fast, or when you want to blur subjects with slower shutter speeds, or when you want to open the aperture for selective focus.

Graduated filter. These filters gradate from clear to some color or neutral density and are used to tone down an area of excessive brightness, such as a gray sky, possibly adding color in the process.

Polarizing filter. A polarizer blocks light that becomes polarized as a result of bouncing off nonmetallic surfaces, thereby reducing or removing glaring reflections, intensifying colors, penetrating the water's surface, and adding depth to blue skies while penetrating haze to some degree. Autofocusing cameras should use a circular polarizer to ensure accurate TTL exposure readings. Otherwise, a linear polarizer is used. The sky-darkening effect is directly related to the position of the sun and the blueness of the sky. What's important to remember is that the cleaner the blue, the greater the effect the polarizer will have. The general rule of thumb—literally, to help visualize the effect—is to open your hand so that your thumb and index finger form a right angle. Point your thumb at the sun. Where the index finger points is the area in the sky where the polarizer will have maximum effect. As the filter rotates around its axis, you can see the increasing (or decreasing) effect through the viewfinder. The loss of light encountered when using a polarizer is typically around 2 stops.

Haze filter. Cuts through atmospheric haze by reducing UV; specifically applicable to aerial photography.

Effects filters. It's easy to get carried away with these filters, so I list just the most practical. Soft focus, diffusion, and fog/mist lens attachments romanticize the feel of a photograph, soften hard lines as well as light and shadow, and add a dreamy or surreal effect, often by spreading the highlights into the shadows. Special diffraction gratings create star patterns, frequently with rainbow-colored rays. And contrast-reduction filters lower image contrast. All these filters generally achieve their goals with the help of embedded or surface patterns or textures that refract and/or diffract the light en route to forming the image.

Traditional Filters: Color Photography

The following filters are designed to correct or shift color balance in a decided direction. This group has limited use in digital photography.

Skylight filter. This improves a scene shot in shade or under overcast skies by screening out short-wavelength blue light and UV, while adding a bit of warmth. The skylight filter may also provide a modicum of haze penetration.

Color-conversion filter. The intention with this filter is to convert ambient lighting to the color temperature of the film emulsion in use. The blue 80-series is for daylight film with indoor/incandescent lighting. The amber 85-series is for tungsten film with daylight or electronic flash.

Light-balancing (LB) filter. This is used to add a little warmth (yellow 81-series) or to cool down the mood (blue 82-series). More specific uses are designed to bring color temperature of ambient tungsten or photoflood lighting up or down to minimize color cast.

Color-compensating (CC) filter. This is for more subtle changes in color balance when used alone, especially in low densities, but often is used in combination with other color-toned filters.

Traditional Filters: Black-and-White Photography

The filters in this group are for traditional black-and-white photography and are not practical in digital capture.

UV filter. This improves a scene by screening out short-wavelength blue light and UV; it may provide a small amount of haze penetration.

Color-correction filter. Corrects for tonal distortions; restores flesh tones.

Contrast-enhancing filter. This controls contrast by dramatically darkening certain colors and/or reducing the intensity of others.

Don't use filters simply to protect the lens, unless conditions seriously warrant it. The filter, as an additional air-glass interface, can degrade the image or introduce flare, especially if it is mounted incorrectly, dirty, smudged, or scratched—or of cheap quality.

Glass filters vary in quality but are better than plastic filters (and dyes in either may fade over time). Coated filters are generally better than uncoated for improved light transmission, color saturation, and tonal fidelity. Gelatin filters are extremely thin, are

easily damaged, fade noticeably with frequent or prolonged exposure to light, and are readily replaceable—but they are the only filters to use when stacking several together. To limit the harmful effects on the image, don't use more than two glass filters together and no more than one plastic filter at a time. Whereas most lenses accept front-mounted filters, some lenses will accept rear-mounted or drop-in filters. Add the filter to the lens before focusing, as the filter may otherwise cause a shift in focus.

No polarizer

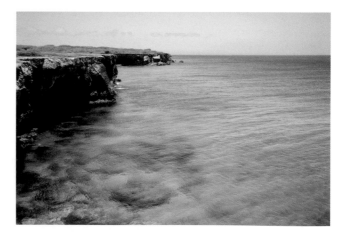

No polarizer

Polarizer

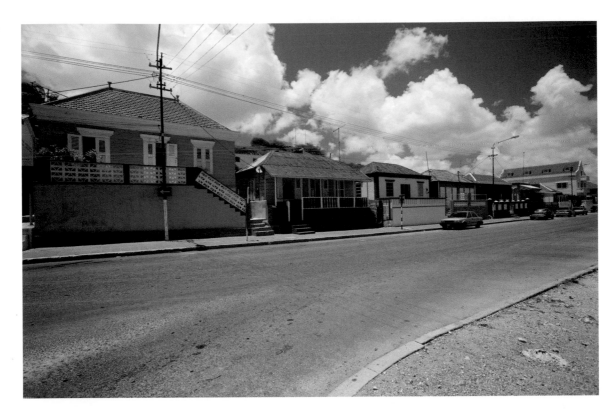

Polarizer

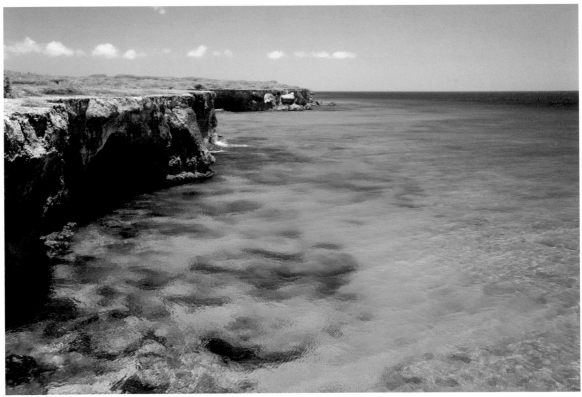

A polarizer can do wondrous things, from simply saturating colors and providing better separation between sky and clouds (or sky and foreground) to letting you penetrate beyond the surface reflections in water.

Contrast-Enhancing Filters

These color-tinted filters are used with panchromatic black-and-white film to enhance certain colors and/or reduce the intensity of others. One application is making clouds stand out against blue sky by using the appropriate filter to darken the sky. Yellow, yellow-green, green, orange, and red will, in this order, increasingly darken the blue sky. The greater the filter density, the stronger the effect.

Filter Color	Effects on Subject	
Yellow	Darkens blue	Lightens green, yellow, red
Orange	Darkens blue, green	Lightens yellow, red
Red	Darkens blue, green	Lightens yellow, red
Green	Darkens blue	Lightens green, yellow, red
Blue	Lightens blue	Darkens green, yellow, red

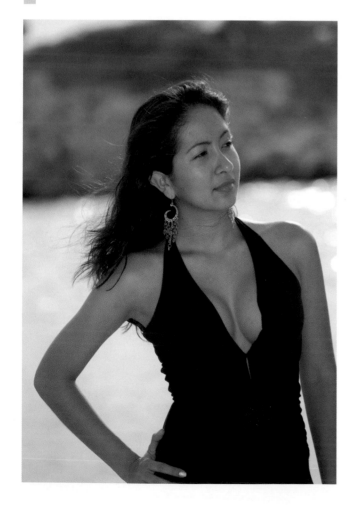

When shooting digital, the use of filters on the camera for color correction often becomes unnecessary. To warm this picture up a bit, I used the 81-series photo filter in Photoshop.

Factor Finding

Keep in mind that most filters soak up light. This light loss is defined as the *filter factor*, which you must use to increase exposure to compensate. With flash, apply the filter factor solely to the *f*-stop so that you don't throw off the flash sync setting.

Manufacturers normally provide filter factors, but not always in a readily usable or handy fashion. While TTL metering should not require any further changes in the exposure settings on the camera, these factors do come into play when using a handheld exposure meter (with ambient light or strobe) and with flash usage based on guide numbers.

Here are two tips to ease the process in arriving at the necessary exposure corrections: For handheld meter and non-TTL flash: You can still take advantage of the camera's TTL meter readings. Read the exposure through the camera lens before and after the filter is in place, reading off a uniform tone, such as a gray card. You're actually finding the amount of light lost directly, not the filter factor, but you can now apply this to any manually calculated (non-TTL) flash exposure or to a handheld meter reading.

For handheld reflectance meter usage: Place the filter over the reflectance sensor, take the reading, and apply that directly to the camera settings.

Cross-processing film in the "wrong" chemistry (negative in slide/transparency or slide/transparency in negative) can lead to startling results. A Photoshop plug-in made this conversion a snap—and I didn't have go into a darkroom. The original (on page 91) is a flattering portrait. This particular cross-processing filter produced a high-key rendition that focuses attention on the model's beautiful eyes and full lips, making her both alluring and mysterious.

Controlling Time and Movement

When you work with ambient lighting, the key ingredient to stopping motion is a fast shutter speed. But shutter speed is relative, with many factors coming into play. Obviously, the easiest first step with an autoexposure system is to put the camera into Shutter Priority mode.

In Aperture Priority mode, the camera delivered a shutter speed of 1/15 sec. Even flash couldn't entirely freeze the movement of the handheld camera. Very subtle blur can be detected, but it serves to add a flattering softness to this portrait.

It's All Relative

There are several guidelines that can help you determine just how fast to set the shutter speed to freeze motion or minimize blur.

The faster the subject's rate of motion, the faster the required shutter speed.

The farther the subject is from the camera, the slower the shutter speed can be, within reason.

The nearer the subject, the faster the required shutter speed.

A subject moving parallel to the camera (or more correctly, the film plane) needs a much faster shutter speed to freeze its movement than does one moving in a perpendicular or diagonal plane.

A subject moving perpendicular to the camera—that is, directly toward or away—requires a slower shutter speed to freeze its movement than does one moving in a horizontal or diagonal plane.

A telephoto lens magnifies movement so that a subject viewed through a long lens appears to be moving faster than one viewed through a wide-angle lens. Your choice of shutter speed with the respective lens should roughly correlate with that perceived rate of movement. All things being equal, that roughly translates into faster shutter speeds with telephotos, slower speeds with wide optics (provided you don't introduce camera shake).

So, freezing the movement of someone walking quickly toward the camera from only a few feet away will require a faster shutter speed than when that same person is moving in the same direction at the same rate of speed but from a greater distance away.

An airplane flying at several thousand feet above your head will require a slower shutter speed than one coming in on approach—especially a plane landing on the tarmac in front of you, which will mandate a much faster shutter speed to achieve the same level of control. As a starting point, determine the shutter speed as you would for camera-shake prevention—that is, equal to the reciprocal of the lens focal length—and modify accordingly.

Avoiding Camera Shake

To avoid unintentionally blurring the subject, use a shutter speed value equal to or faster (shorter) than the reciprocal of the lens focal length, as given by the following formula:

Shutter speed = 1/Focal length

Build in a safety margin with telephoto lenses, and opt for the next fastest shutter speed. So with a 100mm lens, a shutter speed of 1/125 sec. would be prudent. When using a 100mm macro lens for close-ups, you may want to step it up a notch to 1/250 sec. to ensure blur-free results, since all movement is magnified at close range. You might be able to get away with slower shutter speeds with heavier lenses, but lightweight lenses would benefit from faster shutter settings (something to do with torque). Image stabilization provides added margin against camera shake but has no effect on freezing subject movement.

When Movement Almost Ceases

When a dancer leaps into the air, there's a moment—the "dead point"—when motion actually appears to stop. That moment occurs during the shift in direction. In the dancer's case, it happens as the dancer approaches the highest point in the leap and is about to descend. For that instant, fast shutter speeds are unnecessary even with telephoto lenses, and a shutter speed even as slow as 1/60 sec. will most likely capture the moment with little or no blur. This approach only works with vertical movement or movement that follows a tight arc. This, however, does not affect your ability to handhold the lens, so a camera support or image stabilization may still be required at relatively slow shutter speeds.

Motion Blur

Although we strive to avoid blur in most instances, there are times when it adds a definable texture to the photograph and helps us make a stronger visual statement. Often, this is done with the exposure, by available light alone or, as previously discussed, with slow-sync flash, but movement may be simulated with the use of filters during capture or in post with software plug-ins.

You can achieve blur in camera by numerous means. Unless otherwise noted, the camera should be in Shutter Priority mode.

Blur by means of subject movement. Use a relatively slow shutter speed on a stationary camera (mounted on a firm support or with image stabilization) for a subject in motion. With waterfalls, cascades, and flowing streams, this can be very effective at speeds of 1/15 sec. and slower, down to 1/2 sec. With moving vehicles, too much blur will simply look like a mistake, so try shutter speeds of 1/60 or 1/30 sec.—again, relative to the car's rate of speed, direction, and distance.

Blur by means of camera movement. Jiggle the camera or make the exposure with a less-than-steady hand to add a more dynamic element to the picture. In capable hands and with suitable subjects, this looks like anything but a mistake.

Blur by means of both subject and camera movement. Pan the camera, moving it along a path following the subject's movement. Panning keeps much of the subject fairly blur-free while blurring the background. When panning, track the subject a short distance before initiating the exposure. Once you've established the rate and direction of movement, press the shutter button down gently (with the shutter speed set at between 1/60 and 1/15 sec.) as the subject nears the camera (but before it's directly in front, to allow room to travel). Hold the button down as you further track the movement as the subject travels away from you, allowing the camera to complete the exposure before releasing the button. This prevents you from accidentally jarring the camera at the final moment. A tripod with a smooth panhead or a monopod will help keep the subject sharp, but you can handhold the camera if you don't mind a little subject blur, which might enhance the overall effect. Image stabilization that works when panning will help keep the subject clearly defined.

Blur by means of lens movement. Zoom the lens or rack focus. This produces an exaggerated sense of movement inward or outward (depending on the direction of lens movement). This approach, once popular, is largely relegated to moments of boredom when nothing better avails itself.

I panned as the horses came running past me. To further emphasize the movement, I cropped to a tight horizontal panoramic.

Selective Focus

You can selectively focus attention on one part of the scene to add maximum impact to your subject. The effect is a function of depth of field, which, in turn, is governed by several other factors.

Simply defined, depth of field is the zone of apparent (or acceptably) sharp focus surrounding the subject, from foreground to background. Depth of field is governed in camera by lens aperture, distance to subject, and lens focal length, and is further mediated in post by cropping and enlargement (or magnification). At normal subject distances, depth of field extends from one-third of the focusing distance in front of the subject (plane of focus) to two-thirds of that distance beyond the subject. In close-up and macro photography, depth of field is minimal, and almost negligible at life-size and higher magnifications, to the point where it extends equally on both sides of the subject, relative to the focusing distance.

Very often, I'll set the *f*-stop on the lens at or near maximum for shallow depth of field and limit focus to the subject in front of the camera, allowing my backgrounds and foregrounds to blur out softly with increasing distance from the subject or point on which I'm focusing. This is referred to as *selective focus*. Whereas a telephoto optic most often comes to mind for this purpose, it can be achieved to a good degree even with a wide-angle lens. Moving in as close as possible will enhance the effect.

Selective focus can be used not only to direct the viewer's attention to the subject but also to blur out annoying and busy backgrounds. At the same time, it may render them more colorful, as when blurred-out flowers add a splash of color to the picture, or possibly add a sense of intrigue when a "mysterious figure" is lurking in the background.

In-Camera Sequential and Multiple Exposures

You can also capture activity as a sequence of events on multiple frames or on one frame. Here are a number of techniques:

In-camera multiple exposure. This is a good way to show motion, provided the camera allows it. Unfortunately, it's not a standard provision on a digital SLR. With strongly overlapping subjects, reduce each component exposure by 1 EV for a double exposure, 1.5 EV for a triple exposure, and 2 EV for four overlapping images (some exposure bracketing may be required).

Sequential shooting. Select cameras have one or more sequential shooting modes—for example, standard and high-speed. Be careful with exposures. Some cameras in faster modes may lock both focus and exposure. That's not a problem if the subject moves along a parallel plane under constant lighting. However, if any to-and-fro movement or moving in and out of shadows is involved, make sure that the camera is set to refocus and evaluate exposure for each subsequent frame, even if that slows the frame rate considerably.

The announcer gave the audience a hint of what was coming in this high-flying demonstration with dolphins and their trainer at the Curaçao Sea Aquarium. I set the camera to Shutter Priority mode to freeze the action at 1/1000 sec., with continuous autofocus to track the movement. I trained the lens on one spot in the pool in preparation for the breaking action. Then, with the camera in sequential shooting mode, I just held the shutter button down until I captured the complete sequence. A +2/3 EV boost was used to compensate against the bright backdrop, with ISO 800 for an *f*/10 exposure.

Time-lapse photography. This approach captures a sequence of events over the course of several seconds, minutes, or hours. This is a special function and not available on all cameras, or it may be a function of a sophisticated remote release. Time-lapse sequences can be produced by available light or flash. If flash is used, make sure that the strobe is set to wake up when triggered by the camera (if the flash features a standby mode) or that it remains on constantly. Use fresh batteries suitable to the duration of the sequence.

Stroboscopic flash. Some flash units will deliver multiple ultrashort blips (at extremely low output) to capture movement, such as the swing of a golf club or a dancer's pirouette. For maximum effect, shoot the subject against a matte black backdrop (such as black velvet), and extinguish all existing lights and block the windows. This way, you avoid building up the background exposure. And, position the subject far enough away from the backdrop so that the light falls off before reaching too far back.

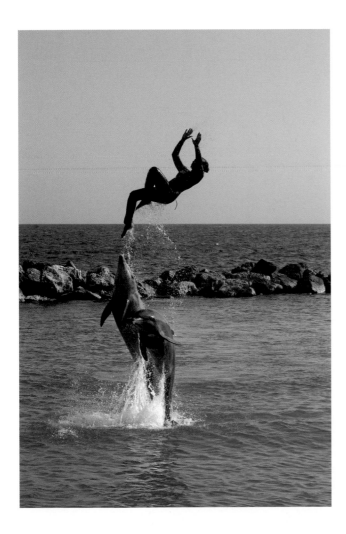 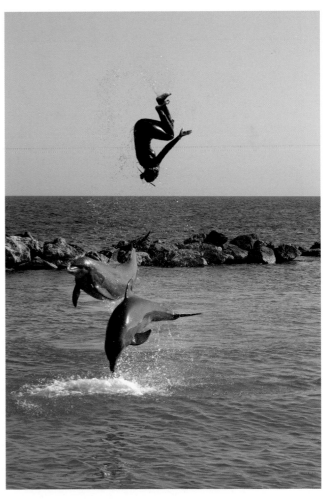

EXPOSURE IN PRACTICE

Exposure control is more than just knowing which combination of *f*-stop and shutter speed to set, or how to use the camera's exposure metering system or a handheld meter. While certain techniques may lend themselves to several groups of subjects, in the end, each subject requires individual treatment. No matter how many times you've photographed one subject, it is never quite the same. With each exposure, something has changed. It may be the subject, or it may be the surroundings, the lighting, a different approach or untried technique, or the new photo gear in your hands. And the way you see the subject and expose for it at that moment may be the defining element.

Of course in this day and age, for many of us, exposure control extends beyond the camera controls. In the past, we might have resorted to processing and darkroom manipulation. Today the digital darkroom has given many photographs—and photographers—a new lease on life. Still, we can only do so much on a computer. The camera remains the key tool in capturing the moment we envisioned. And if we haven't mastered the camera, we will never master the subject.

People

In outdoor portraits, you often want to imbue the subject with a sense of place while controlling contrast, exposure, and color balance. Indoors, lights are rarely where they'll do the most good, unless you introduce and position them yourself: Light levels are often low, you may encounter mixed lighting, and even when working with one existing light source, you can't be assured of correct color balance in advance, given that bulbs age and become discolored. Indoors and out, you have to decide when it's appropriate to introduce a flash into the situation, if at all.

All these concerns pale next to having a kid in front of the camera. At any given age, children are predictably unpredictable. Sit them down in front of the camera for any length of time and they begin to fidget or, worse, cry. The key is patience—lots of it; but you also have to have a way with kids to create a telling portrait. Know your limits—or the child will let you know them soon enough.

Not all portraits depict the subject sitting or standing still. In fact, you'd be lucky to get a nicely posed shot of a kid. Very often the person or child is animated. Kids play with toys, run around, or just thrash about; adults may be playing at sports, exercising, enjoying leisure activities, or performing professionally. The key to any action shot is anticipating the moment.

I provided the prop, this unusual folding piano keyboard, and let the budding pianists have fun while I captured the moment with on-camera flash in bounce mode.

Working with Daylight

Natural outdoor lighting is as variable as the weather and equally helpful or burdensome when capturing a telling portrait. Open shade leads to soft contrast, but deep shade may lead to lifeless portraits; still, either is easy to deal with exposurewise. The same with frontal lighting, which opens up all the subject's features, avoiding any niggling shadows (unless you count the ones that fall behind the subject).

Strong side- or backlighting, however, can prove troublesome as you try to bring key highlight and shadow values under one umbrella, so to speak. High contrast may create deep pockets of shadow; this is good when conveying some sense of mystery or intrigue (not just with silhouettes), but bad when trying to produce a forceful or romantic portrait. Or, when biased toward the shadow, high contrast will result in washed-out highlight values in the face and clothing, and perhaps the subject's surroundings. Excessively high contrast may result in a loss of both highlight and shadow values. Any exposure error could prove disastrous, as the loss of tonal values on film or digital may be irretrievable. And it's not always the light hitting the subject that counts; it may be the ambient surroundings that are a strong concern.

Essential Gear

Lenses. Indoors: a medium telephoto (85 mm) or longer or tele-wide (for example, 28–105) zoom (the faster the better). Outdoors: a tele zoom (in the 70–200mm range) for tight shots, longer for sports (or add a 1.4X converter); tele-wide zoom (28–105mm) for everything from groups to portraits against scenic backdrops. Image stabilization is helpful in any situation with subdued lighting.

Filters. Daylight color film: 81-series warming filter with shade/overcast skies/flash. Black-and-white film: outdoors, medium-yellow filter for improved skin tones. Film or digital: diffusion or soft-focus filter to soften or create a romantic mood.

Lighting. Outdoors: available light, usually coming in on the subject at an angle; on-camera flash as fill for backlighting; a white-, silver-, or gold-panel reflector to reduce contrast under bright sunlight with sidelighting; flash is the obvious choice at night but not mandated where you want to catch the ambiance of the setting. Indoors: available window light possibly with fill flash, or with fill from a reflector; household lighting; candlelight or fireplace; bounce flash to soften light and avoid red-eye; umbrella or softbox lighting for formal portraits; for sporting events, use available light, unless flash is allowed.

Metering. A handheld exposure meter is often best, in incident mode (specifically, flash meter for studio portraits with strobe lighting), but a camera meter will do, especially for kids, outdoor activities, and indoor/outdoor sports; a gray card or similar target is helpful in establishing exposure with reflectance measurement and for white balance calibration with a digital camera.

Focusing Mode. Single-shot AF or manual focus; for sports and action, single-shot or continuous AF, depending on the action.

Correct Exposure Outdoors

Bright surroundings and dark, shaded alleys can throw a meter off. A person's clothing will also influence the reading. And, skin tones are always a consideration. Where practical, use an incident meter reading. This way you avoid all the factors that will throw the reading into under- or overexposure.

In the absence of an incident meter, you can take separate reflectance readings of key tonalities (background, skin tones, clothing) and average them (it's helpful if the camera or meter can store these and average them for you). Or, use a gray card reading with the camera or handheld reflectance meter.

Alternatively, simply bias the exposure to a key subject tone, such as the face. When reading the face, compensate the exposure on the plus side based on the fairness of the complexion. A fair complexion may require as much as +1 stop, and you should bracket for insurance. And sometimes it's just easier to move the subject to another spot with better lighting and a less troublesome backdrop.

With backlit subjects, I often prefer to use an incident meter, but that may overexpose a bright background. Sidelighting presents a different problem. Here, you have to determine whether the highlight or shadow values are of primary importance. For instance, if the person's face is partly in shadow, do you expose for the light or dark side? Part of the answer lies in exposing for the medium (film or digital), but another factor to consider is your intent with the photograph.

In the final analysis, the approach I take depends on how I plan to deal with contrast. With the camera in Aperture Priority mode, I may engage the camera's evaluative metering system with a TTL-governed shoe-mount flash for fill to tackle a backlit subject. Or, with the camera in manual mode, I could read the background separately from the subject, while still engaging TTL flash as fill, bracketing *f*-stops on the plus side for the ambient exposure. (With fill flash, remember to use the flash sync setting, if not set automatically.) If I'm doing a head shot or head-and-shoulders portrait, then the reflecting panel need be no larger than 2 x 3 feet, and the subject can even hold it. (You'll need something larger for a full-length portrait, plus something or someone to support it.) With any reflector, you may have to play around with the placement angle relative to the subject to get the maximum effect. For sidelighting, it's simplest to add a collapsible reflector or white poster board as fill, positioning it off to the side, but nearby. If you're using that shoe-mount flash as fill (preferably TTL flash for simplicity), use it off camera and place it on the subject's dark side, where it will do the most good. Feather the light by aiming it slightly away from the subject so that it doesn't overwhelm the picture. Avoid on-camera flash in this instance, as it will illuminate the subject uniformly. When using studio flash, it's best to read contrast with an incident meter and adjust the lights accordingly or add a fill card/reflector where needed.

The difficulty with this scene was capturing the bright backdrop under the open sky together with the key area in shade. I bracketed exposures and even the -2/3 EV exposure exhibited blown-out highlights. Beginning with what I felt was the best exposure for the main subject, I worked to restore the backdrop while preserving the integrity of the area in shadow.

Color Balance with Film and Digital

Shooting in RAW mode with my digital SLR, I often simply leave white balance (WB) set at AWB (auto white balance) and tweak the setting when converting out of RAW to TIFF or JPEG. That eliminates the need to use any filters over the lens or to second-guess the WB setting in tricky situations. Better still, when time permits, I employ a WB calibration target and set custom WB based on that reading.

When shooting daylight-balanced film, filters often become necessary when the subject is in shade or under an overcast sky, specifically to restore color balance or even to add a drop of warmth. A 1A or 1B skylight filter helps eliminate some degree of the blue light and UV that invade the scene, producing a more neutral picture. However, using an 81-series warming filter (instead of a skylight filter)—usually an 81A or the stronger 81B—adds a more inviting feel to the portrait, although some photographers prefer an 81C for an even stronger effect. Conversely, cooler (unfiltered) tones create a more fashion-forward look, so don't dismiss the "unnatural" out of hand. The moody blue look also complements a gloomy atmosphere. That goes for digital, as well.

Shooting tungsten-balanced film during the day will result in a blue color cast—handy to simulate a moonlit setting or to add a sense of mystery or a shadowy feel, but otherwise not suitable. Shooting daylight film with incandescent light sources will add a warm glow to the photograph, but you might want to pull it back just a bit with a cooling filter so that the photograph isn't excessively orange-red. But, I wouldn't filter the warmth out of an exposure made on daylight film by the light of a fireplace or at sunset. However, where long exposures on color film are involved, you might opt for tungsten film—and perhaps even lean toward ISO 400 negative film to better deal with low light levels and color balance, not to mention potential reciprocity effects.

For this formal portrait on a beach, I had picked a spot that looked ideal until a fisherman suddenly walked into the shot. I decided to shoot anyway and retouch him out later. I used fill flash but the resultant exposure, keyed to the subject, was too light, especially with a +2/3 EV boost. In Photoshop, I adjusted tonality and brightness individually for subject and background (after masking around the subject) to produce the final portrait.

This colorful character was participating in New York's annual Halloween parade. Because the parade is held at night, I employed TTL flash on camera—the only practical way to shoot this. The Shutter Priority exposure was set for slow-sync, so a tiny bit of blur is visible, which seems suitable to a painting.

Indoors and Nighttime

Indoor lighting tends to fall off dramatically, no matter how soft it is to begin with, creating harsh contrasts. Reflective walls are rarely close enough to serve as fill. Relatively low indoor light levels, without the benefit of flash, may mandate the use of a tripod, or a lens or camera with image stabilization. Otherwise, camera shake may intrude on the shot. But that still doesn't address contrast. A fill source would be needed, the easiest, of course, being flash.

If you start with window light, sheer white curtains can help to soften the light further and may even help prevent blowing out the windows in the photograph. Turning on nearby lights can have unpredictable results. A warm bulb might add a nice touch, but a cool fluorescent will likely ruin a romantic feel.

While we often turn to flash at parties and family get-togethers, routinely calling upon the services of the built-in flash, this should be a last resort. The built-in flash is slow to recycle, which interferes with spontaneity, and it produces red-eye—no one likes that—along with harsh shadows. Bounce flash is perhaps the simplest work-around, provided you have white surfaces nearby, adding a kicker panel for catchlights. Of course, if you're photographing a Halloween party, then red-eye and lifeless eyes might be a scream.

The only practical way to tackle nighttime photography of festive occasions is with flash, to freeze the movement. You could also play around with slow-sync flash to add a little more sparkle to the party atmosphere. It works especially well with dancers, particularly when you employ second-curtain sync. For me, the obvious choice, especially at a parade, is a robust shoe-mount flash, which has enough oomph to reach people on the other side of the street, with fast recycling to boot, since you never know where or when that next interesting character will be coming from.

Outdoors, considerable light is lost to the black void of night. With autosensor flash, you would have to increase the exposure 1/2 to 1 stop or more, depending on distance and subject reflectance. TTL flash is designed to provide more reliable results under these conditions, but when shooting digital, keep an eye on the LCD playback for signs that things aren't going as they should—and be prepared to make adjustments. I've found that Program mode, which on my camera selects a slower flash sync setting when needed, works best.

Studio Portraiture

Studio portraits involve a high degree of lighting control. While you can do an awful lot with window lighting or a skylight (as any painter will tell you), very often studio portraiture, even in the home, benefits from accessory lighting, notably strobe. Hot lights are a more economical alternative, though certainly less comfortable to sit under. Daylight-balanced fluorescent lighting doesn't provide the action-stopping power of electronic flash, but it's easy to work with. The glaring light, however, may prove uncomfortable.

With most studio lighting, the illumination out of the box is fairly hard. A photographic umbrella is an economical way to produce a soft, flattering light. The more costly and more complex (only in terms of set-up) alternative is the softbox. A softbox does better at controlling the light, with little or no spill. Umbrellas are notorious for spilling light all over the place. Some people object to the catchlights produced by umbrellas, but they've never bothered me. As an alternative, I like to use flat-panel lighting. As the name implies, this light is rectangular, not round. It comes with a diffusion panel built in, doing away with the need for umbrella or softbox.

In a photo studio, you'll likely employ seamless paper, painted canvas, or muslin backdrops. Location portraiture involving studio lighting can make use of these background materials, but that's not really necessary, since you'll probably want to capture the ambiance of the home, office, or outdoor setting. Provided you have grounded outlets for your lights, you can employ the same lights you use in the studio, but I'd recommend less powerful lights in a home, such as 200 or 300 w/s (watt-second) monolights and nothing stronger than 1000 w/s (preferably powered down). In fact, don't overlook portable strobe lighting—either battery-driven mobile studio lights or even a shoe mount or two. When you're not hampered by the lights, you're free to respond to your subjects, especially if they're kids having fun.

To photograph this attractive young woman, who is both a chef and an actor, as she baked a pizza, I employed a small strobe behind her as a hair and fill light, with the main light positioned to my right. Metering was with a flash meter in incident mode, with the added benefit of a calibration target to fine-tune exposure and color balance.

Developing a Rapport with Kids

Just because parents say it's okay to photograph their kids doesn't mean the child will sit still for you. Outdoors, you may have to photograph a baby or toddler at the mother's side or in her arms. Carriages and strollers don't make for the best settings. Older kids tend to be more independent, providing ample opportunity for candid shots at play or interacting with siblings or other kids. In a studio or home, there should be plenty of toys to occupy the child. The parent can bring them along to the studio or have them on hand in the nursery or playroom, although the area behind the child should be uncluttered and clear of toys. Hand puppets may work to attract the youngster, but so can jingling keys—depends on age. But be prepared to adjust strategies as the child gets bored with each item in turn.

Sometimes, I'll just make faces and funny noises. That works for a short while. Favorite music may help a child to calm down, and playing a video on the set to your immediate right or left will grab a child's attention, if you don't mind pictures in which the child is looking slightly to the side. Many child photographers have found that Cheerios can work wonders with babies and toddlers, but avoid any messy foods so that you don't have to wipe the face every two minutes. *(Before introducing anything into a child's environment, check with the parents, especially about allergies. And be ever vigilant of anything that poses a choking hazard.)*

If you find it difficult to hold the child's attention, ask a parent for help. But if both parents get involved, with grandparents or other relatives or friends thrown into the mix, the child won't know which way to turn, and you've lost control. The parent might also read the child a favorite story, and the resulting expressions may go from gleeful to pensive as the story takes different twists and turns. Most important, know the child's limits. When the youngster says enough is enough or starts crying, call it a day.

When I noticed several children stepping into this wading pool to pet and feed turtles and stingrays at an aquarium, I readied the camera, setting the ISO to 800 for the low-light conditions and the 200mm focal length. With no time to bracket, I put the camera in Program mode for an *f*/8 exposure at 1/800 sec., with a +2/3 EV exposure boost to compensate for the water's tonality. Finally, I added some diffusion digitally to reinforce the dreamlike quality of the image.

Shooting Modes and Flash with Kids

When photographing children, I routinely opt for selective focus, with the camera in Aperture Priority mode, although stopping down to $f/5.6$ or smaller may help to get a restless child in acceptable focus. Using the camera's metering system is great for kids running around the house or yard, but not for a formal portrait. When it really counts, I prefer to use an incident meter to gauge my exposure, with the camera in manual mode. Try to have the exposure locked in before the child sits down. Outdoors, if the kids are really rambunctious and I'm shooting by available light, I'll put the camera into Shutter Priority so that I have better control over the action. I may even try to get children involved in the process if they are old enough, asking them to hold the incident meter or calibration card while I take a reading.

While flash of modest output won't harm the child, I pay attention to the youngster's reactions. My friends' two-and-a-half-year-old was so used to having her picture taken (her parents were photography students of mine) that she sat fairly still even with a studio light blasting away—and she was focused on me despite a house full of guests.

Ordinarily, I resort to on-camera flash only for spontaneous shots of kids. Because, as mentioned, built-in flash often results in red-eye and takes too long to recycle (kids are not going to wait around for you), I prefer to add an external strobe when one is available. If the situation allows, I'll use bounce flash. Outdoors, it's usually easiest to shoot by available light, although fill flash may prove useful. Popping a strobe indiscriminately is no guarantee of better pictures and may simply result in missed opportunities as you wait for the flash to recycle.

With Kids, Watch & Wait

Wait for it to happen, and be prepared for the moment. If the child is moving about, anticipate where he or she will be, and focus on that spot in advance. Perhaps plant a favorite toy there. If the youngster is seated or standing in one spot, train the lens on the eyes. With focus and exposure now locked in, wait for just the right facial expression before releasing the shutter. You might be tempted to use continuous AF, but don't: That will place the eyes dead center, leaving a lot of empty space surrounding the child—empty space that doesn't contribute to a telling portrait.

I used bounce flash to capture this moment. First, I took an incident reading to establish a base exposure, and then I used a calibration target to fine-tune the shot. The bounce lighting lent a nice soft quality to the image, prevented red-eye, and ensured that the light would reach the subjects fairly evenly as they were posing and being playful in turn.

Action and Sports

It often helps to have some knowledge of a sport to do it justice photographically, but keen observation will soon lead to an understanding of the sport without devoting your life to it. Many sports activities occur in bright daylight, whereas others happen late in the day. Or, a game may go on till dusk or nightfall. When there isn't enough available light for stop-action shots, you may have to improvise and switch to a fast film or boost ISO levels on a digital camera. Since shutter speed is often paramount, you can use wider apertures. In fact, selective focus will direct the eye to the key plays and players.

Also keep in mind that tripods are often not permitted at sporting events, although a monopod may be allowed. Flash, too, may be verboten. When shooting under subdued lighting, consider a lens (or camera) with image stabilization.

Exposures can be tricky, with bright backgrounds (such as sky and clouds), highly reflective grass, clay courts or tracks under bright skies, and brightly colored uniforms throwing the meter off. Be prepared to compensate exposure on the plus side. In a night game, you have to watch for stadium lighting intruding on the shot and influencing the exposure, as well.

Then, there's the matter of lens selection. Long lenses are the order of the day in most instances. At any game where you're standing on the sidelines, you might opt for a 70–200mm lens, but when you find yourself farther back, in the bleachers, 200mm may be the starting point. If there's a scenic backdrop, or for shots of an entire team or the entire field, bring along a wide lens, something on the order of a 28–105mm zoom or a fixed 28mm optic.

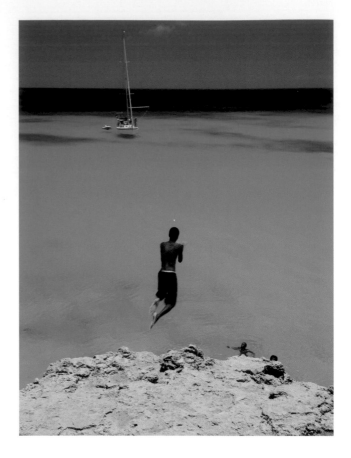

When I first came upon these youngsters diving off a cliff on Curaçao, I had the camera in Aperture Priority mode, which resulted in relatively slow shutter speeds, ranging from 1/40 to 1/50 sec. (above). When I switched to Shutter Priority and set the shutter speed to 1/1000 sec., I was able to capture a blur-free image (opposite).

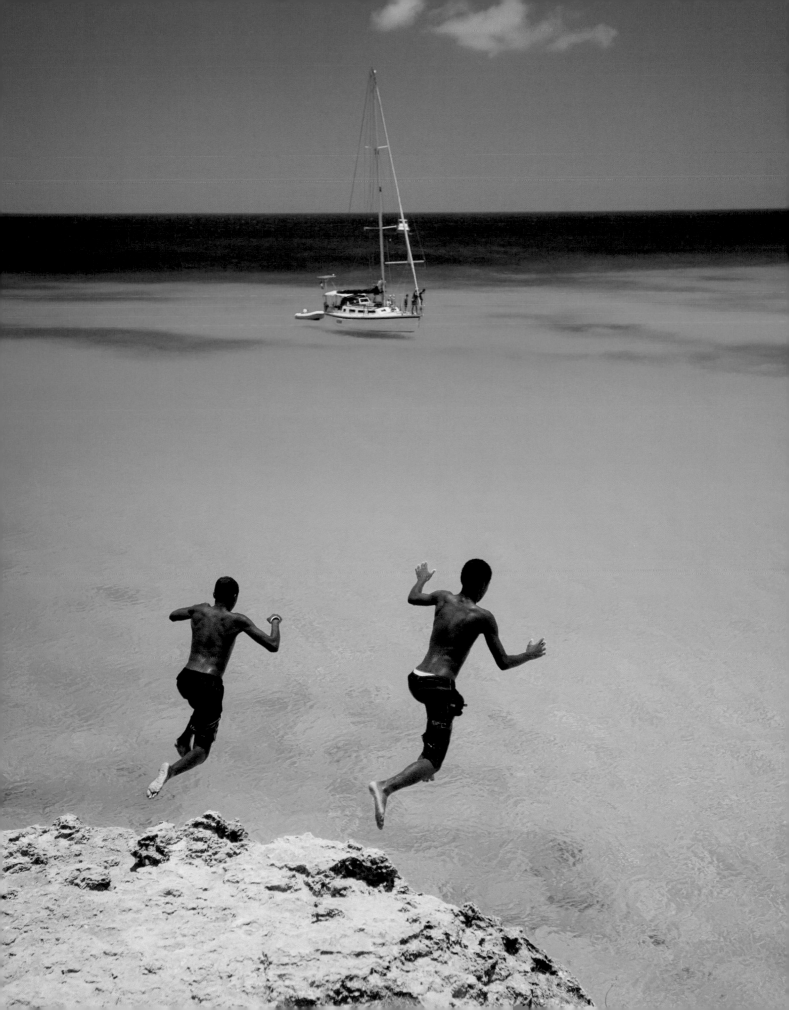

You wouldn't expect to get relatively sharp results of a skateboarder with a shutter speed of 1/125 sec. (ISO 400), but that was the case here. I released the shutter, anticipating the moment when he'd top the railing, which is also when he comes to a virtual standstill—except for some noticeable motion in the hands and, less so, the feet. The lens was a 28–105mm at 90mm on a Canon EOS 10D.

Follow & Anticipate the Action

Many action shots can be successfully tackled in single-shot AF mode by focusing on the subject, such as the pitcher or a player at bat in a baseball game, or a striker or goalie in a soccer match. Or, focus on a spot where you anticipate a key play to occur, such as first base or the net. Don't wait until the play is made to release the shutter. Anticipate it. When photographing the bat hitting a pitched ball, release the shutter when the ball crosses your field of vision, not after the player takes a swing.

Switching gears, when I photographed cliff-diving on Curaçao (page 139), I trained the lens on the kids, releasing the shutter just as they were about to make the leap into the water, before the actual jump commenced. You have to allow for the time it takes for all this to register on your brain, the time it takes to complete pressing the shutter button, and the time it takes for the camera's mechanics to respond in kind.

For breaking action, set focusing to continuous AF to ensure proper focus. Trying to follow-focus manually, or with one-shot AF, is a veritable impossibility and may throw off your timing.

This was one of my first attempts at photographing soccer. I had set the camera in Program mode and followed the action, grabbing the shot at 1/400 sec., just as the goalie caught the ball in midair.

Light levels were low in the park, so I set ISO to 800 to get an action-stopping shutter speed of 1/500 sec. Then, just as this volleyball player made the jump, I released the shutter to catch him in midair.

Pets and Wildlife

My cat, Prudence, initially taught me something very important about exposure by virtue of her shiny white coat. Back then, I was shooting black-and-white film, except that all my pictures of her were coming out gray. So, I explored the problem and eventually resolved it by increasing the exposure. Before long, I had also learned a lot about cat behavior and made an effort to learn how other animals behaved. I picked up a few tricks along the way—a good deal revolving around patience, understanding, and observation. Another thing I picked up was that an animal being photographed must be treated and approached with the same respect you'd give a person. For guidance in the approach, look at an animal's lifestyle, its surroundings, and the way it responds to its environment; but good camera technique, which includes choosing the right exposure—and luck—will factor heavily into your success, as well.

Start by Observing and Understanding

It was one thing to photograph my cat sitting or lying down, but quite another to capture her jumping over the tops of kitchen cabinets or in and out of a paper bag. I learned to understand how my cat behaves by observing her. Yet, no animal is entirely predictable, even though cats may follow more or less predictable behaviors under certain circumstances. Moreover, animals—especially mammals—act one way when young and another as adults, and no two are alike.

Still, there are some things you can do to gain control over just about any situation, even if you can't fully control the mannerisms of all pets or predict how every animal will react with certainty. Some pet reptiles and fish—notably the larger species—will respond to a modicum of training or will repeat the same behaviors over time. Even the untrained pet will conduct itself in a similar fashion given a known set of circumstances. For instance, you can depend on an animal to go to its food or water. Or, it may pick a favorite spot.

Many smaller pet birds love the swing inside their cage, whereas larger birds may prefer to sit atop the cage or on a nearby perch. Lizards love to bask under the glow of heat lamps. Empty a drawer and you may find your cat lounging inside. Give a dog its favorite chew toy and watch its reaction. Fish generally swim in a predictable pattern at a particular level in the aquarium. At the zoo, animals may follow known routes within an enclosure. Fish and large invertebrates at the marine aquarium may have a favorite nook. Animals in the wild aren't much different. They simply do things on a grander scale.

Patience and Timing

When a cat pounces on a toy, chances are it will already be playing with the item by the time you've pressed the shutter button. With animals, as with kids, timing is everything. Understand what triggers the behavior and what form it takes; learn to anticipate it, and be observant—and patient.

With my cat, I would watch for the tail to twitch. Careful observation may also reveal that the pupils dilate the instant before pouncing. Watch the signs. After a few times, you'll know exactly when to release the shutter. You'll develop the same catlike reflexes as your pet. A common question is, Do you focus on the pet or on the toy—the object of the pet's attention? Focus on the toy, with one eye on the pet, finger poised on the shutter release, pressing it fully just as your pet springs into action. Or you can pan as the pet makes a move.

Working with a 200mm lens on an EOS 20D (equivalent focal length = 320mm), I captured this humpback whale from the main deck of a catamaran. With the camera in Shutter Priority mode, I chose 1/1000 sec. to freeze all movement. The ISO was 400, with +2/3 EV exposure compensation for the reflective surface of the water.

Obviously, fast shutter speeds or flash will be mandated to freeze the action, unless you're panning. Because some lateral movement may accompany the leap, stop down adequately—say, 2 to 3 stops from maximum aperture. You can stop down much more if there's no clutter or furnishings around, which is rarely the case at home or even in the yard. A practical speed is ISO 400. As for lens choice, better to go a bit wider than too tight to allow for the movement.

In addition, don't overlook quiet moments. Some of my favorite pictures of my cat were made during pensive moments, by window light, with fairly slow films. Here, I would favor a short-to-medium telephoto, unless I were including the window in the picture, in which case I'd go wider.

Essential Gear

Lenses. Outdoors: long telephoto (200mm or longer) or telephoto zoom (70–200mm or thereabouts), with the possible addition of a 1.4X converter. Indoors: a wide-angle, macro, or tele-wide zoom (28–105mm) with macro focusing. Open indoor displays at zoos or aquariums: a tele-wide lens with macro focusing. Small wildlife outdoors: tele-macro (100mm to 180mm). Image stabilization may be helpful under subdued lighting. Fast lenses are often preferred with wildlife.

Filters. Daylight color film: 81-series warming filter with shade/overcast skies/flash.

Lighting. General: available light; flash where applicable/allowed. Outdoors: on-camera flash. Indoors: bounce or off-camera flash, especially around glass/acrylic enclosures. *Note: Use flash only where it does not harm, agitate, or disturb the animal.*

Metering. Camera's meter; for studied portraits of larger pets in the home, handheld incident meter.

Focusing Mode. Single-shot for stationary animals; single-shot or continuous AF with active animals; manual focus with extreme close-ups.

I photographed my friend's dog using bounce flash. The camera was set to Aperture Priority mode, but a custom setting dictated that the camera would revert to the flash sync speed when a flash was activated, hence the exposure at 1/200 sec., minimizing the effect of the existing light. Working with TTL flash, I gave the ambient exposure a +2/3 EV increase against the bright surroundings.

Tips for Working with Small Pet Enclosures

Cages, aquariums, and terrariums test your photographic prowess in different ways. Use any lens with close-up capability. Existing lighting is often unsuitable, so have a flash ready, and be prepared to use it off camera.

WIRE CAGES

Birds tend to peck at any mirrored surface, which includes the optics in the lens. For this reason, you should keep the lens a safe distance from the cage. You can also safeguard the lens behind a clear sheet of glass or acrylic, but this may be more trouble than it's worth. Focus on the bird's eyes, but try to get the colorful plumage in reasonably sharp focus, which might be difficult since you'll also be shooting at a wide aperture to blur out the wire.

When employing flash, use bounce flash with a kicker panel. With available light, you may need a high ISO (400 or more) and action-stopping shutter speeds and/or a fast lens. The smaller the bird, the more it moves around—probably a survival instinct—so don't expect it to sit still for more than one or two shots. It might be easiest to train the lens on a favorite spot and wait for the bird to reach it.

AQUARIUMS

The lighting in an aquarium is rarely suitable: It's the wrong color balance and produces harsh contrasts from top to bottom. That means you'll need flash. Avoid on-camera flash, as it will reflect in the glass on the opposite side of the tanks, if not the facing side, resulting in glaring hot spots. Specifically, use bounce flash, or better still, shoot with flash off camera. Position the off-camera strobe at a downward angle to simulate daylight. If possible, use two strobes, one on each side. That would allow you to move freely along the length of the tank, although that may create double shadows—try diffusing the strobes also. Don't put the flash above an open aquarium: Fish may leap out, or water may hit the strobe, creating a hazardous condition. Stop the lens down enough to ensure adequate depth of field to compensate for movement. At the same time, remember that a small aperture restricts the throw of light from the flash.

Position the camera lens flush against the glass to avoid reflections. But be careful. Project a pinkie out as a feeler while slowly nudging the lens toward the tank to keep from bumping into it and to avoid scratching the glass when repositioning the camera. A rubber lens hood would be prudent, as well, especially with acrylic, which scratches fairly easily.

Some fish, such as zebra fish, dart about, while others, such as angelfish, remain stationary for relatively long periods. Some, such as neon tetras, frequent the upper levels, whereas catfish, loaches, and eels prefer the aquarium floor. You'll need to develop different strategies with each species.

TERRARIUMS

With these enclosures, again hold the lens flush against the glass. Even though there may
be sufficient daylight, the heat lamp may impart its own color, so once again, flash would
be prudent. Follow the recommendations outlined for aquariums, with one added note:
Provided the animals are nonpoisonous or can't climb out (don't do this with geckoes, for
example), you may be able to remove the lid and position a strobe above the terrarium to
simulate sunlight. Or, place the flash above a screened lid. (But please be careful of heat
lamps.) A second flash (at low power or heavily diffused) might be needed for fill from the
front. Focus on the eyes but try to get enough body detail with a suitable lens aperture so
that the pattern and shape are recognizable. If you time the shot right, you may be able
to capture a chameleon shooting its tongue out to catch a cricket. There are telltale signs
to watch for, and even then, it takes lots of practice.

Electronic flash is a tool that lets you capture subjects in ways that would otherwise seem
impossible. The use of available light would have blurred this bearded dragon's tongue as it
shot out to grab the lettuce from my hand. (In post, I scanned the image and replaced a lack-
luster background with something more interesting.)

Zoological Parks

Today's zoos and safari parks offer countless opportunities to capture intimate wildlife portraits with the sense of almost being there in an animal's native habitat. Zoos allow you to saunter past animal enclosures in a variety of indoor and outdoor environments, each designed for the safety of animals and visitors alike. Planned primarily for the comfort and benefit of the animal, some of these habitats can be quite challenging from a photographic standpoint. But we can also make use of some of the obstacles that appear to stand in our way.

Indoors, a wide-to-tele zoom with macro focusing is best. Flash is normally allowed, although its use may be restricted in dark-adapted environments and other areas, so look for posted signs. One known fact: no tripods allowed, as they pose a hazard to pedestrian traffic, especially kids running around.

Outdoors, distance is often the biggest bugaboo. Animals are far enough away that anything less than a 200mm or 300mm lens won't do them justice, so a telephoto zoom to encompass animals near and far is preferable. The addition of a 1.4X teleconverter would be helpful. Use large apertures to "shoot through" such obstacles as wire mesh fences.

The animals may be hidden among the branches or shaded by nearby trees, or they may be partly in sunlight and partly in shade. An animal's deep black coat may absorb light, whereas brightly colored feathers will reflect it, both resulting in exposure error and a need to compensate accordingly (keep in mind that some coats are more reflective than others). Grass, foliage, and water will each reflect back light to varying degrees, requiring additional exposure.

Daylight may be sufficient for outdoor available-light shots, but long lenses may still mandate high ISO settings (400 and beyond). Indoor exhibits are often illuminated by artificial light, but even where natural light is used, light levels indoors are relatively dim in keeping with the animal's natural environment, again making it necessary to employ high ISOs (when not using flash).

Many zoo enclosures are still small enough that a flash will produce noticeable shadows and may even reflect off a back wall. The way around this is to use small lens apertures to restrict the throw of light and to shoot either with the flash off camera or to employ bounce lighting. I've found that it's possible even to use a nearby display window or overhead grating as a bounce surface. Granted, this will only work with a subject that's fairly close to the camera, since much light will be lost in the process. Plants, rocks, and overhangs can cast shadows, so be on the lookout.

Having trouble getting a good tight shot of the animal? If the animal is too far away for your lens, try using a nearby tree and branches as a frame, or photograph two animals a short distance apart, with the second one a short distance away (and possibly out of focus) so that they form a diagonal line in the frame (that's more dramatic than putting them on the same plane). With moving animals, try panning with the movement or prefocus on one spot in anticipation of the animal's arrival. If you find that shutter speeds are too slow for handheld photography (lacking an image-stabilized lens) and that flash is impractical, use a railing (preferably without anyone leaning against it), wall, tree, or even a friend's shoulder as support.

In a safari park, wildlife is free to roam, while people are confined within some mode of transportation, such as a car—hands inside at all times, please. When inside a closed vehicle in a safari park, there is the temptation to place the lens flush against the window, but keep in mind that the window glass will transfer vibrations to the camera. In any vehicle, image stabilization can prove helpful, but fast shutter speeds may still be necessary to freeze movement. Another problem comes about when someone else is in the driver's seat, such as on a scenic train. You may slow down, but not come to a full stop, in which case you have to be ready for anything. If possible, do some advance research to find out how close animals can get to you or you to the animals. Where the wildlife can come right to the window, obviously a wide-angle lens or wide zoom would be helpful. At other times, lenses of 200mm or 300mm (or longer—keep that trusty 1.4X converter handy) may be needed. A long zoom (70–200mm or more) would be a good choice.

Quick Tip: Using Filters

Whether in a zoo or an aquarium, light levels for indoor exhibits and even many outdoor habitats are relatively low, so it's best to avoid using filters to compensate for artificial lighting when shooting by available light. In many cases, it's not even clear what type of lighting is used. Outdoors, under overcast skies or in shade, a skylight or 81-series filter can be used, although you may still need faster ISOs to deal with light levels or for long lenses. When shooting digitally, color balance corrections are best made in post.

Gorillas in our midst—well, actually on the other side of the glass in this spectacular exhibit at New York's Bronx Zoo. The male silverback can be seen in the foreground, with a female gorilla carrying her baby in the background. The exposure, made in Program mode, was 1/125 sec. at f/2.8 (ISO 400) with a zoom lens at 50mm (equivalent to 100mm in Four-Thirds format).

Marine Aquariums

Increasingly, the marine aquarium is becoming not only a place to appreciate various fishes, sharks, and sea invertebrates but to view many aquatic mammals performing trained behaviors on command. These behaviors are rarely repeated, so be prepared: Listen for cues from the trainers, be vigilant, and have your camera ready for the moment. With fast-breaking action, there's no time to change lenses or even zoom out; the focal length must be set and the lens focused on the spot where the peak action will occur. Good practice is to opt for a wider lens setting than you might otherwise use with a subject in a fixed location (for example, 90mm on a 70–200mm lens, depending on where you're sitting or standing) and to train the lens a short way into the area beyond where the action will occur.

Also, to capture action such as dolphins jumping into the air as a sequence, set your camera to continuous AF and sequential capture. Keep your finger poised on the shutter button and wait for the action to begin— in this case, for the dolphins to break the surface of the water and just come into frame before releasing the shutter. Continue to hold the button down for as long as necessary. And be sure to keep the camera steady and fixed in position during all the excitement.

Aquatic displays may be lit artificially, but more and more aquariums are employing natural light exclusively or expressly for their larger habitats. Either way, once light hits water, it is absorbed to some degree, increasingly so with depth, so that available light rarely proves adequate to the task. That said, in larger habitats with sunlight pouring in, the existing light is often the best light to use, as flash will get soaked up and warped by the water with increasing distance and floating debris. Singular shafts of sunlight may make their way to these depths, playing with the fish and posing a challenge of contrasting light and shadow for the photographer in the process, while adding an exciting element to the shot.

The water also filters and colors the light. Corrective filters will reduce the amount of usable light and are totally impractical; I never use them and don't recommend them. However, if you've scanned or digitally captured the image, you can try a red photo filter in Photoshop (under Adjustments in the Image pull-down menu) to correct for a cyan cast.

On-camera flash will produce backscatter when the light encounters floating particles and aeration bubbles, which act like tiny mirrors bouncing back light. Heavy aeration and feeding time (when the fish kick up a lot of debris) hinder visibility and contribute measurably to backscatter with flash, so avoid such situations.

When using flash, the time-tested approach with aquatic displays behind glass and acrylic is to hold the strobe off camera, with the camera flush against the glass as always. Where practical, try to create the impression that the light is coming at an angle from the surface. At the very least, restrict the throw of light with small ƒstops, and watch for reflective backgrounds. Plants, rocks, coral, and other fish can cast intrusive shadows, so be watchful of them, as well.

I recently tried a different approach: I attached a bounce card to the flash head, which sat atop the camera, and tilted the head at an angle instead of straight up (the normal bounce position). For my ƒstops, I found myself using ƒ/5.6 or thereabouts to compensate for the light loss. This lighting resulted in a soft-edged shadow behind the subject and with practically no backscatter.

Bounce lighting also makes it less likely to create hot spots (from highly reflective fish scales) and blow out light tonal values in brightly colored fish. I may also use a Levels adjustment in Photoshop to darken the background in some shots and make the subject pop out. Some brightly colored fish may throw off the exposure, requiring an increase to compensate. Dark recesses may have the reverse effect, requiring less exposure.

The best choice in optics when photographing fish in small or large aquatic exhibits is a zoom with macro focusing. My preference is a 28–105mm or 24–105mm lens. The wide focal length is especially useful with sharks and aquatic mammals underwater—sometimes, they swim practically against the glass. A fixed focal length, even a macro lens, may prove very limiting, but if I were to go with a fixed lens, it would be a fast 50mm macro or, better yet, a fast 28mm. Remember that water acts as an optical magnifier.

The camera's autofocusing system can't respond quickly enough in a situation as tight as this, so I set focus manually. I then used the flash in bounce mode with a bounce card to capture these two fish just as they approached the glass at the Curaçao Sea Aquarium. That explains the lack of hard shadows. I tweaked the image during RAW conversion and in post. A handful of particles did manage to intrude on the shot, owing to backscatter, so I retouched them out. Direct flash would have produced hard-edged shadows and considerable backscatter. The image at right shows a typical exhibit at this facility. Note the contrasts from direct sunlight.

Aquatic Subjects behind Glass

The thick aquarium glass or acrylic plastic may have some effect, degrading images due to scratches, dirt, and fingerprints on its surface. Distortion can also enter the picture when the lens is tilted, so keep it flush against the glass (a very lean tilt may have a negligible effect). On top of that, you'll likely also catch reflections in the glass when tilting the lens or if you pull away even one centimeter. Which reminds me, if your zoom lens uses a petal-shaped lens hood, keep one hand over the open spacing as much as possible precisely for this reason.

Additionally, a problem with many zooms is that, as you're focused on the animal and pressing the lens up against the glass (whether at a zoo or an aquarium), the lens barrel will be pushed back, so don't press too hard.

Flash and Critters in Small Spaces

Flash can even annoy sea creatures and reptiles. Once, when I photographed an octopus—a mollusk, no less!—at an aquarium, I observed it flinching each time the flash popped. I had a similar experience once when photographing a snake at one zoo (although not with the same species of snake at a different zoo). Moral: If you find that flash annoys or agitates the animal, stop using it. I can't say that enough!

Animal Behavior and Lifestyle in the Wild

Feeders are often a good starting point for photographing many small birds, although you may happen upon some of nature's intruders, as well. In autumn, wild birds can be found around trees with ripe berries. A hawthorn tree once provided a great backdrop for me to photograph both a visiting woodpecker and mockingbird. I quietly inched my way forward, with a tele-zoom lens on the camera and a flash seated in the hot shoe for fill.

When aiming for larger game, look for watering holes. The seashore is obviously a great place for shorebirds and waders. Among mammals, the easiest animals to spot are the foraging herbivores on prairie, veldt, and pasture—hulking bison, elegant giraffes, stately elephants, graceful gazelles, and grazing cattle and horses, to name a few—often in herds, sometimes solitary and slow to move, unless frightened. Of course, time of year is everything. To arrive at a lake that an egret is visiting during its migration is an opportune moment indeed.

Remember that many animals live hidden from view in the forest canopy, beneath rocks, among foliage, in grass, deep inside crevices, and in other areas that provide safe harbor from predators. Numerous animals also use camouflage to stay safe, whereas predators remain concealed in wait for prey. All this makes them difficult to see. And if concealment doesn't keep you from photographing them, their fast reflexes and speed will. Predators and scavengers may be emboldened by the prospect of finding unattended scraps of food, but they may not hang around when you approach. For that matter, mind your manners and don't interrupt a carnivore while it's feeding; it may not take kindly to the interruption.

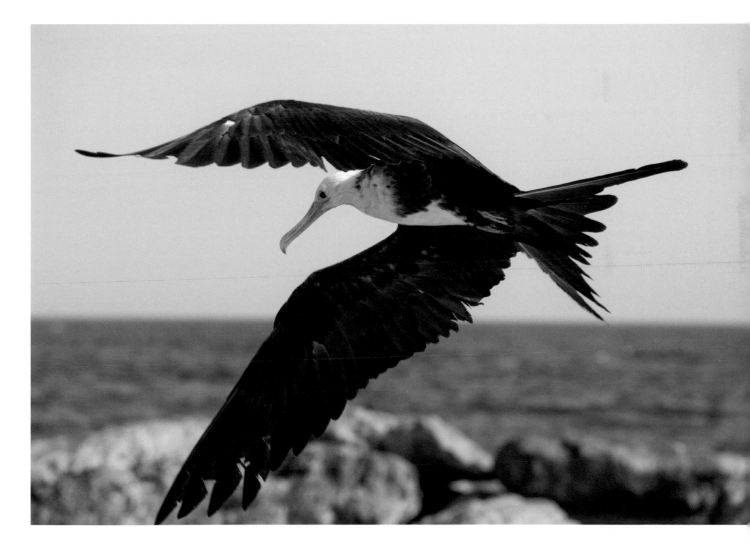

I saw this frigate bird come swooping in to steal food as the trainer at an aquarium was feeding the dolphins. I already had the camera set in Shutter Priority mode at 1/1000 sec. in continuous autofocus—perfect for this situation, since the bird was in the center of the frame. I zoomed the lens out to 200mm.

Many animals are territorial, and patience is usually rewarded with the return of the animal to claim its domain. On St. John in the U.S. Virgin Islands, I once waited for an anole lizard to return after it ran away on sensing the vibrations from my approaching footsteps. My patience was soon rewarded: Once we became acquainted, this tiny reptile didn't seem to mind an intrusive photographer, but each time the flash popped, the lizard skittered away, only to return and repeat the process over the course of countless minutes.

Something similar happened in New Hampshire with a frog in the river just within reach of the shoreline. Sensing my footsteps, it ducked beneath the water. Before long, it popped its head up and pretty much ignored me and the macro lens just inches away (no flash this time). In each instance, I made sure to get my gear ready in advance of settling in to wait so that I wouldn't be making any sudden or disturbing movements when the animal reappeared.

Birds at the nest are an oft sought-after subject for the camera, but one that should be approached with care and caution so as not to interfere with normal feedings. The young of any animal are always intriguing to photograph, but be watchful of the irate parent that might see you as a threat.

As you approach an animal, you will reach a buffer zone where survival dictates a fight-or-flight response. If necessary, step back. If the animal ignores and tolerates you, or just doesn't sense your presence, take time to observe it before starting to take pictures so that you can begin to discern some patterns in its behavior. Then take at least one picture from where you stand, just in case it flees when you take the next step. A wide shot could serve as a record of its habitat.

While these two birds visited the same tree only moments apart, I photographed them differently: For the mockingbird (left), I used Program mode, which set flash sync at 1/60 sec. and resulted in a ghost image because of the relatively bright ambient light. The tiny female woodpecker (naturally upside down, opposite) came out sharp with a flash sync of 1/250 sec. on my EOS 20D.

Not all critters run and hide. In North Carolina, when I came upon an adult timber rattlesnake, coiled and trying to soak up the sun, I noted how one step meant the difference between the rattle warning me to stay away and it going dormant. When I failed to listen and approached even closer, my guide warned me to pull back as the snake began to rear its head with my approaching footsteps, in preparation for a strike. I followed his advice and then used a 200mm lens with my APS-C digital SLR (the equivalent of 320mm), adding the built-in flash to capture the moment. It was the high point of my trip. You just never know when nature will pop out and surprise you.

Approaching Wildlife

When you sight wildlife, stop where you are, advancing only when the animal appears to ignore you. The animal will be less likely to flee or respond aggressively if:

- You don't make sudden movements.
- With mammals, you approach from downwind so that your scent is carried away from the animal.
- You approach from a vehicle or boat.
- You're working from within a photographic blind or otherwise remain camouflaged.
- You don't appear threatening to its young.
- You don't appear to be challenging it for food or territory.
- You don't break twigs, bump into branches, cause leaves to rustle, otherwise make noise, or, in the case of small animals and insects, cast a sudden shadow over them.

I came upon this donkey in the road on Curaçao. It seemed tame enough and proved very cooperative as I inched my way closer, going practically nose to nose with my 17–40mm lens set at 17mm. This exposure of f/8 at 1/125 sec. (ISO 100) required a small boost in post. Had I shot on slide film I would have been happy with the +1/3 EV bias I originally gave the exposure.

Selecting Wildlife Gear

The wildlife I expect to encounter, the shooting environment, and the mode of transportation are often my first considerations when packing gear. I take into account not only the airplane I first board but any subsequent craft, such as tiny puddle jumpers, that I'll be using for connecting flights. If I expect to be on foot under a tropical sun, or riding in a Jeep or an SUV on a mountain road, the amount of gear, as well as size and type of camera backpack, may vary. Usually, I end up traveling a combination of routes, so I pack for the worst-case scenario and learn to be adaptable. I also don't overlook all the other photographic possibilities I might encounter, such as majestic scenic views.

While I prefer a 200mm F2.8 lens or a 70–200mm F4 optic (because of their relatively compact size and light weight) with 1.4X teleconverter at the ready, others may opt for focal lengths of 300mm and longer (or with teleconverter attached) when photographing birds and many other wild animals—the faster the better, especially when you consider that a lot of wildlife makes an appearance early or late in the day, when light levels are low.

I find that, because of its heft and size and the fact that I'm on foot most of the time, I leave my 300mm F4 IS lens at home, resorting to it when shooting on my home turf. I never use a 2X teleconverter because it results in too much light loss and deterioration in image quality, and it slows down autofocusing. And, I always carry a flash. A tripod (or monopod) is a worthwhile option, if it doesn't weigh you down; there are excellent lightweight tripods (under 4 pounds) that are surprisingly effective, even with long lenses.

When hiking, the only camera bag that proves practical is a photo backpack. While protecting camera gear, it allows you to carry all essential equipment and keeps it organized and properly distributed on your back for better balance. A comfortable, secure harness system ensures that the bag doesn't shift weight and throw you off balance and that your shoulders and body are not overly fatigued. I also try not to overpack, developing a sense of what I'm photographing, where I'm going, and how I'm getting there well in advance.

Beyond that, an adequate water supply, suitable clothing and outerwear, comfortable hiking shoes or boots, insect repellant and sunscreen, food or snacks, a compass or GPS for off-road trekking, and various other necessities will all contribute to the success of your outdoor adventure. In unknown territory, a guide is an invaluable asset.

Wildlife Technique

Focusing, exposure, lighting, and timing are the principal watchwords with wildlife photography, but don't overlook good old-fashioned composition. A poorly positioned animal may make even the most dramatic scene appear lifeless.

When it comes to focusing with active animals, follow the procedures previously outlined. Fast action usually implies fast shutter speeds, which may necessitate high ISOs. And don't overlook panning with a running, flying, or leaping animal.

Again, food and water are great lures, so find a fruit-bearing tree, a watering hole, or even a carcass and wait for wildlife to approach. If you spot a predator on the prowl, its prey can't be far away. Photograph the hunter, and then train the lens on the potential victim and wait for the moment to happen. When working from within a photographic blind, mount the lens on a tripod. In a vehicle, boat, or aircraft, image stabilization would prove helpful.

In the end, it may still be necessary to crop the image to arrive at a suitably tight portrait. But don't think all wildlife portraits have to be tight shots. Backgrounds give the animal a sense of place, and other animals in the background provide a feel for the rhythm of life and the dynamic relationship among the various species. That's why a zoom may be a better choice than a fixed-focal-length lens, although zooms tend to be considerably slower and heavier.

Flash can often be used, provided the animal is within reach of the light, and that usually means an external shoe-mount strobe—but not something meek. The camera's built-in flash is unsuitable with subjects more than a few feet away, and flash recycling may hamper your ability to go with the flow and capture unfolding action. (I just barely squeaked by using the built-in flash with the rattler—admittedly, I got caught up in the moment and neglected to bring out my other strobe.) Sometimes flash is not an expedient choice. One such situation involved a mockingbird nest— not because of the nest itself, but because of where it was perched—hidden inside a dense shrub among branches and twigs. The elderly gentleman who was photographing the chicks used a mirror to bounce sunlight into the nest. When done, he moved all the twigs and branches back in place to keep the nest hidden from predators and prying eyes.

Considerable wildlife photography takes place in the moments surrounding twilight. Aside from low light levels, this is also the time when pesky insects love to make your life miserable. Early one morning, I was plagued by a swarm of midges at a salt marsh. I wasn't concerned about my own health but about one of them getting inside the camera when I opened it to change film or lenses. I had to quickly walk a few feet away, managing to complete the task before they tracked me down.

Low light levels may necessitate an ISO of 400 or faster, and flash may still be necessary even then. Light levels fall dramatically under a forest canopy, but in meadows or at the edge of the forest, the light is much brighter. The deer under the shade of a nearby tree will likely require flash, but the bison grazing in the meadow may not.

Made when I took the image on page 149, this portrait offers a more intimate view of the majestic silverback. Because the lens was braced against the glass, I was able to use a 1/60 sec. shutter speed (at *f*/3.5) with a 50–200mm lens at 200mm (equivalent to 400mm in Four-Thirds format).

Landscapes

Each landscape presents a smorgasbord of contrasts, textures, and colors. You can choose to see what everyone else sees or look for the subtle nuances, the intimate details, the alternate viewpoints even of the commonplace—whether by your choice of lens, shooting angle, time of day, weather, framing and composition, lighting, or any combination of these and other elements.

From mountains and waterfalls to fountains and skyscrapers, each landscape element poses untold challenges for the camera and for exposure under all kinds of weather. It's easy to *see* a cloud formation, a fogenshrouded mountain, a sunset over a tropical beach, a solitary tree, a monolithic office tower, but *interpreting that sight in a dynamic way*— one that conveys a sense of its beauty and strength all the way to one's soul— takes more than simply pressing a button. It requires that you envision the possibilities and take control of the moment, not simply respond to it.

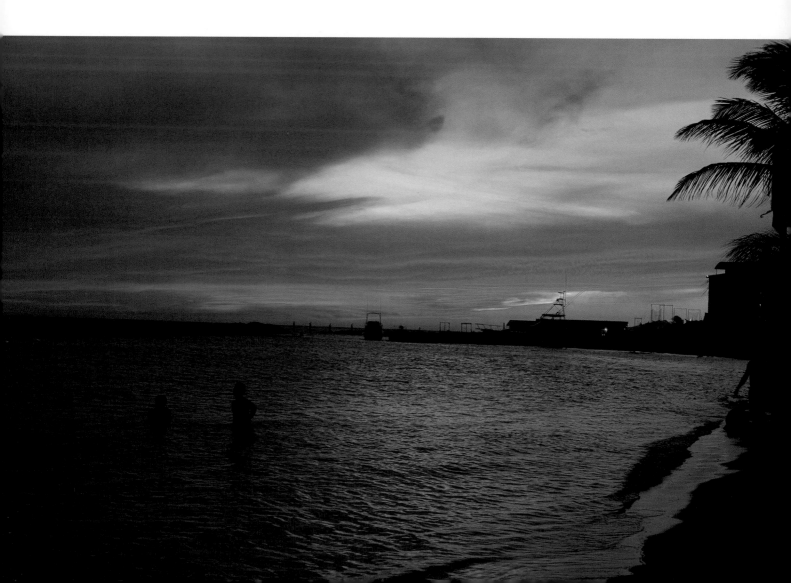

The City by Daylight

Any city, no matter how busy or quiet, requires you to have a shooting plan, even if it's one you've visited countless times or even live in. Today's urban environments are evanescent—you never encounter the same thing the same way twice. Map out the area you plan to visit on paper or in your mind, and know what you'll be shooting. But be prepared for surprises—they're there at every turn.

On Curaçao, I knew I'd be confronted with a colorful architectural display fronting the main harbor separating Willemstad into Otrabanda and Punda, but was pleasantly surprised by what I found everywhere I went within the two halves of the city. Even crossing the pontoon bridge or the more expansive auto bridge, or taking a ferry ride opened my eyes to new viewpoints. I returned to many of the same spots at different times of day, only to discover how the lighting gave the scene a new vitality. When clouds blew in over Punda, I mounted a polarizer to my lens and shot the same scene I had shot before—only then it was markedly different, with the clouds taking on a more dramatic role.

Essential Gear

Lenses. Wide-angle lenses or wide zooms, or even a tele-wide zoom (24–105mm) for a range of perspectives; perspective-control lens for buildings and urbanscapes (preferably 24mm); fish-eye lens for unusual, all-encompassing views.

Filters. Daylight color film: skylight filter with overcast skies/shade/haze. Black-and-white film: UV or haze filter to reduce atmospheric haze; contrast-enhancing filter for more dramatic skies. Film or digital: polarizing filter for saturated colors and striking images.

Lighting. Available light; flash as primary light source or fill, as applicable, with nearby subjects.

Metering. Camera's meter in evaluative or spot mode; handheld spot meter.

Focusing Mode. Single-shot AF or manual focus.

Shooting a sunset requires an increase of about 1 stop if basing the exposure on the colorful sky. However, decrease the exposure by an equal amount when basing the exposure on a duller foreground reflection when that is the point of focus. When shooting digital, you may still need to increase saturation, as I did here.

And in many places, it's not just the architecture that grabs your attention. It may be a kiosk, a marketplace, an ornamental cannon, a flowing fountain, a monumental statue, or even a playground. Shops and restaurants can make for interesting pictures, especially when populated by patrons. And of course there are parks, large and small, and sometimes a lake or two within the city limits. Shopping malls and industrial complexes may also be of interest photographically.

But as photographically enticing as they are, cities can be challenging to capture exposurewise. The urban environment tends to be awash in steel, glass, asphalt, and concrete—all highly reflective. Sidewalks and pavement bounce back lots of light, as do the gleaming towers. Streetlights and car headlights might also throw off the exposure. Each of these elements will result in underexposure. A good starting point is to add +1/2 or +1/3 EV to the exposure, and bracket on the plus side, but usually not more than +1.5 EV.

What's more, on a bright day, one side of the street can be well illuminated while the other stands in shadow. Or, the building's exterior can be well illuminated, but peer inside its doors, and you encounter utter darkness by comparison. In other words, contrast can be excessive, making it difficult to capture detail in highlights and shadows without sacrificing one or the other. You might try opening up 1/3 to 1/2 stop to capture some of the shadow detail without sacrificing the highlights, although you may lose some of that intense blue in the sky.

In any of the above situations, making an evaluative-metered exposure will provide a reasonable image, as will employing centerweighted averaging. However, you might want to go one step further and make spot readings of key subject tones and center the reading around either one key spot reading or an averaged exposure based on multiple spot measurements. Keep in mind that if you bias exposure to a single spot reading, you still need to compensate for excessive brightness or darkness to arrive at a usable exposure.

When photographing a shop from the outside, you may have to settle for a dim interior unless the store owner will let you strategically position a flash inside, which is very unlikely. If the dark interior will present itself as an intrusive black hole on the picture, you would do best to avoid it. On the other hand, if you're shooting digital, you can do either of two things: Shoot the picture and attempt to correct for the excessive contrast in post (which isn't always doable when shadows are blocked up or highlights blown out), or shoot one exposure for the exterior, a second keyed to the interior, and composite the two on your computer. It's a laborious task, and you'll have to use a tripod to ensure that you capture the identical image both times from the same exact position and angle. Provided there is absolutely no movement inside the store or out (which includes no reflections of passersby or swaying tree branches in the shop windows), you can also try Merge To HDR in your image-editing software (see pages 112–113), making a series of bracketed digital exposures keyed to both the interior and exterior.

Extended depth of field is often a priority, unless you want to isolate certain landscape elements with selective focus. Subjects such as fountains benefit from relatively long exposures to give the water that sense of flowing movement. However, shots of the fountain can be equally effective with the water frozen entirely. It's a judgment call, depending also on the availability of a firm support for those long exposures (within reason, image stabilization will help). To determine how much, if any, exposure compensation is needed for the water, study the reflectivity of the pool and foaminess or whiteness of the water; if it's considerable, it will throw the meter off toward underexposure. The added exposure will likely be between +1/2 and +1 EV, if that. What about background tonality? That may add to the problem or perhaps work to balance the exposure. If the water appears blue and the building behind is gray, you probably can go with the metered expo-

sure. As for ISO, you'll only need ISO ratings higher than 100 or 200 on overcast days or when shooting in the shade.

Some structures, such as statues, are interesting to picture in silhouette. Simply base the exposure on a reading of the bright blue sky, and open up just a bit so that the sky doesn't turn a murky blue.

One filter that will come to the fore with urban landscapes captured by daylight is the polarizer. It will intensify blue sky and remove reflections from glass and many painted surfaces. You might want to rethink using a polarizing filter with a reflecting pool, since the reflections in the water add to the pool's allure. When shooting daylight color film, a skylight filter might be needed in the shade, but not if part of the scene is illuminated by skylight, with part in shadow, as that will add too much warmth where it's not needed.

Some places are best known for their medieval or ancient architecture, others for the colorful atmosphere they create. On Curaçao, colorful buildings are the theme, and a bright sun helps bring out the intensity of these colors when it fully illuminates a facade, especially when you use a polarizer. Shooting in Program mode, I increased exposure by +1/3 EV for the digital capture of the orange facade, then gave a small boost to brightness, saturation, and sky intensity in post.

Interiors

When an architectural photographer shoots an interior, the job often involves using numerous strobes or hot lights to paint every essential surface in light. The travel photographer takes a more laid-back approach, perhaps throwing one strobe into the mix to augment the existing light. Obviously, as a passerby with a camera, whether amateur or pro, you won't be allowed to set up lights on stands—and it will be very unlikely that you'll get permission even to set up a tripod. With low light levels, ISO will be of greater importance. However, think long and hard before using a digital ISO higher than 800 or pushing film beyond this point. The whole idea behind architecture and interior photography is to see crisp detail. Grainy textures in film and digital noise only work against the picture.

Interior lighting may vary widely. These days, with fluorescent bulbs replacing incandescent lighting, you can never be sure of the lights until you see the distorted colors in the picture. When shooting color film, the best choice would be negative film, since it can best tolerate the wide spectrum of colors encountered in today's lighting. With digital, take a custom white balance reading and use that. Shooting in AWB (auto white balance) and correcting during RAW conversion may do the trick, as well. Of course, very often the colorful play of lights can be very effective, so don't dismiss it out of hand: Fluorescent lighting will often add a green tinge that makes a dingy interior look more ominous. Incandescent lighting will have a welcoming warmth, but if not to your liking, that can easily be fixed with the appropriate filtration or WB correction. However, keep in mind that the use of camera filters may produce an even slower exposure or limit depth of field.

Exposures can be very tricky indoors, owing to the interplay of light and shadow in areas touched by the light or hiding from it. The contrast may be dramatic, as in a dimly lit house of worship where flash may not be permitted. Each situation is unique.

For indoor and outdoor situations, a contrast-reduction filter might prove helpful to tone down the highlights or beef up the shadows. With digital, you can try a low-contrast setting in the camera or deal with exposure and contrast problems in post, assuming they're not excessive.

The old synagogue in Willemstad, Curaçao, actually has a sand floor. The interior was lit only by available daylight, necessitating an exposure of *f*/4.5 at 1/30 sec., but I did have to go to ISO 800—not an optimum setting for digital capture. Because of the contrasty interior illumination, I bracketed at +2/3 and -2/3 EV around a base exposure, then opted for the +2/3 EV boost and made some adjustments afterward.

This jewelry store on the main thoroughfare in Willemstad was well lit, so I was able to bring my ISO down to 200 for a 1/100 sec. exposure at *f*/4.

In My Camera Bag

It's interesting to compare equipment for different locations. Below you can see how my Curaçao trip stacked up to a photo-hiking trip I made to North Carolina.

WESTERN NORTH CAROLINA EXPERIENCE

- Canon EOS 20D digital SLR camera
- Canon 17–40mm F4L lens
- Canon 28–105mm F3.5–4.5 II lens
- Canon 200mm F2.8L lens
- Canon 1.4X extender (for the 200mm)
- Canon 100mm F2.8 Macro lens
- Canon TTL auto shoe-mount strobe
- Canon TTL auto macro ringflash
- Compact tripod w/compact ball head
- Canon remote triggering switch (for camera on tripod)
- Canon remote flash transmitter (for off-camera strobe)
- Lens shades
- Heliopan circular polarizing filter
- Compact point-and-shoot digital camera
- Photo backpack

CURAÇAO EXPERIENCE

- Canon EOS 5D digital SLR camera
- Canon 24–105mm F4L image-stabilized lens (first trip) or 17–40mm F4L lens (second trip)
- Canon 70–200mm F4L lens
- Canon 1.4X extender (for the 70–200mm)
- Canon 100mm F2.8 Macro lens
- Canon TTL auto shoe-mount flash
- Compact tripod w/compact ball head
- Canon remote triggering switch (for camera on tripod)
- Canon remote flash transmitter (for off-camera strobe)
- Lens shades
- Heliopan circular polarizing filter
- Sekonic handheld flash meter
- Compact point-and-shoot digital camera
- Photo backpack

The City at Dusk and after Nightfall

Often, the best time to capture the lights of the city and the nearby buildings and streets is at or around dusk. The lights have come on, but they won't produce excessive contrast against the grayer surroundings. At night, you might try using flash with nearby structures to augment the existing street and store lighting. The mix of colors on daylight film or with the camera set to AWB can lead to some very interesting results. If you're shooting RAW, play around with the WB settings during conversion for an array of possibilities.

Floodlighting and nearby streetlights can be helpful, provided the lighting remains more or less even over the face of the structure. Otherwise, the hot and cold areas become troublesome, and it might even be best to pass up that structure and focus on another one that is better lit. Sodium vapor adds colorful touches of yellow-orange to anything it touches. Against a dusky blue sky, these contrasting colors make the picture surprisingly vibrant. And of course, if you want vibrant colors, nothing beats neon, provided it's not overexposed.

When viewed from a distance, a city skyline at twilight or after nightfall may appear to be a difficult subject, but today's camera metering systems do a surprisingly good job of it. I bracket exposures not so much as a safety measure but because the amount of exposure is a judgment call. It depends on city lights, cloud cover, the presence or absence of the moon, foreground, and subject-to-camera distance, which then determines how much of the scene is surrounded by a black void.

A tripod is often a necessity with slow films and low digital ISO settings, although image stabilization, perhaps together with a boost in ISO, may make the tripod unnecessary. Flash can be used with nearby buildings to add a colorful twist to an already colorful scene. I have managed to capture some interesting scenes at night with flash on camera, thanks to the 24–105mm image stabilized Canon lens. The blackness of night exhibits digital noise readily, so I avoid digital ISO settings higher than ISO 400 where possible, and certainly nothing more than ISO 800. Even then, it may be necessary to employ a plug-in to remove noise or do some retouching. Films rated faster than ISO 400 tend to be grainy. For that matter, for any city scenes involving ISO 400 and faster color film, my preference would be for negative emulsions, which tolerate exposure and color variances much better than slide film, without the associated grain texture.

For many of the fireworks exposures I shot in Coney Island, I kept the moon in the shot for dramatic effect. The camera was, of course, on a tripod, remotely released. The lens was a 24–105mm, and exposures ranged from 2.5 to 5 seconds with the camera in Shutter Priority mode.

Rock Formations, Mountains, and Trees

The landscape is filled with captivating shapes and forms of varying brightness. A tree might not be unduly bright, but the leaves reflecting sunlight will throw the meter off, leading to underexposure. Landforms may be gray, but even lava rock, for example, under bright sunlight will reflect more light than that same rock in the shade. And many landforms exhibit light tonalities to begin with. Surround that formation with reflective grass, sand, or sky and the exposure meter will doubtless lead you down the wrong path—into underexposure.

Rocks that get wet, whether by rain or a cascading stream, tend to take on a duller appearance, one that's more in tune with your exposure meter. But then consider sunlight glinting off the wet rock or off pools of water within shallow nooks or crannies in the rock, creating glaring hot spots that again throw the meter off toward underexposure.

And, bright scenes aren't the only vistas we encounter. In contrast, if either heavy shade or a cave entrance dominates the scene, that may lead to overexposure. Granted, in nature we are less likely to come upon such scenarios. The best option might be to focus on the areas of darker tonality and largely, if not entirely, eliminate the contrasting bright elements through in-camera cropping. Compromising the exposure to include both may lead to an unsatisfactory image of either. If the surrounding area is equally important, it might be best to allow the cave to go dark to give the viewer a sense of its ominous nature. You may be able to bring up the tonalities in post, in digital capture or in the scanned image.

Any time of year is a good time to study the bark patterns and tree forms in broad-leafed trees. Some trees are more interesting for the shapes that evolve after the tree is laid bare in winter, especially in silhouette, whereas others, conifers among them, appear more interesting with leaves intact. The most eye-catching shapes and forms reveal themselves under a variety of lighting, from flat to strong sidelighting. Learn to shoot tight and you may uncover strange faces and monstrous manifestations in the trees.

Distant mountains and mountain ranges require that you take the haze and sky into consideration. Haze will make any mountain seem brighter, and sky will, of course, complicate the exposure even further, both leading to underexposure. However, a little underexposure can make the mountain appear more looming and ominous or make a mountain range appear more mysterious, so don't automatically assume that you need to fully open up to compensate. Bracket exposures to get a range of up to +1.3 or +1.5 EV, and then evaluate the results. If you're standing on the edge of a road or another mountain and include part of this in the foreground that overlooks the distant scene, the exposure should take this foreground element into consideration. The tricky part is not overexposing or underexposing, because either would diminish the role the foreground element plays. Remember that foregrounds help establish depth, as does the presence of aerial haze.

The brightly colored leaves can trick a camera's metering system into underexposure. That's not entirely bad when shooting transparencies and slides. Controlled underexposure helps to saturate this dazzling splash of autumn color.

Landscape Exposure Guide

Spot-meter readings taken in New Hampshire's White Mountains revealed the following, in order of brightness:

Subject	Spot Measurement (ISO 100)
Sunlit snow	15 2/3 EV
Blue sky	14 2/3 EV
Snow in open shade	13 2/3 EV
Sunlit meadow	13 1/2 EV
Forest: sunlit patch	12 EV
Forest: shaded patch	8 EV

Oceans, Rivers, and Waterfalls

Water is a tricky subject to photograph. Sometimes, it's highly reflective; other times, it appears to soak up the light. Of course, it depends on your shooting angle, the depth and clarity (or murkiness) of the water, and the prevailing light conditions.

A small stream or narrow river channel may be surrounded by foliage and rock, with the dark-toned water balanced to some extent by the reflective rocks and foliage. Then again, the sun may be glinting off the water, and deep pockets of shade may swallow up light. You have to weigh each in turn to determine which way the exposure should go.

A rushing stream, cascade, waterfall, or wave crashing against rock or shore can lead to a variety of images and emotional responses, depending on the shutter speed used. Slow shutter speeds (usually not longer than 1/2 sec.) create an evanescent texture and a sense of timelessness in brooks, cascading waters, and falls. In contrast, freezing the crashing wave with a shutter speed of 1/1000 sec. so that it appears to have fingers that reach out to grab you captures the power and majesty of that wave, especially when you time your exposure to catch the wave at its crest (release the shutter just as the wave is about to hit). Then again, employing a shutter speed even as slow as 1/160 sec. can lead to a complex blend of foamy textures and seemingly floating droplets.

Using filters is an individual choice. On Curaçao, where I began using a polarizer in earnest with my wide zooms, the use of this filter helped me bring out the blue sky as a backdrop to many (but certainly not all) scenes involving water. Keep in mind that there is a substantial loss in light with this filter that cannot always be compensated for with any satisfaction by boosting the ISO (owing to grain and noise).

With any landscape, keeping the blue hue that shade and overcast conditions produce helps to convey a different emotional response to the picture. In fact, the blue color may enhance the image, whether it entirely envelops the image or forms only part of it, serving as a color accent in contrast to the surrounding warmer or neutral tones.

In any event, white foamy textures will fool the meter into underexposing. A very small degree of underexposure, to maybe 1/2 stop, will help preserve the detail in the water. Overexpose and that detail is certainly lost. Judge the resulting exposure not simply by the water but by any surrounding rocks and foliage. If they appear blocked up, with lost shadow detail, then you'll need more exposure. If uncertain, bracket around the metered camera exposure. Or, base the exposure on spot-meter readings.

A polarizing filter brought out the clouds and intensity of colors in this scene in camera. Then, I applied a strong tone curve and increased saturation to make this scene of a Curaçao beach as stark as possible after increasing exposure in post. A 1/1000 sec. shutter speed helped freeze the surf breaking against the rock.

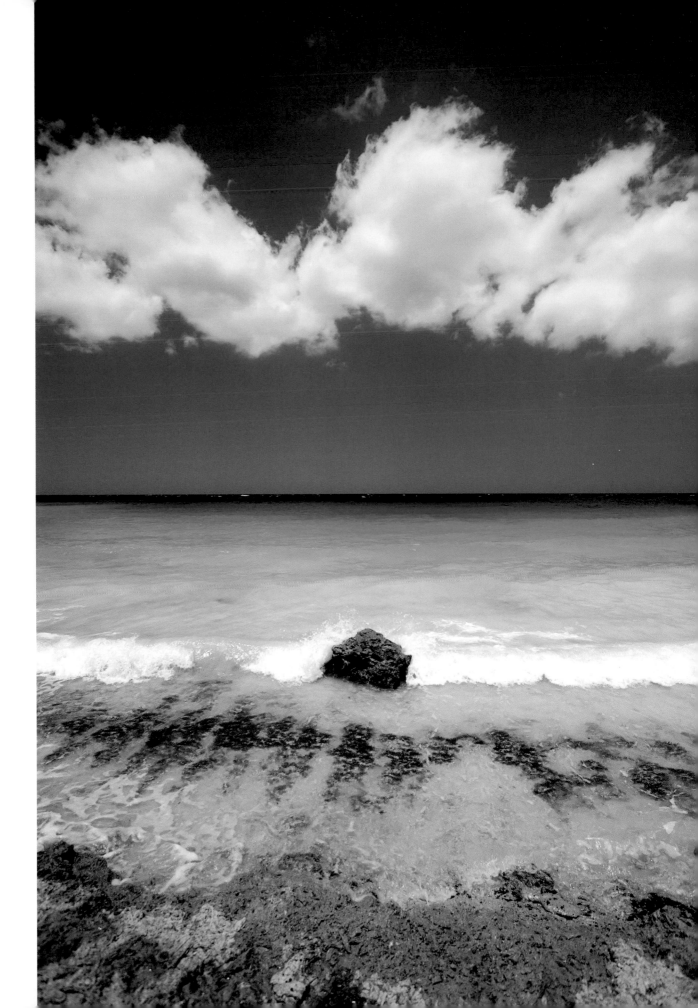

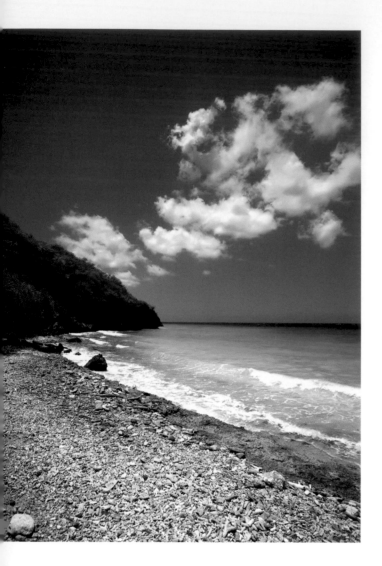

I was very taken with this scene, focusing most of my attention straight ahead. As I turned to my left (and right), I noted the captivating diagonal lines that formed. Even though I used a polarizer, I felt the scene needed a bit more intensity, so I pulled a Photoshop rabbit out of the hat, as it were, and applied the Equalize command (an Image/Adjustments function).

Sun, Moon, and Clouds

A deep blue sky, especially with just the right clouds in strategic locations, can provide a dramatic backdrop to any scene, or it can be the raison d'être for the picture in the first place. Sky and clouds can, however, trick the meter into underexposing by as much as 2 full stops, resulting in a dull, muddled sky with gray clouds instead. But, we don't really want to compensate fully—not more than perhaps +1 to +1.5 EV, to retain some of that texture in the clouds.

Sunrise and sunset are magical times with the sky all aglow in shades of red, pink, orange, and yellow. Give about 1 stop of added exposure when making readings of the sky at a point low on the horizon. Otherwise, the surroundings will be grossly underexposed, to the point of being a murky blur. If your exposure is based on a foreground reading, decrease the exposure by the same amount to ensure the intense colors in the sky.

Dusk and dawn can be even more magical, with just a hint of blue in the sky and clouds wrapped in subtle shades of pink and magenta. No exposure correction should be needed unless brightly lit buildings are in the foreground. Either situation may be bright enough for you to take the picture with the camera handheld, especially with an image-stabilized lens in play. Long, slow lenses will require a tripod. Filters will suck the life out of the shot and result in a critical loss of light.

Light levels are often quite low when the moon makes an appearance, although I have seen it fairly high in the sky during the day at times. I've found myself capturing the most dramatic moonscapes after the sun has gone down, with the moon against a deep black sky. That said, throwing up a cloud cover to reflect the moonlight and spread it out over a wider area can have its poignant moments, as well. It also makes it a bit more difficult to establish an exposure, especially with brightly lit buildings in the foreground. Too little exposure and you lose the outward spread of light permeating the clouds; too much and the moon becomes lost in a wash of white light among the clouds. Exposures may run several seconds in the dead of night, even with illuminated buildings in the scene.

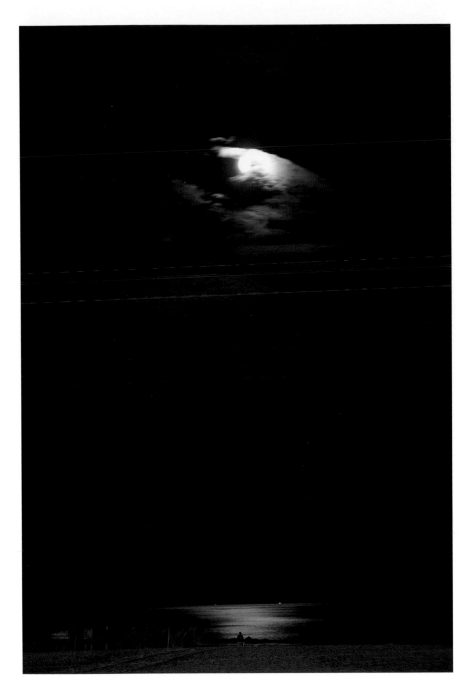

I went to Coney Island to photograph the fireworks, but I also came back with this image. The moon was nearly full and playing hide-and-seek with the clouds. Here, it appears to be dipping behind a hole in the sky. But if you look really closely, you'll see a very subtle lunar rainbow coming off the moon. Exposure at ISO 200, in Shutter Priority mode, was 3.2 seconds at f/4.

Caution!

Never point a telephoto lens or a spot meter directly at a bright sun for any length of time, as you may do permanent damage to your eyes and the camera/meter. With digital cameras, damage to the imaging sensor may also result.

Snow, Fog, and Rain

Giving a snow-covered scene a +1.5 EV exposure increase will convey the impression of a winter wonderland. Bring tonal levels down with only a +1/2 to +1 EV boost and you may help capture the gloom of a cold day, especially when the arctic blue is not filtered out. The reduced exposure will also help bring out textural detail.

Ice, on the other hand, will lose much of its texture if overexposed or even when exposed to its brilliant whiteness, so you might want to compensate the exposure no more than +1 to +1.5 EV. As with snow, keeping some of the blue could help convey that icy-cold feeling. If the ice and snow aren't the central element in the scene, then the exposure compensation should be reduced.

That said, a blanket of snow or ice surrounding the subject, say an isolated tree, will mandate more exposure compensation (perhaps as much as +1 to +1.5 EV) than would a small patch of white adjacent to the subject, which might not need more than +1/2 EV. Just watch that adjacent dark tonalities aren't blocked up by undercompensating. By the same token, overexposing the snow and ice may lead to some color distortion in the burnt-out highlights.

Rainwater tends to darken pavement and rock, but as mentioned earlier, glints of bright lights in the wet areas will throw back too much light, causing underexposure. Puddles of water can be treated as neutral, unless they have a very deep tone or are reflecting bright sky, in which case exposure should be compensated accordingly.

Fog, which is essentially a low-lying cloud, creates a blinding wash of white that a meter interprets as too much light, leading to underexposure. That's a good thing, up to a point. If you overcompensate by adding too much exposure, you lose details in the fog. So, bracket at the metered exposure, followed by +1/2 and +1 stop, going to +1.5 EV if you also filter out the blue. The fog should hold some mystery, and by revealing a smidgen of what is within, it proves even more tantalizing to the senses.

In contrast to fog, mist is not as dense and rises upward, but it may still require a bit of exposure compensation to deal with the reflective nature of the fine airborne droplets enshrouding the scene. Aerial haze contains both solid and liquid airborne particles, which explains its variegated effect on the scene. It doesn't carry the romantic or gothic allure associated with fog and mist, and it often simply leads to a loss of detail in the image, hence attempts to get around it with various filters. I prefer to leave the haze, as it adds depth to the scene, but the use of a polarizer may pull some of the haze out of the shot. A polarizer, however, is not effective with fog and mist.

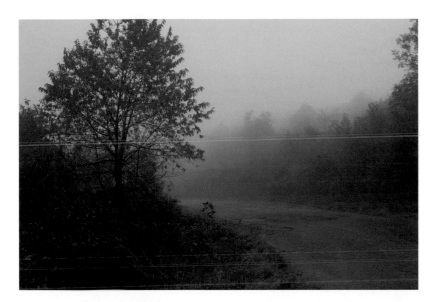

When I photographed this road in western North Carolina, with the camera in Program mode, I set ISO to 400, and then bracketed at normal, + 2/3 EV, and + 1.3 EV to compensate for the fog's brightness. I prefer either of the latter two exposures, but the final choice is subject to personal taste and the feeling one wishes to convey. And you might choose to bracket at different increments—but don't go too far or you'll lose the effect.

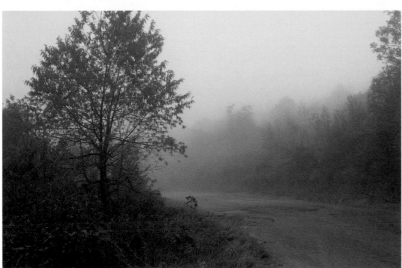

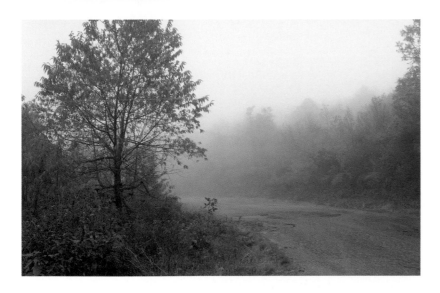

Rainbows

A rainbow is a phenomenon involving light being reflected and refracted by airborne moisture droplets, much like a glass prism acts on light. Most of us are familiar with daylight rainbows resulting from sunlight hitting raindrops or water spray. The physics of light aside, rainbows are fascinating and magical if we just allow ourselves to get lost in the moment. Photograph the rainbow the moment you see it, then move around to shoot it from a different angle, which may reveal more or less of it. If you're lucky, you may see a double rainbow—consisting of a primary and secondary, but fainter, rainbow—and possibly the more elusive supernumerary rainbow. Any autoexposure mode will do in the daytime, with a bit of underexposure helping to saturate the colors.

There are also lunar rainbows, which are fainter than regular rainbows and result from bright moonlight hitting water droplets. You can also often observe a variant of the lunar rainbow in a cloud surrounding a full or near full moon in the dead of night (as I did with the moon over Coney Island on page 173). Lunar rainbows may require exposures extending several seconds or longer. For the image on page 173, I had to pull back on the exposure in Photoshop to bring out the colorful glow in the clouds.

How Would You Tackle This Situation?

Nothing beats a well-exposed image. How do you know when the image is correctly exposed? Much of that depends on the effect and mood you're trying to convey. What's "correct" is relative, but from a purely technical standpoint, a good exposure captures all the important details from the shadows (the darkest tones) to the highlights (lightest tones). That means you have to determine what's important to the picture. Which tones, if any, can be sacrificed so that other tones are recorded with sufficient depth and detail?

Knowing when you've overstepped the bounds of good exposure can be tricky sometimes and comes with experience, but if the picture looks muddy or washed out, or simply feels wrong, you'll know you've taken the exposure too far in the wrong direction. If it looks clean and crisp, you've hit the nail on the head. Once you're there, you can experiment by degrees with over- and underexposure for special effect and mood, such as with high- and low-key imagery, foggy scenes, and fashion shots.

In a high-contrast situation, defining important shadow and highlight detail is more important than ever. What do you define as a key tone? How do you recognize it? Let's say you have a person standing in the shadow of a tree surrounded by a sunlit meadow filled with spring flowers. How would you approach this situation?

I would look at the scene and judge the meadow to be as important as the person, considering that it occupies a large expanse within the frame. If allowed to burn out, it would be a major distraction. On the other hand, if you lose sight of the portrait subject and underexpose the person, the picture is a failure.

So, the question I leave you with is this: Where do we go from here? Hint: Don't overlook the medium in use (i.e., film or digital) and its special needs; the applicable mediating processes, including developing, scanning, software editing, and printing; and the end use—the image's final destination.

As the bus I was on stopped to let passengers off, I spotted this beautiful rainbow (with a faint secondary rainbow to the right). I hurried off the bus, camera in hand, and had just enough time for two exposures before the bus took off. I later scanned the slide and made an exposure adjustment in post.

Close-ups

There's nothing as exciting as coming nose to proboscis with a butterfly or capturing intimate details in a flower. Close-up photography is a specialized pursuit, especially when it extends into the macro range, but no more so than studio portraiture or wildlife photography—each requires a certain discipline and a mastery of the tools germane to that specialty. You can begin to shoot close-ups with any lens equipped with a macro setting, but to really get in there, you'll need a little more: a true macro lens. The wondrous images that reveal themselves will amaze and astound everyone who views them.

You don't need a macro lens to get a tight shot of a large blossom. A wide-angle lens allows you to get a different perspective on flowers. Here, I used a 10–22mm lens on my Canon EOS 20D (an APS-C format), setting focal length at 22mm and moving in as close as possible. Setting ISO at 400 and shooting by available light, I was able to stop down to f/10 for considerably greater depth of field than with my 100mm macro lens under the same conditions.

The Tools

My choice in lenses with a film or digital SLR is a macro lens ("micro" in some circles), specifically one in the short telephoto range of 90 to 105mm. Shorter lenses may be slightly faster and a little easier to work with under ambient light conditions, but these longer lenses give you more breathing room with skittish subjects, meaning the nearest focusing distance is greater (about 1 foot). Even longer macro lenses (for example, 180mm) tend to be heavy and bulky and more suitable when mounted to a tripod. I, however, prefer to shoot handheld and therefore opt for the lens that will let me do so comfortably, especially since I often find myself holding the camera—sometimes with one hand—for long periods of time as I wait for a critter of one kind or another to settle in. With inanimate subjects, I may still prefer to work handheld so that I have greater leeway in shooting angles.

Essential Gear

Lenses. Macro lens; any lens with compatible extension tube attached; any lens with close-up (plus-diopter) lens attachment; zoom lens with macro-focusing.

Filters. Daylight color film: skylight filter with subjects in shade.

Lighting. Available light or macro flash.

Metering. Camera meter.

Focusing Mode. Manual focus is often preferable with close-ups at or near life size (and beyond); otherwise, autofocus will do.

Flies don't stand still, and bringing the lens to bear on this one was no easy feat. To complicate matters even further, I employed a special macro lens—the Canon 65mm 1-5X, which lets you shoot up to five times life size, although I was probably at two times life size for this exposure. The macro ring flash helped freeze the moment. Although I stopped down to f/16, at this magnification depth of field is negligible, so I focused on the compound eyes.

Most macro lenses today focus to life size. A few focus only to half life size. You can increase magnification with practically any lens by adding an extension tube. The standard extension tube is a hollow ring. These accessories may come individually or in sets of two or three, consisting of rings of varying length that may sometimes be used in combination to achieve the desired magnification. There are also variable-length tubes that prove very convenient. The extension tube attaches to the back of the lens at one end and, just like any lens, mounts to the camera at the other end. Unlike an extension tube, the life-size adapter is a tube matched to a specific macro lens (one that only goes to half life size), adding glass elements for improved performance.

The use of a life-size adapter or extension tube changes the lens aperture to a smaller effective *f*-stop. Fortunately, through-the-lens metering compensates where needed, with both ambient light and TTL flash. When using a handheld meter or non-TTL flash, the story changes: You'll have to apply the lens extension factor or calculate the effective *f*-stop by using a mathematical formula. (See *lens extension factor* in the glossary.)

As an alternative, there's the plus-diopter (close-up) filter; it's not a filter so much as a lens attachment, but this piece of glass does mount to the front of the lens like a typical filter. The downside: The added air/glass interface degrades the image (less so in better-quality filters made with compound glass elements and coated optics), and you need a filter of the right size for each lens (or the appropriate adapter ring). On the positive side, there is no loss in light. Plus, it's much faster and easier to attach to the lens, and you don't need to remove the lens—a consideration where dust or tiny flying insects might be a problem. Older camera systems also made use of a macro bellows and special macro-bellows lens.

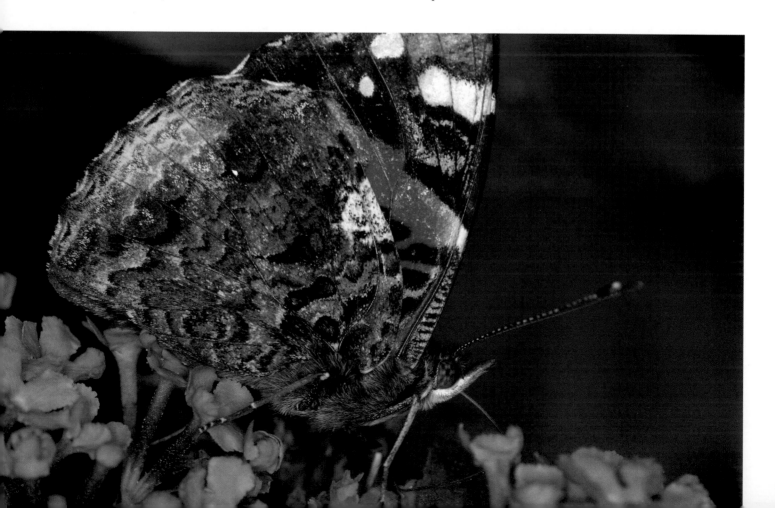

The Basic Underlying Principles, and then Some

There are several basic concepts you have to wrap your head around before you can successfully take great close-ups. On top of that, there a few things you should keep uppermost in your mind:

- The closer you get to the subject, the less depth of field there is, which means that at or near life size (1:1 reproduction ratio or 1X magnification) and beyond, depth of field is practically negligible, and there is no room for focusing error, so focus carefully.

- At life-size magnification and beyond, set focusing manually to the closest focusing point on the lens; then physically move to and fro with the camera to lock in focus.

- All movement at the camera is magnified, and the image will easily blur or go out of focus, so aside from controlling your breathing and holding absolutely still, use fast shutter speeds or any shutter speed that is at least equal to the reciprocal of your lens focal length—or use flash.

- Use a tripod or tabletop tripod, where practical, with a remote release.

- Be prepared to release the shutter when the subject moves into focus.

- Use available light and selective focus to blur out the surroundings, which can create inviting splashes of color with the right background.

- Use flash to freeze subject movement; use high-speed sync to reduce the available-light exposure where high ambient light levels might introduce a blurry ghost image behind the flash-frozen subject.

- Use flash with small *f*-stops to squeeze every drop of image depth you can muster (but don't stop down too far, as that will introduce diffraction and degrade the image).

- Use flash with small *f*-stops to restrict the reach of light and thereby throw distracting backgrounds in shadow (or use high-speed sync where applicable).

The tough part about photographing butterflies is deciding whether to catch them with wings folded or open (which is when they're often most colorful). I was lucky to capture this red admiral as it was fanning its wings while feeding on the nectar from these flowers. Situations such as this also make it difficult to find just the right spot on which to focus. I usually opt for the near wing and work from there, although there are times (such as when the butterfly is feeding) when it's best to focus on the area of the head, proboscis, and, possibly, the antennae, and see where that takes you.

Macro Flash

In close-up photography, the problem with seating a conventional flash atop a hot shoe is that the flash head is designed to throw light at more distant subjects. When the strobe is situated on camera, the light emitted shoots past anything too close to the lens. Some flash heads feature a downward tilt function, but clearly that's a waste of time: Chances are that the lens or lens shade will block the light to some degree, if not entirely, and more so the closer the lens is to the subject. Whether it's TTL flash or not, the story is largely the same—even worse for non-TTL flash systems, in fact. Taking the shoe-mount flash off the camera is not the answer.

The more practical solution is to use a macro flash. This flash sits on axis with the lens, ensuring that the light actually reaches the subject. These strobes are relatively weak, with the light reaching a few feet at best. To be practical, I'll limit this discussion to TTL-dedicated systems.

Macro flash takes several forms. The most common and easiest to use is a ring flash, a circular flash tube that attaches to the front of the lens. Modified configurations exist, but they essentially work in a very similar fashion. As a more powerful alternative,

I photographed this surprisingly patient dragonfly in Ashualot State Park in Keene, New Hampshire, amid droves of mosquitoes taking turns at me. I mounted a ring flash onto the 100mm macro lens and kept shooting as long as the dragonfly would allow, not letting any breeze get the better of me.

Note that when a ring flash is used on axis with animals (or people), it has the same effect as an on-camera shoe-mount flash, producing red-eye—or in the case of my cat, glowing green eyes.

use a twin-head macro flash system. This consists of two flash heads that mount to the front of the lens. These tiny flash heads weigh next to nothing and can be positioned individually around the lens, providing more flexible lighting. The power/control module in all these macro lighting systems sits in the hot shoe and drives the flash head. The major benefit behind the ring flash is that it can squeeze into tight spaces where a twin-head arrangement (or shoe-mount strobe) dares not go.

Many macro flash units feature a set of focusing lamps that are manually activated to help you see in dimly lighted conditions. It makes more sense than pulling out a flashlight.

Irises are one of my favorite close-up subjects, and iris buds even more so, especially when shot with selective focus. Interestingly, I didn't use a macro lens for the image at right. Instead, I used a 70–200mm lens coupled to a 1.4X teleconverter, which brought the lens to a closer focusing point than normal. I opened up +1/3 EV (ISO 100) for a 1/200 sec. exposure at f/5.6, which was still wide enough to bring the flower in the background to a soft blur. And, I used shoe-mount flash.

As a comparison, for this available-light shot of a bearded iris blossom below, I employed a 100mm macro lens for an f/5 exposure at 1/320 sec. (ISO 400). The camera was in Program mode and set for evaluative metering. I gave the picture a +1/3 EV boost for good measure.

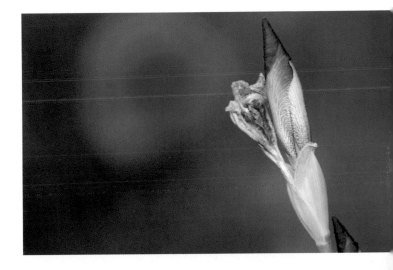

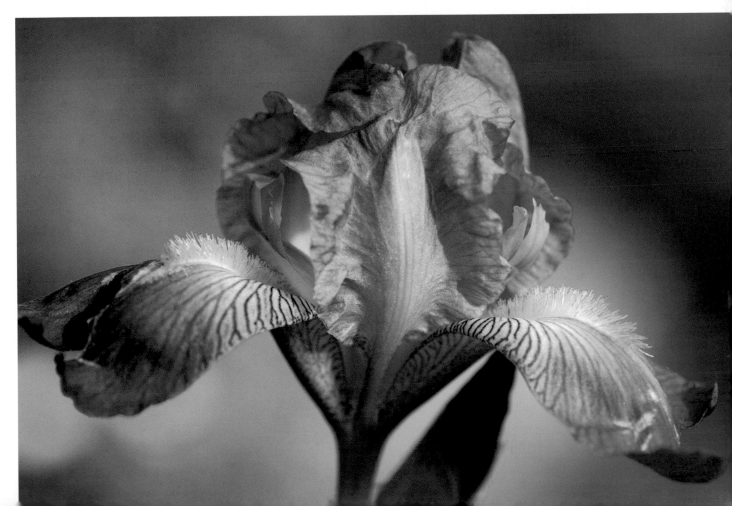

Appendix A: The Effect of ISO on Exposure

The table below represents relative ISO values and the resultant effect on exposure were you to shift to a higher or lower ISO for a given purpose: higher for sharper results throughout (to stop action, prevent camera shake, enhance depth of field); lower to blur action (for slow shutter speeds) and backgrounds (for selective focus). Think of it as High = sHarp, LOw = sLow and sOft.

Note: Shutter speeds and *f*-stops are provided simply as examples and don't necessarily reflect actual exposures for a given ISO. Individual exposures will vary under any given set of circumstances.

Higher vs. Lower ISO	Lower vs. Higher ISO
Higher ISO enables use of smaller aperture or faster shutter speed.	Lower ISO enables use of larger aperture or slower shutter speed.
ISO 400 vs. ISO 200 Effect: 1 stop smaller or twice as fast (for example, *f*/8 at 1/250 sec. vs. *f*/5.6 at 1/250 sec., or 1/250 sec. at *f*/8 vs. 1/125 sec. at *f*/8).	ISO 400 vs. ISO 800 Effect: 1 stop larger or half as fast (for example, *f*/8 at 1/250 sec. vs. *f*/11 at 1/250 sec., or 1/250 sec. at *f*/8 vs. 1/500 sec. at *f*/8).
ISO 400 vs. ISO 100 Effect: 2 stops smaller or 4 times as fast (for example, *f*/8 at 1/250 sec. vs. *f*/4 at 1/250 sec., or 1/250 sec. at *f*/8 vs. 1/60 sec. at *f*/8).	ISO 400 vs. ISO 1600 Effect: 2 stops larger or one-fourth as fast (for example, *f*/8 at 1/250 sec. vs. *f*/16 at 1/250 sec., or 1/250 sec. at *f*/8 vs. 1/1000 sec. at *f*/8).
ISO 400 vs. ISO 50 Effect: 3 stops smaller or 8 times as fast (for example, *f*/8 at 1/250 sec. vs. *f*/2.8 at 1/250 sec., or 1/250 sec. at *f*/8 vs. 1/30 sec. at *f*/8).	ISO 400 vs. ISO 3200 Effect: 3 stops larger or one-eighth as fast (for example *f*/8 at 1/250 sec. vs. *f*/22 at 1/250 sec., or 1/250 sec. at *f*/8 vs. 1/2000 sec. at *f*/8).

Appendix B: Converting EV Changes to F-Stop and Shutter Speed Values

Although equivalent values in the table below are given either for *f*-stop or shutter speed, the adjustment can be made through a combination of *f*-stop and shutter speed values.

Think of the *f*-stop as a reciprocal value, for example: $f/4$ as $1/4$, which is then larger than $f/8$ or $1/8$. Obviously, in shutter speeds, $1/4$ sec. is slower (longer) than $1/8$ sec. Then keep in mind that you let in *more* light with a *larger f*-stop or a *slower* shutter speed, and *less* light with a *smaller f*-stop or *faster* shutter speed. Think of the lumbering giant tortoise taking in more of the view versus the speedy petite hare who sees too little too quickly.

If your metered exposure were $f/8$ at $1/8$ sec., you would be *increasing* the exposure by +1 EV (1 full stop) by going to $f/5.6$ at $1/8$ sec. or $f/8$ at $1/4$ sec. If you went to $f/5.6$ at $1/4$ sec. (adjusting both values by the same amount—one step for each), you would be giving a +2 EV exposure increase. Again, starting with $f/8$ at $1/8$ sec., you would be *decreasing* the exposure by 1 stop (-1 EV) if you went to $f/11$ at $1/8$ sec. or $f/8$ at $1/15$ sec. Likewise, if you took that same metered exposure to $f/11$ at $1/15$ sec., that would be a -2 EV loss in exposure.

Important note: If you make any adjustment to ambient exposure compensation in any automatic exposure mode, do not follow up with a change in *f*-stop or shutter speed—the camera will do that automatically.

Exposure Increase in EV	Exposure Decrease in EV
+1 EV Results in: 1 *f*-stop larger or 1 step slower shutter speed. Example: *f*/8 to *f*/5.6 or 1/125 sec. to 1/60 sec.	-1 EV Results in: 1 *f*-stop smaller or 1 step faster shutter speed. Example: *f*/8 to *f*/11 or 1/125 sec. to 1/250 sec.
+2 EV Results in: 2 *f*-stops larger or 2 steps slower shutter speed. Example: *f*/8 to *f*/4 or 1/125 sec. to 1/30 sec.	-2 EV Results in: 2 *f*-stops smaller or 2 steps faster shutter speed. Example: *f*/8 to *f*/16 or 1/125 sec. to 1/500 sec.
+3 EV Results in: 3 *f*-stops larger or 3 steps slower shutter speed. Example: *f*/8 to *f*/2.8 or 1/125 sec. to 1/15 sec.	-3 EV Results in: 3 *f*-stops smaller or 3 steps faster shutter speed. Example: *f*/8 to *f*/22 or 1/125 sec. to 1/1000 sec.

AE. *Autoexposure.*

AE lock. *Autoexposure lock.* A manually activated camera function that locks the camera's automatic exposure reading. May be a separate button or engaged by pressing down halfway on the shutter release.

AE override. *See* autoexposure compensation.

AEB *Autoexposure bracketing.* A camera mode that automatically brackets exposures, typically following a user-defined sequence. *See also* bracketing; exposure bracketing.

AF. *Autofocus* or *autofocusing.*

AF lock. *Autofocusing lock.* A manually activated camera function that locks the camera's automatic focus setting. May be a separate button or engaged by pressing down halfway on the shutter release.

AF mode. *Autofocusing mode.* Normally a choice between one-shot AF and continuous AF (or some variation thereof).

ambient exposure. Any exposure based on ambient, or existing, light conditions.

anti-shake technology. *See* optical image stabilization.

Aperture Priority mode. Shooting mode whereby the user selects the aperture (*f*-stop) and the camera selects the shutter speed, at a given ISO setting.

ASA. Film speed rating based on standards established by the American Standards Association, and more recently ANSI (American National Standards Institute). Replaced by ISO. *See also* DIN.

autoexposure compensation. With the camera in any autoexposure shooting mode (except perhaps fully automatic/basic modes), this is a user-activated camera function that overrides the camera-determined exposure in a specified direction, plus or minus, in response to a subjective appraisal of a subject's tonality or scene brightness. *See also* exposure compensation.

autosensor flash. Also known simply as *automatic flash* and *auto-thyristor flash.* Flash mode whereby the onboard sensor reads light emitted by the strobe to determine output duration and, thereby, the flash exposure with recycling in turn governed by thyristor circuitry.

available light. Existing light; ambient light. Any existing illumination used to make an exposure.

background. (1) Backdrop. (2) Broadly, a subject's surroundings, encompassing both foreground and background elements.

background light. Any light used to illuminate a backdrop.

backlighting. Light that comes primarily from behind the subject.

black point. In digital imaging, a governing value affecting tonal range in the shadows and dark tones. Compare *white point.*

blocked (-up) shadow detail. Lost shadow detail owing to underexposure or excessive contrast.

blown-out highlight detail. Lost highlight detail owing to overexposure or excessive contrast. Synonymous with *washed-out highlights, burnt-out highlights.*

bounce card. Any relatively small surface that's used to bounce light from a source back onto the subject or a select subject area. *See also* collapsible reflector.

bounce flash. Any flash illumination reflected off a bounce card or other surface, such as a ceiling or wall, and mainly used to soften the light.

bounce lighting. Any light reflected off a nearby surface.

bracketing. Shooting multiple frames of the same image while varying one parameter in an effort to produce a usable image, usually by increasing and/or decreasing exposure; on some cameras this may also apply to focusing and white balance. *See also* AEB; exposure bracketing.

brightness contrast. Brightness range, or the range of highlight to shadow values as measured by a reflectance meter; often expressed numerically as "brightness ratio." *See also* contrast.

bulb exposure. Time exposure involving the "B" (bulb) shutter speed setting on the camera. May also denote Bulb shooting mode.

burnt-out highlights. *See* blown (-out) highlight detail.

calibration target. Gray card or multi-tonal target (for example, white/gray/black) designed for custom exposure and white balance settings under tricky or uncertain lighting conditions. *See also* 18% gray card.

camera shake. Unintentional movement of the camera during the exposure, resulting in motion blur. Usually applies to exposures made with a handheld camera at longer-than-optimum shutter speeds for the lens focal length in use.

capture. Also *image capture*, an image recorded by a digital imaging sensor into memory, usually with a camera; a digital photograph; a scanned image; broadly, any recorded image, even on film.

centerweighted averaging. In-camera TTL metering mode/pattern that bases exposure primarily on the subject area in the center of the frame, with increasingly diminishing emphasis toward the periphery.

chromogenic black-and-white film. A black-and-white dye-based negative emulsion that is processed and printed using the same color processes as any color negative film, including those in automated labs.

circular polarizer. Polarizing filter designed to be used with autofocus cameras, notably film and digital SLRs, in order to achieve a correct exposure reading.

clipping. In digital photography, the loss of highlight or shadow values owing to excessive contrast or exposure error. It is often indicated in a visual representation of the image in the display, with the affected part of the image flashing or otherwise designated by a specified color.

color balance. (1) Color of light prevalent in a scene. (2) Color temperature. (3) White balance.

color cast. An unnatural shift in color or a color imbalance over all or part of the image due to exposure of one type of film or a specified digital white balance (WB) under lighting of the wrong color temperature, or resulting from an unsuitable mix of light sources. **color temperature.** (1) A hypothetical measurement in degrees Kelvin that defines color sensitivity of a film emulsion or the color emission characteristics of a light source. (2) In digital photography, white balance setting designed to match predominating lighting conditions. *See also* color cast; color balance.

color-compensating filter. A CC-designated filter that provides subtle color balance correction. These filters may be used with other filters to correct for color casts.

color-conversion filter. Filter that dramatically alters color balance so as to bring the lighting in line with film or digital camera color balance. Kodak Wratten 80-series (blue) filters convert tungsten to daylight; Kodak Wratten 85-series (amber) filters convert daylight to tungsten.

color-correction filter. Color-tinted filter used with panchromatic black-and-white film to restore skin tones under specific lighting conditions. In daylight, a medium-yellow filter is used to counteract the blue component of the light; under incandescent lighting, a yellow-green filter will counteract the red-orange component.

color-temperature meter. A special handheld meter used primarily with film and designed to read the color of light sources and recommend corrective filtration.

continuous AF. Also known as *servo-focusing* or *servo-AF*, an autofocus setting whereby the camera's AF sensor continues to focus and track movement, locking in focus the moment the shutter is released. Usually used with action and sports. *See also* predictive AF.

contrast. Refers to the tonal or brightness range expressed by the subject, film/media, ambient conditions, lighting, and photographic image alone or in combination. *See also* brightness contrast; contrast ratio; high contrast; lighting contrast; low contrast.

contrast-enhancing filter. Color-tinted filter used with panchromatic black-and-white film to enhance certain colors and/or reduce the intensity of others.

contrast ratio. A numerical expression of subject brightness range or lighting contrast. *See also* brightness contrast; lighting contrast.

contrast-reduction filter. Special-effects filter designed to reduce contrast in a scene by boosting shadow detail, reducing highlight brilliance, or both.

cord mode. A mode on a flash meter that requires the sync cord hookup between flash and meter to trigger the flash and take the reading.

cordless mode. A mode on a flash meter that eliminates the need for a sync cord to take flash readings, with the user manually triggering the flash for a reading.

creative mode. Shooting mode that gives the user creative control over all exposure parameters and settings.

cropping. Eliminating unnecessary picture areas in order to focus attention on the subject, in essence getting rid of any distracting elements, such as clutter or hot spots, that would weaken the photograph or visual statement. Generally applied to work done in post but may also refer to framing in camera.

cumulative flash. *See* multiple flash.

custom WB. White balance setting, based on a user reading of a calibration target, designed to render neutral subject tones under any lighting conditions.

daylight-balanced. Refers to film designed to be exposed by light of a color temperature of 5500 K. Also refers to light sources of this color temperature, including typical daylight (sunlight with some clouds in the sky) and electronic flash.

dedicated flash. Flash unit designed to operate with a specific camera system whereby multiple electrical contacts provide enhanced communication between flash and camera. *See also* TTL flash.

depth of field. The zone of acceptable or apparent sharp focus surrounding the plane of focus (the exact subject area targeted by the lens).

depth-of-field (DOF) preview. A camera function that stops the lens down to the taking aperture to enable the photographer to preview depth of field surrounding the subject.

digital noise. Noisy artifact introduced into the digital image during capture, often as a result of underexposure, use of excessively long exposures, or setting a high ISO value; also a result of a camera manufacturer trying to cram too many pixels onto a tiny chip. *See also* noise filter.

DIN. Film speed rating based on standards established by the Deutsche Industrie Norm, currently Deutsches Institut fur Normung. *See also* ISO.

DNG. Digital negative. A file format developed by Adobe that can be shared across camera platforms (in other words, not camera-specific), providing the equivalent of the camera manufacturer's native RAW file format as a basis for enhanced image development and editing.

dragging the shutter. Using a long exposure.

dynamic range. In digital photography, the range of tones that can be successfully recorded by an imaging device.

effective f-stop. Newly calculated *f*-stop resulting from the use of lens extension.

18% gray card. Medium-gray calibration target designed to provide a neutral exposure, independent of subject/scene tonality and reflectance, when read by a reflected-light meter (in-camera or handheld device), with ambient light or flash. Also used to calibrate white balance with digital cameras.

EI. *Exposure index.* The film speed as it actually applies to a certain film emulsion, as determined by empirical testing designed to meet actual working conditions.

EV. *Exposure value.* A simplified numerical expression that denotes exposure levels, contrast, or exposure compensation in place of using actual *f*-stop and shutter speeds.

evaluative metering. In-camera TTL metering mode/pattern that uses countless algorithms to determine the exposure based on readings taken from a segmented photocell array, with each segment weighted for relative importance to the exposure. The focusing sensor may also play a role, depending on design. Also known as multipattern or matrix metering.

EVF. *Electronic viewfinder.* An internal full-information alphanumeric display used for viewing, composing, and exposure readings (in place of an optical viewfinder) and often found in modified SLR-type cameras that incorporate a zoom lens.

EXIF. Acronym for Exchangeable Image File. In digital photography, this is the data attached to an image file and may include such information as camera model, capture date/time, exposure data, and operating parameters used for a specific exposure. In a limited way, also applies to scanner captures.

expose (to the) right. In digital photography, a technique that pushes the histogram to the right (short of clipping the highlights) during capture, effectively overexposing the image to a controlled degree in an effort to prevent digital noise from being introduced into the darker tonal regions in the photograph; this is followed by corrections made in post, wherein exposure is pulled back down to the necessary levels during image editing.

exposure. (1) The total amount of light needed to form an image. It is expressed by the Law of Reciprocity as an equation: $E = I \times T$, where E = exposure, I = intensity of illumination (or *f*-stop), and T = time (duration, or shutter speed). (2) Also loosely used to mean picture, image, frame, and so on.

exposure bias. Exposure compensation.

exposure bracketing. Shooting multiple frames of the same image at different exposures—usually as a sequence of normal, plus, and minus (not necessarily in this order)—in an effort to ensure a usable image. Bracketed exposures are usually in 1/3-, 1/2-, or 1-stop increments. *See also* AEB; bracketing.

exposure compensation. Overriding the metered exposure to compensate for excessive light or dark tones or brightness values exhibited by the subject and/or surroundings. *See also* autoexposure compensation; flash exposure compensation.

exposure latitude. (1) Leeway in exposure; specifically, exposure increase or decrease level beyond which critical detail will be lost and often as a function of subject/scene contrast. (2) Margin of exposure error before serious damage is done.

exposure meter. A handheld meter. *See also* flash meter; light meter.

extender. Teleconverter.

extension tube. Close-up tube or ring that mounts behind the lens.

F/16 Rule. A popular, yet perhaps overly simplistic, approach for setting exposure with film under daylight conditions. It states that the exposure under bright frontal sunlight with distinct shadows should be *f*/16 at a shutter speed roughly equal to the reciprocal of the film speed. Also known as the Sunny 16 Rule and the Sunny F/16 Rule.

fast lens. Lens with a relatively large maximum aperture, making it suitable for handheld photography under a wide range of conditions, particularly low light levels. A 300mm F2.8 lens would be considered "fast." Compare *slow lens.*

FE lock. *Flash exposure lock.* A manually activated camera function that locks the TTL-flash sensor's reading as a way of bypassing unusual tonalities during normal flash operations or to override automatic output in fill flash.

FE override. *See* flash exposure compensation.

FEB. *Flash exposure bracketing.* A function that lets you bracket flash exposures in a similar fashion to AEB. Requires a suitably enabled TTL flash unit, with settings made on the strobe directly.

fill. Any form of illumination that is used to raise tonal values in deep shadows, thereby reducing subject contrast. When flash is used, it is referred to as *fill flash* and sometimes *flash fill.*

film speed. A measure of a film's light sensitivity and numerically represented by an ISO value.

filter. (1) Glass, plastic, or gelatin material that corrects or otherwise modifies the light entering the camera through the lens prior to reaching the film or imaging sensor. (2) In digital photography, a filter can also be an effect added to the image in photo-editing software programs; a plug-in.

filter density. The strength of a filter's effect, usually translating onto some degree of light loss.

filter factor. Numerical value (based on density and color absorption) used to compensate for light loss due to the use of one or more filters on the lens. UV and skylight filters generally have a negligible effect, so no filter factor is applied. Filter factors are only necessary with (1) non-TTL camera metering, (2) handheld exposure measurement, or (3) use of non-TTL flash lighting.

first-curtain sync. Also known as *leading-curtain sync*, standard flash synchronization occurring when the shutter curtains open. Compare *second-curtain sync.*

flare. Non-image-forming light resulting when bright light surrounding the subject enters the lens and bounces off reflective surfaces in the lens and camera. When flare takes on the shape of the iris diaphragm in the lens, it is known as a *flare spot* or *flare ghost.*

flash. Electronic flash, unless otherwise noted, which includes any reference to flash lighting, bounce flash, stroboscopic flash, and so on.

flash-analyzing function. A function of more sophisticated flash meters that analyzes the contribution of flash in a fill-flash exposure.

flash duration. Effectively, flash output.

flash exposure compensation. Also called *FE override*, this is a user-activated flash override function solely affecting TTL flash output.

flash-fill. *See* fill.

flash meter. A handheld exposure meter equipped to read the short bursts of light emitted by an electronic flash unit as well as ambient light.

flash sync. Flash synchronization speed, or sync speed. The shutter speed setting at which flash is synchronized to fire in coordination with shutter curtain movement. Cameras with a leaf/between-lens shutter can be fired at any shutter speed and still achieve proper flash synchronization, whereas a focal-plane camera (the typical 35mm film and digital SLR) has a specified maximum flash sync speed. *See also* high-speed sync.

flat lighting. A form of lighting that seemingly fails (either accidentally or intentionally) to reveal form or surface texture.

FP sync. *See* high-speed sync.

frontal lighting. Lighting coming primarily from in front of the subject, illuminating key subject areas facing the camera.

full auto mode. A shooting mode whereby the camera takes over all exposure functions, possibly even automatically activating the built-in flash.

gain. The recording level that defines ISO in digital photography as a measure of light sensitivity. Turning up the gain, or ISO, increasingly produces more and more noise in the image.

GN. *Guide number.* A measure, or rating, of a flash unit's efficiency under a given set of conditions, at a stated ISO setting, taking into account such factors as reflector design, attached panels, bounced lighting, and ambient surroundings (specifically, reflectivity and size of room). To calculate GN, especially when you find that the flash is under- or overexposing consistently in a given setting, use the following formula: GN (in feet) = *f*-stop x distance (flash to subject distance, in feet). Set up the flash at a distance of 10 feet from the subject (a gray card will suffice or, better yet, a person holding a gray card), and shoot a series of exposures, bracketing around the recommended exposure given by the flash calculator; then select the most suitable exposure. All settings for the flash will then have to be modified accordingly. You may want to establish a specific GN to be used with shooting outdoors at night.

graduated filter. A filter designed to gradually reduce light intensity over a portion of the scene, usually the sky, and sometimes imparting a color in the process.

gray card reading. A reflectance reading made off an 18% gray card (or similar calibration target) at the subject position or, when taken from a short distance away, in the same lighting that's hitting the subject. It produces the equivalent to an incident meter reading.

hair light. A light designed to add some sheen and dimension to the hair. Often positioned behind and above the head.

handle-mount strobe. Any electronic flash unit fitted with a grip handle and designed to be attached to the camera via a bracket while requiring a PC cord or TTL cable connection (as applicable) to the camera for synchronized triggering.

hard lighting. A form of lighting that tends to accent, if not exaggerate, texture and form, often resulting in harsh contrasts; sometimes also referred to as *specular lighting*.

haze filter. A filter designed to reduce aerial haze in high-altitude photography by cutting UV in the atmosphere. The embedded yellow tint also adds a warm touch to the scene. It may come in varying densities for heavy or light haze. Also known as a *haze reduction filter*.

HDR. *High Dynamic Range. See* merge to HDR.

high contrast. Applies to a tonal range dominated by deep shadows and dark tones at one end and bright highlights and light values at the other, but with few gray tones in between. Also refers to lighting that involves a high lighting ratio. Compare *low contrast*.

highlight. A key value of light tonality and/or high reflectance; a tonal value of greater than 18% reflectance.

highlight bias. An exposure reading keyed to a highlight value. Compare *shadow bias*.

high-speed sync. Also *FP sync*, this is a special flash synchronization mode on focal-plane SLRs, both film and digital, that allows any shutter speed to be used well past the specified flash sync setting. Usually used in fill flash operations under bright existing lighting.

histogram. A graph showing the tonal range, density, and contrast digitally captured at a given exposure. *See also* live histogram.

hot spot. Any subject area of excessive brightness, to the point where detail in that area is lost entirely, creating a disturbing visual element; a glaring reflection; specular highlight.

image mode. *See* picture mode.

image stabilization. *See* optical image stabilization.

imaging sensor. A CMOS or CCD chip that is used to capture an image in a digital camera or scanner.

incident dome. The hemispherical white plastic diffuser that sits atop the photocell in an incident meter.

incident-light measurement. Exposure measurement of light falling on the subject independent of subject tonality or brightness. This measurement utilizes the white incident dome and normally places the meter at the subject position, with the white dome aimed at the camera for the reading.

IR. *Infrared.*

ISO. Light sensitivity rating applied to both photographic film emulsions and digital capture based on standards established by the International Organization for Standardization. Replaced ASA.

joule. *See* W/S.

JPEG. Acronym for Joint Photographic Experts Group. A compressed file format that exhibits an observable loss in image quality, increasing with higher levels of compression.

kicker. (1) A kicker light: a small light used to accent a specific subject area, such as a hair light, or used as fill. (2) A kicker panel: a small panel either added to or built into a shoe-mount flash unit and designed to add catchlights to the eyes (and some fill) when the flash head is raised for bounce applications.

Kodak Wratten filter. A filter designation used with Eastman Kodak filters but widely (though not universally) applied throughout the industry.

LCD. Liquid crystal display.

LED. Light-emitting diode.

lens conversion factor. Also known as the "sensor factor," this is the number used in calculating the working focal length on many digital SLRs based on imaging sensor size. A full-size sensor (equivalent to the 35mm film format) is 1.5X or 1.6X the size of an APS-C sensor and 2X the size of a Four-Thirds sensor. Multiply these magnification factors by the original lens focal length to arrive at the working focal length on the digital camera in question. The net effect is the same as cropping a full-size image. The derived focal length is the one used to determine shutter speed when shooting handheld under subdued lighting or with long lenses (to prevent camera shake).

lens extension factor. Correction factor for lens extension. When shooting close-ups involving lens extension, the *f*-number marked on the lens is no longer valid: The effective aperture is now smaller and has to be recalculated to arrive at the necessary exposure. TTL metering will automatically compensate, as will TTL flash. Where necessary, you can calculate the effective *f*-stop based on the following formula: effective *f*-stop = original *f*-stop x (magnification + 1). If image magnification = 1 (life size) and the original *f* stop is *f*/5.6, the effective *f*-stop would be 5.6 x (1 + 1) = 11.2, which rounds out to *f*/11. Lens extension factors are only necessary with (1) non-TTL camera metering, (2) handheld exposure measurement, or (3) use of non-TTL flash lighting.

lens hood. Lens shade.

Light-balancing (LB) filter. In color photography, any filter designed to produce a more restrained warming or cooling effect on color balance than a color-conversion filter would deliver. LB filters generally fall under the designation of Kodak Wratten 81-series (yellowish) for warming and 82-series (bluish) for cooling.

lighting contrast. A ratio of the key-plus-fill light to the fill light alone as measured with an incident-light meter. Often expressed numerically as *lighting ratio*. The lighting ratio should generally not exceed 3:1 to avoid losing important highlights or shadow detail, such as facial features in a portrait, although 4:1 may produce more dramatic results. *See also* contrast ratio.

light meter. Handheld exposure meter designed to read ambient light levels. Compare *flash meter*.

linear polarizer. Polarizing filter designed to be used with any camera, except autofocusing designs.

live histogram. A histogram displayed by a digital camera, usually on the external LCD, prior to capture to help in evaluating the tonal range and contrast in the scene with given exposure settings.

low contrast. Applies to a tonal range dominated by gray values and possibly even lacking deep shadows or bright highlights. May also refer to low-contrast lighting. Compare *high contrast*.

LV. *Light value.* A reading of ambient light levels obtained with older light meters. Largely replaced by EV in popular usage.

macro-focusing. A term loosely applied to any lens, especially a zoom, capable of focusing closer than it was normally designed to do thanks to the incorporation of specially configured optics; more correctly *close-focusing*, since these lenses rarely reach into the true macro range.

macro lens. Lens designed to capture images at life size or half life size magnification without the aid of auxiliary optics or accessories and, ideally, with little to no deterioration in image quality across the field of view.

macro photography. Photography at life size and larger magnifications, but usually topping out at around 5X (5:1) or thereabouts, and certainly well under the magnifications used in photomicrography or photomicroscopy (with a microscope); also known as *photomacrography*.

magnification. The size of the captured or viewed image relative to its actual size. Life-size magnification signifies a reproduction ratio of 1:1, or 1X magnification; half life-size is 1:2, or 0.5X, and twice life-size is 2:1, or 2X. *See also* lens extension factor.

manual mode. (1) Camera shooting mode in which the user sets both the

lens aperture and shutter speed. (2) Flash mode that fixes output to full or a ratioed value.

masking. In digital editing, defining a picture area (through the use of selection tools) so that it remains unaffected by work done in a "selected" area. Think of masking tape used around a window sash to prevent it from being painted.

match-needle metering. Metering system, either in camera or in a handheld exposure meter, in which a galvanometer-driven needle indicates the exposure when light hits the photocell. Depending on the system in use, the indicator may point to a scale of values (EV or LV), with that number then transferred to another dial, or you may be required to manually match up the needle with a pointer—hence the term *match-needle*. More economical digital LCD meters may also take this approach, in a modified fashion.

matrix metering. *See* evaluative metering.

maximum aperture. The widest (largest) aperture setting on a lens, as designated by the smallest ordinal number. For example, *maximum* aperture on a 300mm F2.8 lens is *f*/2.8. This value determines the "speed" of a lens. *See also* fast lens; slow lens.

memory. (1) Onboard camera buffer memory that determines how many sequential exposures can be captured and processed. (2) Memory function on a handheld exposure meter that is used to store individual measurements as an aid in determining contrast or averaging exposure readings. (3) Camera memory used to store multiple spot readings prior to averaging them. (4) Memory card. (5) Backup camera or meter memory, which may utilize a separate battery.

merge to HDR. A digital technique whereby you recapture the widest possible dynamic range, approaching what was originally found in the scene, through a series of merged bracketed exposures.

midtone. Middle, or 18%, gray, or generally a gray tonality or equivalent color value.

minimum aperture. The smallest aperture setting on a lens, as designated by the highest ordinal number. Compare *maximum aperture*.

mirror lockup. A function of select SLR cameras, both film and digital, that locks the mirror in the up position to prevent its movement and resultant mirror bounce (or, technically, bound) during a long exposure, which in turn might induce camera shake. Use of the camera's optical viewfinder is disabled for the duration, until the mirror is returned to its normal position.

multi-pattern metering. *See* evaluative metering.

multiple exposure. Two or more exposures superimposed on one frame.

multiple flash. Repeated popping of one or more strobes to build up exposure. Multiple Flash (or Cumulative Flash) mode on a flash meter measures the cumulative exposure and may also provide a reading of the number of flash pops.

ND filter. *Neutral-density filter.* Colorless filter that uniformly reduces the amount of light reaching the film or imaging sensor in specific amounts, or densities, effectively reducing film speed or light sensitivity, in order to permit longer exposure times or larger lens apertures. *See also* graduated filter.

negative film. Any film stock designed as an interim step en route to becoming a photographic print (usually processed in C-41 or similar chemistry); print film

noise filter. A software filter or plug-in that reduces or eliminates digital noise but which may also soften the image in the process. To compensate, the filter may include sharpening algorithms, or sharpening may be added with another filter.

noise reduction. Also known as *long exposure noise reduction*, in digital photography this function reduces digital noise during camera exposures lasting 1 second or longer and may be activated automatically. In-camera noise reduction may effectively double the exposure time when factoring in the added processing, which may work against you when shooting continuous activity. On some cameras, it is a custom function setting.

one-shot AF. Single-shot autofocusing mode whereby the camera refocuses each time the shutter button is pressed.

optical image stabilization (IS). A technology within the lens that physically stabilizes it, thereby allowing you to shoot handheld at slower-than-optimum shutter speeds without fear of inducing camera shake. Typically, image stabilization is effective down to three or four steps slower than would be required with a specific focal length. Optical IS is far superior to electronic IS, which interpolates pixels. Shake reduction (or anti-shake) arguably delivers the same performance as optical IS, although anti-shake technology is found in the camera body itself, making it usable with a wider range of optics for a specific camera, hence more economical.

overexposure. (1) Any exposure in which too much light contributed to the formation of the image, resulting in dill midtones and shadows and possibly burnt-out highlights. (2) Intentionally giving more exposure than indicated by the meter to correct for erroneous measurement or to preserve or enhance a mood, such as high key.

panchromatic film. Typical modern film emulsion that is sensitive to visible light and UV.

parallax error. The error resulting when a sensor, viewfinder, or flash fails to target the subject in perfect alignment with what a camera's optical system sees when capturing the image. May also be applied to a handheld meter, where the accessory optical spot attachment fails to align with the target measured by the reflectance sensor.

partial-area metering. Also called *partial-spot metering*. A compromise in-camera approach to spot metering that incorporates a wider field of view than that normally encompassed with spot metering.

photocell. The light-sensitive device used by an exposure metering system to read light levels.

Picture mode. A basic shooting mode that automatically optimizes exposure keyed to a specific subject category, such as portraits, action, or night photography. Also known as Image mode or Scene mode.

polarizer. Polarizing filter. This filter acts on reflected light to reduce or eliminate glaring surface reflections in water, glass, and painted objects; to intensify colors, especially in blue sky and practically anything but unpainted metal; and to penetrate haze to some degree. Rotating the polarizer varies its effect on the scene from practically negligible to profoundly noticeable. Loss of light: about 2 EV. *See also* linear polarizer; circular polarizer.

positive. (1) Reversal film. (2) Polaroid print. (3) Photographic rendition that corresponds to actual subject tones, from highlights to shadows.

post. Short for *postproduction*, this is work done on an image, or the phase or process that occurs, after capture. Usually applies to digital editing, retouching, and compositing.

predictive AF. An extension of continuous AF whereby the camera "predicts" the position of a subject at the moment of exposure (utilizing selected AF points), even a fraction of a second after the shutter is released, ensuring sharp focus, provided the subject is moving in the same direction and at a constant rate.

pre-flash. Any short flash blip that precedes the actual flash output as an aid in determining TTL flash exposure. Also used to reduce the effects of red-eye.

print film. *See* negative film.

Program mode. A shooting mode whereby the user sets the ISO and the camera selects the shutter speed and *f*-stop.

push/pull film. Setting ISO higher (pushing film) or lower (pulling film) for an entire roll of film in response to prevailing light conditions, subject needs, or personal taste, followed by push- or pull-processing, respectively, to compensate for what is effectively an under/overexposed roll of film. Push-processing results in enhanced contrast and possibly an increase in graininess and a color shift, whereas pull-processing produces lower contrast, tighter grain, and, again, a color shift.

RAW. (1) Unprocessed digital camera file format that retains all original capture data known as "metadata." Processing a RAW file involves correcting and interpreting the image in an attempt to restore or enhance the numerous parameters that define the image, principal among them exposure, contrast, tonal range, and colors. (2) Camera mode resulting in RAW capture.

reciprocity effect. Reciprocity-law failure. The failure of a film to perform as expected when subjected to an excessively long or short exposure, resulting in a color shift (color film only) and loss of film speed (color or black-and-white film).

red-eye. The phenomenon in which the eye reflects back light through the pupils with a strong red patina (green or yellow-green in some animals).

Red-Eye mode. A flash mode that emits a pre-flash burst or series of bursts or constant bright light in an effort to reduce the size of the pupil and, subsequently, reduce or eliminate red-eye.

reflected-light (reflectance) measurement. Exposure measurement of subject/scene tonality and brightness. This measurement normally involves the camera's built-in metering system or a handheld reflectance meter pointed at the subject.

reflector. (1) Bounce card or flat. (2) Highly reflective dish or bowl surrounding a lamp of some type (for example, a flashtube) and designed to control the pattern, distribution, and throw of light from a light head.

reproduction ratio. *See* magnification.

reversal film. Any film emulsion designed to be processed (usually in E-6 or similar chemistry) in such a way that the same film becomes the end product for viewing as a slide or transparency (chrome).

scanner. A device used to capture and digitize a piece of film, photographic print, or any document, the intended purpose being digital storage and manipulation.

Scene mode. *See* Picture mode.

scrim. A sheer material that reduces light intensity, thereby lowering contrast. Often used outdoors to screen out bright sunlight or to selectively hold back light in the studio.

second-curtain sync. Also known as *trailing-curtain sync*. A flash synchronization mode whereby the flash fires when the shutter closes to ensure that the ambient exposure of a moving subject is seen as a trailing blur. Compare *first-curtain sync*.

self-timer. A means of releasing the shutter after a prescribed time period of several seconds without further involvement by the user. Used with a tripod or other firm support so that you can get in the picture, but also comes in handy in place of a cable/remote release for long exposures.

shadow. A key tonal value of low reflectance; a tonal value of less than 18% reflectance; tones in the range of deep gray to black.

shadow bias. An exposure reading keyed to a shadow value. Compare *highlight bias*.

shake reduction. *See* optical image stabilization.

shoe-mount strobe. Any electronic flash unit designed to sit in the camera's hot shoe or a standard shoe atop the camera or on a flash bracket.

shooting mode. Camera operating mode. *See also* Aperture Priority mode; Creative mode; full auto mode; manual mode; Picture mode; Program mode; Shutter Priority mode.

shutter lag. The delay between the moment you press the shutter button and the instant the shutter is actually released (when you hear the click), signifying completion of the exposure.

Shutter Priority mode. A shooting mode whereby the user selects the shutter speed and the camera selects the *f*-stop, at a given ISO setting.

sidelighting. Lighting that strikes the subject primarily from the side.

skylight filter. Filter designed to screen out UV radiation and add a warming touch to the scene, owing to its pink color. Primarily for use in color photography, especially with color reversal film.

slave sync. Triggering a flash remotely.

slow lens. A lens with a relatively small maximum aperture, making it unsuitable for handheld photography, especially under low light levels. A 300mm F5.6 lens would be considered "slow." Compare *fast lens*.

slow sync. Relatively slow shutter speed used with flash to allow ambient light levels to record.

soft lighting. A form of lighting that produces soft shadows and low contrast.

spectral sensitivity. Color response. An imaging medium's response to the different wavelengths of light, which defines how well those colors are recorded.

specular highlight. A hot spot, often of a small, definable nature.

specular lighting. Hard lighting that tends to produce hot spots.

spot metering. Reflectance measurement involving a spot meter reading of a well-defined subject area, usually measuring one degree of arc. This allows you to pinpoint the exact subject area that is of utmost importance to the picture and key the exposure accordingly—namely, to a key highlight, shadow, or midtone. Select metering systems can store two spot readings (key highlight and shadow), or multiple spot measurements, and average them.

spot mode. In-camera TTL metering mode/pattern that limits the area being measured to a very small. definable circle, usually described by the central focusing area, and varying with the lens's field of view. There's also a partial spot mode, which uses partial-area metering.

stopping down. Setting a smaller *f*-stop on the lens.

stops (and steps). Although the terms *stop* and *step* are often used interchangeably, there's a technical difference between them. A *stop* refers to an *f*-stop; a *step* usually applies to shutter speed, ISO, and EV values.

stroboscopic flash. A sequence of extremely short, low-power flash bursts designed to capture movement as a multiple exposure on one frame.

subject. The area of primary concern when composing, focusing, and/or determining exposure; by extension, the *scene* in front of the camera.

subject contrast. (1) Brightness contrast. (2) More specifically, the aggregate of tonal range, subject reflectance, and lighting that affects our technical or aesthetic judgment of the image. In digital photography, dynamic range also enters the picture. (3) More loosely, subject tonal contrast.

Sunny 16 Rule. *See* F/16 Rule.

sync speed. *See* flash sync.

tele. Telephoto.

teleconverter. A ring with optical components that mounts behind the lens and increases (or extends) the focal length by a known factor, usually 1.4X or 2X.

TIFF. Acronym for Tagged Image File Format. File format typically used for quality printing and reproduction.

time exposure. Timed, long-duration exposure, often involving the B setting on the camera's shutter speed dial or a special Bulb mode.

tonal contrast. Perceived (not measured) relationship between key highlights and key shadow values.

tonal range. Range of recorded or printed tones from key highlights to key shadow values.

tone curve. In digital photography, the curve representing the tonal range and contrast in an image (somewhat analogous to a film's characteristic curve).

TTL. Through-the-lens.

TTL metering. Exposure measurement made through a camera lens.

TTL flash. Flash exposure control made through the camera lens using one or more sensors in the camera and microprocessors in both camera and flash, with camera and flash communicating through a complex array of dedicated electrical contacts usually in the hot shoe. *See also* dedicated flash.

tungsten-balanced. Refers to film designed to be exposed by light of a color temperature of 3200 K. Also refers to halogen light sources of this color temperature.

tungsten WB. In digital photography, a white balance setting designed to provide correct color balance under tungsten (or, by extension, incandescent) lighting. Might also be referred to as "indoor WB." Can be used for effect to impart an eerie blue color cast under daylight conditions.

underexposure. (1) Any exposure in which too little light contributed to the formation of the image, resulting in muddled tones and blocked-up shadows. In digital capture, there may also be evidence of noise. (2) Intentionally giving less exposure than indicated by the meter to correct for erroneous measurement or to preserve or enhance a mood, such as low key.

UV. Ultraviolet.

UV filter. Filter designed to screen out UV radiation. Principally applicable to black-and-white photography.

vignetting. (1) Peripheral image loss; veiling or a cutting-off of the image around the periphery accidentally (due to use of an unsuitable lens shade or resulting from the lens's optical design) or intentionally (in printing or with imaging software). (2) Loss of illumination from a light source over the periphery of the image due to the use of a wider lens focal length than that covered by the flash. (3) Loss of illumination over a portion of the subject obstructed by a long lens or lens shade.

visible spectrum. Visible light between UV and IR. Often used to refer to colors that fall within this range.

warming filter. A light-balancing filter, generally in the 81-series, that can be used to warm up a subject or scene shot under overcast skies or in shade.

washed-out highlights. Burnt-out highlights. *See* blown-out highlight detail.

WB. *White balance.* In digital photography, generally refers to a setting that will produce an acceptable color balance (or neutral white light) under prevailing light conditions. White balance settings can be custom-calibrated to meet virtually any lighting, such as fluorescents or mixed light sources, without resorting to the use of camera filters.

white point. In digital imaging, a governing value affecting tonal range in the highlights and light tones. Compare *black point*.

wireless flash. A remote flash synchronization technique or system involving a photo-optical, IR, or radio trigger at camera, with a corresponding receiver attached to or built in the flash, doing away with the need to use sync cords.

Wratten filter. *See* Kodak Wratten filter.

W/S. Watt-seconds (joules in Europe). Potential output/energy rating applied to studio strobes and select handle-mount strobes.

X-sync. (1) Typical flash synchronization setting used with studio strobes and other non-dedicated flash units. (2) The on-camera terminal used in this connection.

Further Reading

Not everything is about technique. You first have to "see" the image to visualize what it will, or can, become once captured. Then and only then should you begin to work on realizing your vision, creating a product of mind, heart, technology, and technique. The following works provided valuable information and inspiration that contributed to the creation of this book. While specific articles are not cited, various magazines (most notably *Shutterbug* and *Photo District News*) and Web sites (among them The Luminous Landscape/www.luminous-landscape.com and Digital Photography Review/www.dpreview.com) also proved invaluable.

Advanced Photography by Michael Langford (Focal Press, 6th edition 1998)

Amphoto's Guide to Creative Digital Photography by George Schaub (Amphoto Books, 2004)

The Art of Outdoor Photography by Boyd Norton (Voyageur Press, revised edition 2002)

Colour Photography in Practice by D. A. Spencer (Focal Press, revised edition 1975)

The Creation by Ernst Haas (Penguin Books, 1976)

Dictionary of Contemporary Photography by Leslie Stroebel and Hollis N. Todd (Morgan & Morgan, 1974)

The Digital SLR Guide by Jon Canfield (Peachpit Press, 2006)

EF Lens Work III: The Eyes of EOS (Canon Inc., 3rd edition 2003)

Electronic Flash (Kodak Workshop Series) by Jack Neubart (Silver Pixel Press, 1997)

Handbook of Kodak Photographic Filters (Eastman Kodak Co., 1990)

Industrial Photography by Jack Neubart (Amphoto Books, 1989)

Kodak Color Films and Papers for Professionals (Eastman Kodak Co., 1986)

Location Lighting Solutions by Jack Neubart (Amphoto Books, 2006)

The Manual of Photography revised by Ralph E. Jacobson (Focal Press, 9th edition 2000)

The Master Guide to Photography by Michael Langford (Alfred A. Knopf, 1982)

Mastering Digital Photography and Imaging by Peter K. Burian (Sybex, 2004)

Photography and the Art of Seeing by Freeman Patterson (Sierra Club Books, 1988; revised edition: Random House, 1990)

The Photographer's Guide to Exposure by Jack Neubart (Amphoto Books, 1988)

Studio Lighting Solutions by Jack Neubart (Amphoto Books, 2005)

Visual Concepts for Photographers by Leslie Stroebel, Hollis Todd, and Richard Zakia (Focal Press, 1980)

Index